W9-BGN-778

Posing
Techniques
FOR
PHOTOGRAPHERS
AND MODELS

About the Author

Cheyenne is a professional fashion model, photographer, and television producer who comes from the city of her namesake, Cheyenne, Wyoming. She has been seen on the covers and inside some of the world's most glamourous magazines, including *Harper's Bazaar*; the French, Italian, and American *Vogue*; *Queen*, *Zoom*, *McCall's*, *Look*, and *Cosmopolitan*. She has modeled all over the world for such leading photographers as Richard Avedon, Irving Penn, Francesco Scavullo, Hiro, Henry Clark, Bill King, Bill Silano, James Moore, Norman Seeff, David Bailey, J. Frederick Smith, David Montgomery, Arthur Elgort, Barry Lategan, and Peter Beard. Her own photographs have appeared in *Playboy*, *Town and Country*, *Cosmopolitan*, and in the internationally acclaimed photography magazine, *Zoom*.

Cheyenne received her bachelor's degree in fine arts from Colorado University in Boulder, Colorado. She has produced, written, and styled fashion shows for television and has taught photo posing and ramp modeling techniques at top modeling agencies in New York City and Hawaii.

Posing Techniques

FOR
PHOTOGRAPHERS
AND MODELS

BY CHEYENNE

AMPHOTO
American Photographic Book Publishing
An Imprint of Watson-Guptill Publications
New York, New York

Dedicated to the creativeness in man
and his love expressed in the moment.

Copyright © 1983 by Cheyenne

First published 1983 in New York, New York by American Photographic Book Publishing,
an imprint of Watson-Guptill Publications,
a division of Billboard Publications, Inc.,
1515 Broadway, New York, N.Y. 10036

Library of Congress Cataloging in Publication Data

Cheyenne.
 Posing techniques for photographers and models.

 Includes index.
 1. Fashion photography. 2. Photography—Portraits—
Lighting and posing. 3. Models, Fashion. I. Title.
TR679.C43 1983 778.9′9391 83-19761
 ISBN 0-8174-4525-0 ISBN 0-8174-5544-2 (pbk.)

Distributed in the United Kingdom by Phaidon Press Ltd., Littlegate
House, St. Ebbe's St., Oxford

Manufactured in U.S.A.

6 7 8 9/95 94 93

Design by Bob Fillie
Graphic production by Hector Campbell

Acknowledgments

Thanks to
Don Manza
John Gotman
Joan Kramer
Elizabeth Bright
Jill Adams
Herely and Herbert Papock
Lori French
Irving Penn
Gerald Gentile
Jack Lemmon
Francesco Scavullo
Richard Hood
Bruno
Foto-Style
Louis Canalis
Frank Campisano
Allan Rogers
Rick Davis
Ann Darling
Phillip and Rich
Jean and Joe
Mockingbird
Hygia
and
Ramtha.
A special thanks
to Don Manza
for his assistance
in lighting,
Leonardo De Vega
for his hair
and makeup artistry
for the cover art,
and to John Gotman,
a special friend.

Contents

Modeling for Commercial Products 128

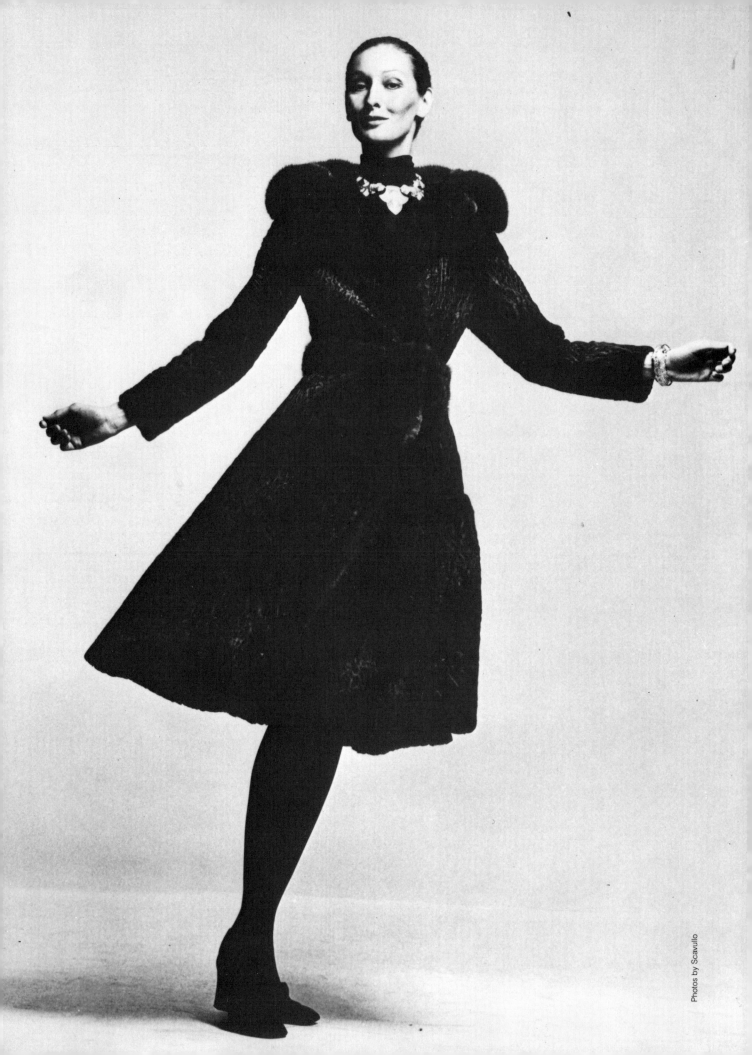

Foreword

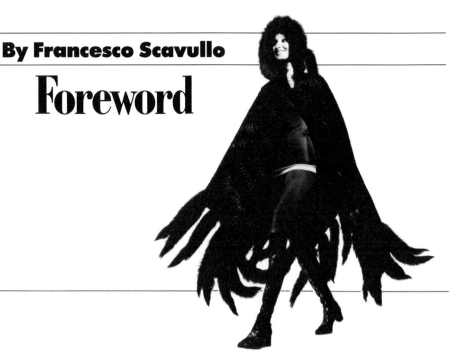

The first time I saw Cheyenne, I was photographing an editorial fashion spread for *Harper's Bazaar* in my studio in New York City. As I looked up toward the reception area, I caught a glimpse of what looked like a fantastic, energetic amazon flash by. Because I am naturally curious, I gave everyone on my staff a ten-minute break and walked into the reception area to see an exceptionally tall lady who seemed to be about seven feet tall, so you can guess what my first question to her was. She replied, "I am only six-feet, one-inch tall, but my fur hat and cowgirl boots add another seven inches, so I appear as if I'm six-feet, eight inches!" Cheyenne was wearing a beautiful, huge red fox hat, a finger-tip jacket, white leather gloves, trousers, boots, and yellow-and-green ski goggles that were so large that they covered three-quarters of her elegant face. China McChado, then the senior fashion editor of *Harper's Bazaar*, had sent Cheyenne around for me to consider as a potential model for an eight-page editorial spread on designer evening gowns. And although I found her very interesting looking and her portfolio was incredibly beautiful I felt overwhelmed by her height and knew that she was too tall for these particular clothes.

Years passed before I actually got to photograph Cheyenne, although periodically she would stop by just to visit or was sent over by an agency or a magazine editor. I always looked forward to these visits because I enjoyed seeing the imaginative outfits that she could conjure up. Cheyenne is that rare personality in the fashion business: her sense of fashion is truly unique; she is a genuine trend setter. She is also very amusing, and I found that she lifted my spirits. But still her exotic look did not fit into the type of fashion photography that I was doing at the time.

Then, one day, *Harper's Bazaar* sent what seemed like tons of fur coats, hats, skirts, and jackets over to the studio. These rather oversized and dramatic garments were all designed by Giorgio Sant-Angelo from his American Indian collection. I knew that it would take an experienced and exotic-looking model to show these clothes off to their best advantage, so I immediately thought of Cheyenne and sent her a telegram. When she didn't reply, I arrived on her doorstep the following morning and took her back to the studio, where I photographed Cheyenne in gorgeous furs for the next four days.

On another one of Cheyenne's visits, she arrived decked out in a tophat and tails. She looked so fantastic that I put her right on the set, taking several shots on the spot. Another time, Cheyenne showed up with two other very exotic-looking women. They were Asha, a lovely singer from India, and Valli, a fabulous artist who proceeded to paint intricate, colorful tatoos on Cheyenne's, Asha's, and her own face. The three of them looked so wonderful together that I began photographing them immediately. Later, one of those shots made the cover of *Zoom* magazine.

Throughout the years that I have had the pleasure of working with Cheyenne, I've always thought that she is capable of accomplishing anything she set out to do. To me, she is the exception rather than the rule: that rare combination of talent, energy, and awareness. Because I work with so many models that are new to this business of fashion, it is a delight to work with a seasoned professional like Cheyenne. Her graceful movements have always been a complement to my pictures.

Cheyenne's book is a generously informative source book for the aspiring model and photographer, and as unique and professional as she is. For those of you who want to learn all you can about this most fascinating and glamourous of professions, I suggest that you read on.

With warm wishes and love,

Frank Scavullo

Introduction

Photographic fashion modeling is a great adventure and a glamourous and creative career that can be extremely financially rewarding. But despite these obvious enticements, many people believe they don't have the necessary good looks or the talent to break into this exciting field. What they don't realize is the most important and valuable skill they need is one that can be learned. Therefore, even though you may consider yourself an average-looking person, you can still become a successful model, if you know the skill of *photo posing*. Makeup and hairstyling skills are also important, but many times these are services that are provided by other professionals. Photo posing, however, is the most valuable technique of all because no one can pose for you, but you! Similarly, a photographer may be creatively and technically proficient, but so inexperienced at directing the model that the results look dull and stilted, rather than lively and exciting.

Over the years, newcomers to the fashion business, and sometimes even established professionals, have confided in me that their biggest problem was not knowing the basic photo posing techniques and that they were filled with fear when they went for a modeling assignment or test. And since acquiring these necessary skills requires at least one year of on-the-job training, this lack can also mean the loss of an entire year's income. As both an experienced fashion model and photographer, I have observed that new models, along with some experienced ones, don't possess enough of a sense of their physical

selves to project that aura of confidence needed for fashion photography. And in those cases where the model has had to be coached on every facial and bodily expression, all liveliness and spontaneity seem to be drained from the resulting photographs.

I wrote *Posing Techniques for Models and Photographers* because I felt that there was a real need for a comprehensive text on photo posing techniques. This book covers a multitude of techniques that are needed for nearly every possible situation for the photographer and the model; and it serves as a handbook on the various areas of fashion photography, from the glamorous, high-styled modeling that appears on the pages of elegant fashion magazines to the more ordinary, but equally important, pages of the mail-order catalog.

This book is composed of three parts. The first part covers the preparatory and business aspects of the modeling profession, and a section on technical and business information for the photographer, including a fully illustrated section on what to include in a model's professional portfolio.

The main body of the book spans twenty-six chapters on the various fashion categories; and interspersed throughout are examples from all four areas of fashion modeling. These are:

1. *Editorial Fashion.* This kind of photography is shown on the editorial as opposed to the advertising pages of a fashion magazine, such as *Vogue*, *Glamour*, or *Seventeen*. Here, the photographer is responsible to the style and

outlook of the magazine, not to the manufacturer of a product. The idea is to create a look that will have the greatest appeal to a particular magazine's audience, while still focusing on the apparel or products being shown. Editorial fashion is associated with greater artistic freedom than is advertising fashion: the photographer largely determines the concept to be followed, the models and locations, and the mood of the entire shooting.

2. *Advertising Fashion.* This is a more conservative field than editorial fashion. The photographer is working directly for the manufacturer or an advertising agency, and the product takes precedence over all other concerns. In this area of fashion, the photographer's job is to present a product in a way that will best promote it.

3. *Catalog Advertising.* The purpose of catalog modeling is to present clothing or other merchandise in a very straightforward and highly detailed way. The objective here is to clearly show each feature of the garment or product.

4. *Illustrative Advertising.* This type of photography and modeling is a variety of advertising photography that is set in a "real life" environment, where two or more models are posing and reacting to each other in a setting and manner that is natural to the product, such as sunglasses at the beach or beer at a tavern.

In each of the various fashion situations in this book, I have included specific instructions to both the photographer and the model. For each shooting, the model is advised on how to best direct herself and how to most successfully interact with the photographer. The photographer is similarly informed on the best way to direct the model in each pose. In addition, each chapter includes demonstrations of five successful poses (the do's) as well as five unacceptable poses (the don't's). These pictures of actual modeling sessions are all accompanied with commentaries that analyze the important aspects of each pose. Finally, because the main purpose of this book is to demonstrate how to arrive at the final fashion photograph, each chapter concludes with a best picture and a summary that explains why that particular photograph is the most successful.

The last and third section of the book covers a very important and lucrative part of commercial photography: product modeling. Here the model is secondary to the product. Often, in this type of advertising, only one part of the model's body is featured, such as a hand or a foot. However, the placement of these body parts is a very important component in successful product advertising. So, to all you aspiring models and photographers, I hope that this book will be a source of ideas and encouragement as well as a practical guide to your fashion career. And that with careful analysis of the various posing techniques shown here, the novice can achieve the skills and confidence needed to assure financial and artistic success, and the professional can become an even greater creative force in the fashion industry.

With love,

Cheyenne

Richard Blinkoff and I created this softly lit photo of me one warm spring day. It was shot during that critical time when Richard was building his first fashion portfolio.

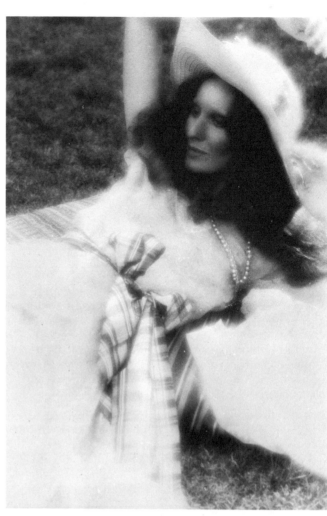

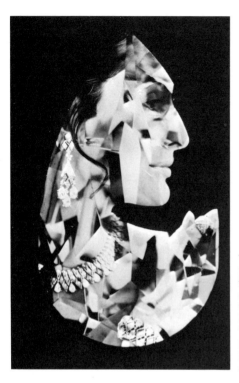

This image of my profile as seen through a pear-shaped diamond, was shot by Phillip Leonian for Tiffany's. It appeared as a full-page ad in *Harper's Bazaar* magazine.

Phillip Leonian shot two treatments of this idea (one with movement and one without) for a Thanksgiving poster. Phillip is well known for his action shots.

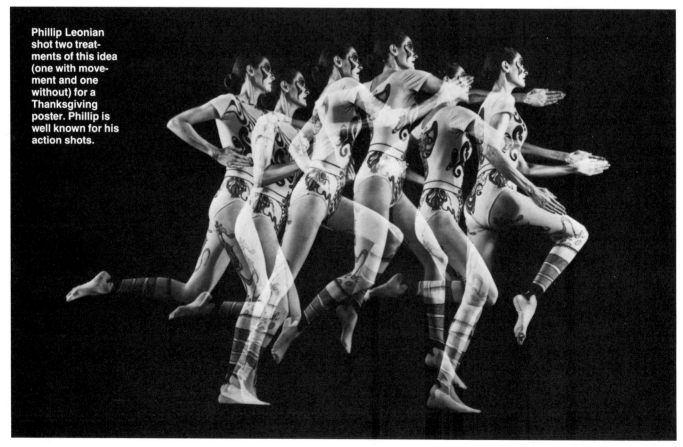

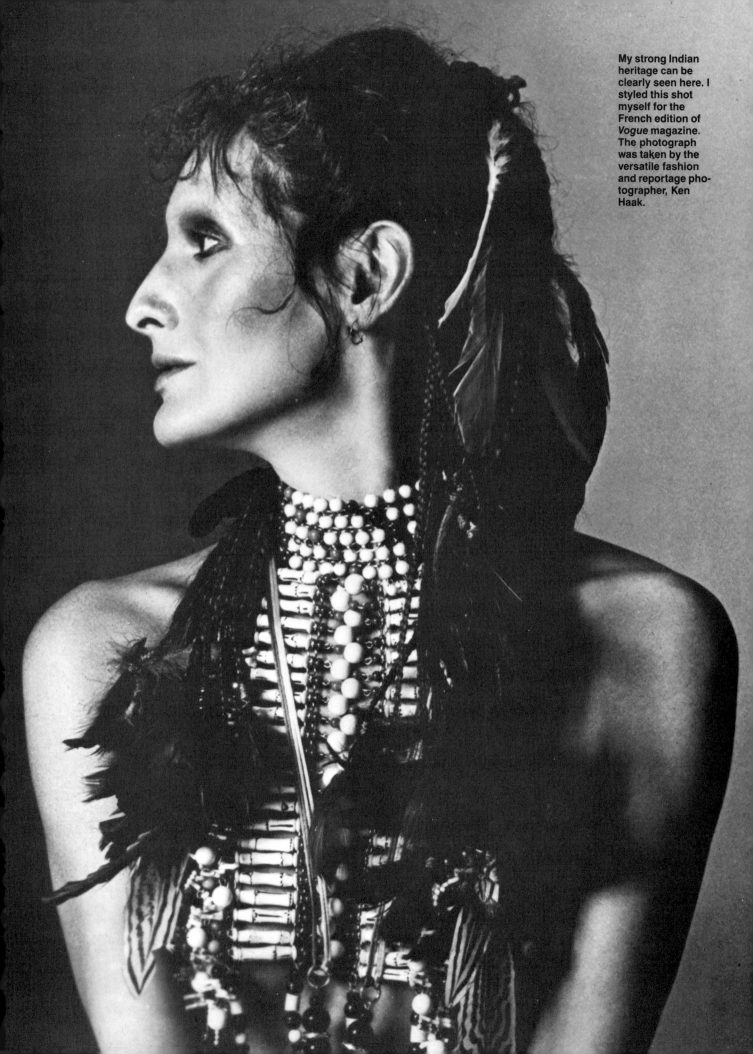

My strong Indian
heritage can be
clearly seen here. I
styled this shot
myself for the
French edition of
Vogue magazine.
The photograph
was taken by the
versatile fashion
and reportage pho-
tographer, Ken
Haak.

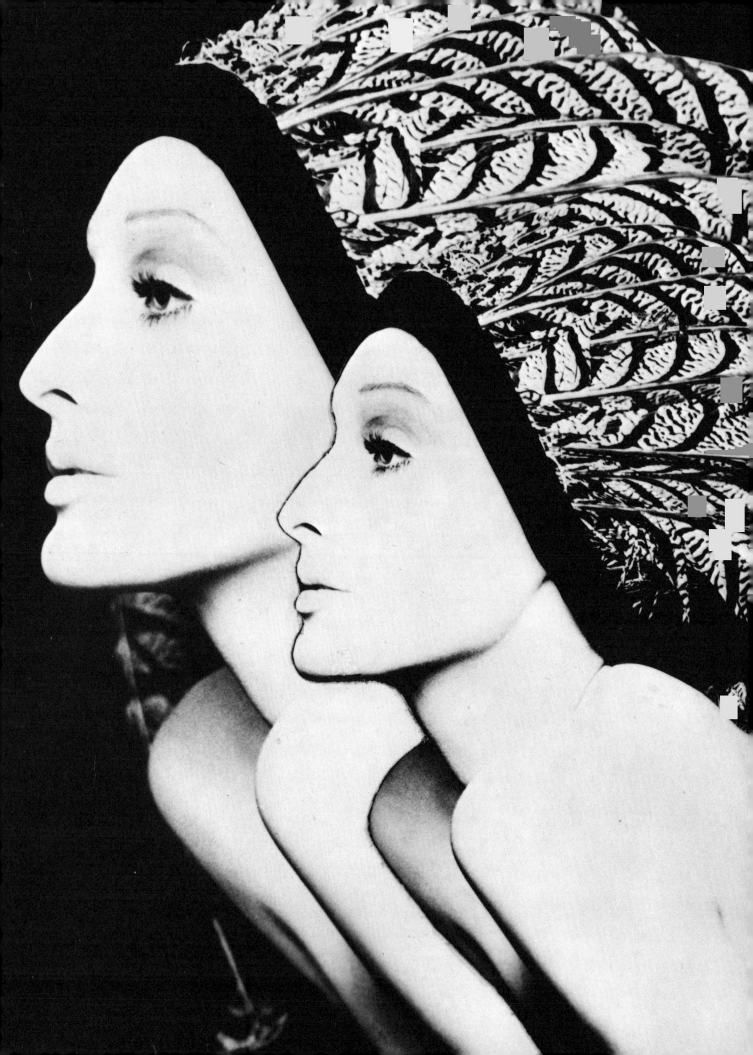

Currently working in Los Angeles, Roberta Booth was one of the top fashion and beauty photographers in New York City. This shot was taken by her for a publicity story on me that appeared in an Italian magazine.

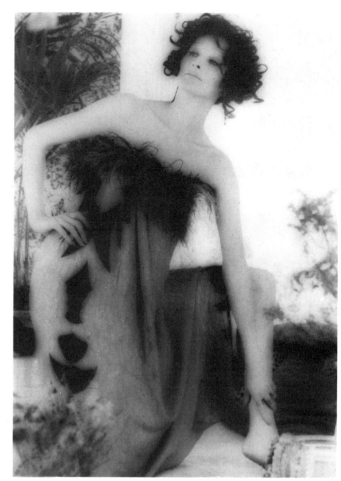

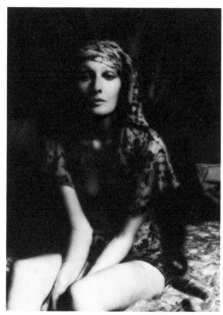

Norman Seeff, medical-doctor-turned-photographer, took this shot of me in London for a book entitled *Hot Shots*.

J. Frederick Smith has photographed me many times during my career. He is a favorite of any model, because he encourages women to discover themselves and their own feelings when they are in front of the camera.

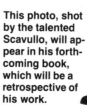

This photo, shot by the talented Scavullo, will appear in his forthcoming book, which will be a retrospective of his work.

I love working with
Ken Haak. When I
was new to the
business, he
taught me a great
deal about the art
of photo posing.
He would phys-
ically demonstrate
the pose and mood
he wanted me to
execute *before* he
began to shoot.

Peter Beard is
known for his
editorial essays on
both celebrities
and wildlife. Peter
gets the results
he's after even if he
has to shoot thirty
rolls of film a day.
Believe me! I once
worked five days
in a row for Peter
and I lost a pound
a day.

Ryszard Horo-
witz's stark
graphic style is
popular with ad
agencies and pho-
tography maga-
zines. He took this
surrealistic shot of
me for the cover of
*Modern
Photography*.

This cover shot for
the Italian *Harper's
Bazaar* was taken
by photographer
Bob Krieger.

This is an advertis-
ing shot that I did
for Monsanto. Bar-
bara Bordnick, the
photographer, was
one of the first
women to become
a major talent in
both editorial and
advertising
photography.

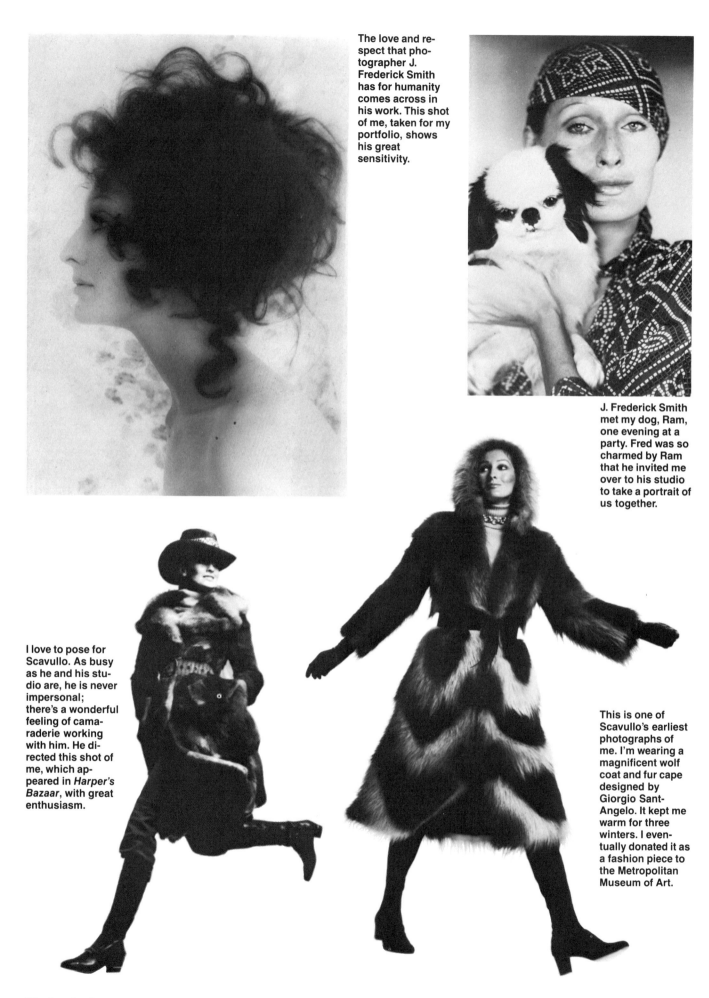

The love and respect that photographer J. Frederick Smith has for humanity comes across in his work. This shot of me, taken for my portfolio, shows his great sensitivity.

J. Frederick Smith met my dog, Ram, one evening at a party. Fred was so charmed by Ram that he invited me over to his studio to take a portrait of us together.

I love to pose for Scavullo. As busy as he and his studio are, he is never impersonal; there's a wonderful feeling of camaraderie working with him. He directed this shot of me, which appeared in *Harper's Bazaar*, with great enthusiasm.

This is one of Scavullo's earliest photographs of me. I'm wearing a magnificent wolf coat and fur cape designed by Giorgio Sant-Angelo. It kept me warm for three winters. I eventually donated it as a fashion piece to the Metropolitan Museum of Art.

Photographer Gary Gross, known for his sensitive style and superb lighting techniques, took this publicity shot of me. My hair and makeup were done by the famous makeup stylist, Way Bandy.

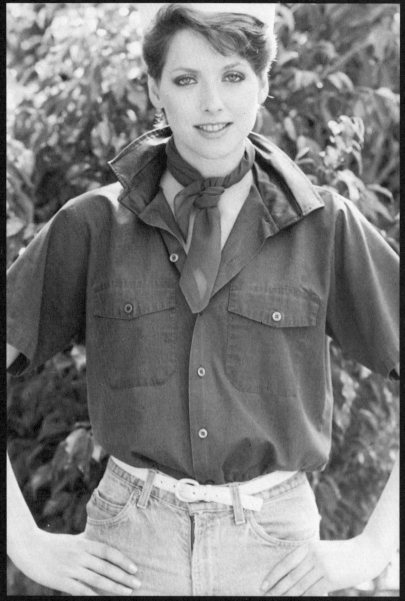

Preparing for a Fashion Career

Advice to the Model

What is the best way to clean my particular type of skin?

Normal Skin. If you have normal skin, all you need to care for your skin is a glycerine soap or any ordinary soap that doesn't contain chemicals, a mild astringent, a cleansing cream, and a water-based moisturizer. To remove makeup, use a cloth (you can tear up an old towel or sheet into squares) instead of facial tissue, because tissue is made from wood, as are all paper products, and is too rough on your skin.

Dry Skin. If you have dry skin, you need a rich cleansing cream and a soap that contains cream or oil, an alcohol-free freshener, and a rich moisturizer.

Oily Skin. If your skin is oily, use a low-alkaline glycerine bar or a special wash made especially for oily skin, an alcohol astringent, and a water-based moisturizer. Clean your skin at least twice a day. If you have combination skin, apply to the dry and oil areas appropriately.

Can you tell me about the different kinds of makeup foundations?

There are several types of foundations. A *liquid base makeup* gives smooth, easy coverage. It is good for a basically clear complection. A *souffle creme makeup* has a fresh look and is terrific for teenagers, as it is very light and gives the illusion of not wearing makeup. A *matte finish makeup* has a smooth look and is good for heavy cover-up. It gives the skin a dull finish and does not require powder. *Translucent gel makeup* (for both men and women) provides color with a staining effect. It says on for five hours or so and looks like you have a tan. A gel goes on best over moisturizer. *Pancake makeup* (also for both men and women) is used a lot for television commercials and for stage use. It is applied with a wet sponge and gives a matte finish look and there is no need for powder. Use moisturizer before applying pancake makeup or it will feel or look too dry; it is hardly ever used on extremely lined or dry skin, because it tends to exaggerate the lines and dryness.

How can I correct with makeup the shape of my nose?

If your nose is too short, you can make it look longer by highlighting the center line and the tip of your nose with a lighter color than your base makeup. If, on the other hand, your nose is too long, it can be made to look shorter by shading the tip of your nose with a darker base color. If you nose is crooked, apply a darker color foundation to the crooked area only, then powder over it. If your nose is too broad, shade the sides with a darker foundation and use highlighter down the center line of the nose.

What shade of foundation is good for my complexion?

Skin Color	Makeup Shade
fair	very light pinkish tones
tan to light brown	beige, yellow, ivory
ivory to yellowish tones	ivory, beige
dark brown to black	golden tan to darker shades

What lipstick shades should I use to complement my hair color?

Hair Shade	Lipstick
dark brown	red, blue-reds
	mauve, pink, orange, rose
light brown	pink, rose, coral, clear red
light to dark	pink, orange-red, bronze, corals
light to dark blond	rose, pink, coral

Where do I apply blusher to my face? Can I use blusher to change the shape of my face?

Oval-shaped Face. Blusher is touched on at the point of the cheek bone and blended up toward the temples.

Round or Square-shaped Face. Blusher is applied closer to the nose, starting about one inch under the pupil of the eye and blending outward as far as the outside line of the eyebrow. This will tend to narrow a too-broad face.

Oblong-shaped Face. Blusher should be applied to the upper part of your cheek, starting from a point under the outer corner of the eye and blending toward the side. This will give the illusion of shortening the face that looks too long.

Triangular, Square, or Diamond-shaped Face.

Blusher should be applied on your upper cheek, not too close to your nose. Applying blusher to your temples or jawline would only accent the shape of the face.

Inverted Triangle-shaped Face. Apply blusher to your lower outer jaw and cheek, and dab a little on your chin.

Is the shape of my face an important consideration when choosing a hair style?

Very definitely. Beautifully cared for hair and a flattering style complements your entire look. Hair, like a hat, should suit your body size, shape of face, personality, and life style. Your hair length should be in proportion to your height. A long mane of heavy hair on a petite model with small features looks overpowering, while an extra short boyish cut on a tall or big beauty model makes her look even larger and taller and out of proportion.

Can you give me advice on how to handle my hair type?

Thin, Delicate Hair is either soft, silky, and shining or brittle, dry, drab, and won't hold a curl. Fine hair rarely stays in place and this kind of hair should always be kept covered in cold weather. All hair should be protected from the bitter cold or else it breaks. Cream rinse and hair spray will help keep fine hair in place. It looks best with a straight cut.

Avoid any product that will harm your hair, such as a cheap permanent. Jane Hickcock, a top model for eight years, has thin hair and she pays $250 for a permanent; it's worth every penny of it she says. Because she's a working model she must go to the best. She can't take the chance of ruining her hair.

Thick Hair holds a set very well, can hold pins and combs, and be worn in many different styles. It can be thinned if you desire, because if it's too heavy it can be uncomfortable and hard to manage.

How can I correct lips that are too full or too thin?

Full Lips. Choose a medium to dark shade of lipstick, but *not* an extra light or extra dark shade. Apply only to the inside of the natural lip line.

Thin Lips. Use two shades of lipstick; with the darker shade, outline beyond your natural lip line. Then fill in with the lighter shade and blend.

Do male models need any special hair care?

A man needs a great cut because after the cut there is very little styling involved. First, study the shape of your face and type of hair and talk it over with a stylist. Your style should fit your personality, life style, shape of head, face, and neck, and be in proportion to your height and weight.

If you want a complete change, consider having your hair dyed or getting a wig, or a permanent wave. Women do it all the time; there's no reason a man shouldn't if it's tasteful and flattering. Wigs should be thinned and styled by an expert who specializes in this field. Men can use hair spray, too, and should learn how to use a blowdryer if it's appropriate.

Do you have any advice on how to treat dry or oily hair?

If your hair is dry, condition it with mineral or vegetable oils and a dry-hair formula cream rinse. Dressing gels are excellent. It is especially important to keep dry hair covered in the sun and cold weather. Brush it a lot; it will activate your oil glands.

If you have extremely oily hair, shampoo it every day. Be sure to wear a style that doesn't need a lot of combing during the day; frequent combing will make your hair even oilier.

Can you suggest the best kinds of hair styles to complement the different face shapes?

Oval. If you have the classic oval face, you can luckily wear your hair in any style because the oval face is considered to have the most harmonious proportions. However, if you are very tall, as I am, keep in mind that your hair should be worn to balance your height. I have never had my hair shorter than two inches below my shoulder.

Round Face. The round face needs a style that doesn't add extra width. Straight hair that's cut off at the chin or mid-neck is good because the hair covers your cheeks, which can make your face look thinner. Side parts are also good, as are off-center pony tails and braids, adding top height.

Long Face. A long face can be made to look shorter with medium to long bangs. Your face can also be made to appear less long by adding extra hair fullness to the side of your face.

Square Face. The porportions of a square face (or square jaw) are improved by hair framing the face. It can be softened with soft side curls and waves around the hair line and sides of your face.

Inverted Triangle Face. This face shape is the easiest to change: if you arrange your hair soft and full on the top, it will balance your face and make it look more oval. Short hair with more curls on the top and upper sides is the best.

Heart-shaped Face. The heart-shaped faces need a minimum of volume on the top of the head. Wear it full and forward around the sides of your face to minimize its broadness.

Are there certain types of eyebrows that go best with certain types of faces or eyes?

Far Apart Eyes. For eyes that are set far apart, tweeze some hair from the outside area of the eyebrows and draw thin lines exactly like your own brow on the inside of your brows toward your nose. This will give the illusion that your eyes are closer together.

Oblong Face. If your face is too oblong, you'll look prettier with a straight brow, so it is best to minimize the natural arch if it is extreme.

Round Face. If your face is round, accent your eyebrow arch or make your brows straight and full to help your face appear less rounded.

Low Eyebrows. If your eyebrows are too close to your eyelids, tweeze hairs from underneath the brow and add

some soft pencil lines on the top and powder them for softness.

Thick Eyebrows. If your eyebrows are too thick, and you would like more space between your eyelid and eyebrow, tweeze them from the bottom line; those are very fine hairs and they leave no trace that they were once there. If your brows are very thick, tweeze hairs from both the top and bottom line of the brow to achieve the desired effect.

How can I improve with makeup the less than perfectly shaped eye?

Small Eyes. If your eyes are small, wear only the light shades of shadow on your lids; light shades make eyes look larger, dark shades smaller. Apply color to the outer part of your lid and brow area.

Shallow Eyes. If your eyes are set shallow, give them depth by using brown on your lid for depth and drama. Use white highlighter to make your eyelids and brow area appear larger.

Close-set Eyes. Close-set eyes will appear wider apart if you use a dark color on the outer half of your lid and a half strip of false lashes on the outer edges of your

Wide-set Eyes. If your eyes are wide set, use a medium-to-dark tone shade of shadow or light brown on the inside half of your lid; you can even blend shadow colors up into the inside bridge of your upper nose and brow area.

Eyes Slanting Down. If your eyes slant down at the outer corner, give them a lift by applying your eye shadow with upward strokes. Use a light-colored shadow on the outside half of the lid.

Under Eyes. For discoloration under the eyes, males and females both can use a cover-up stick (choose one that is slightly lighter than your base color). Be sure to powder once only; your cover-up will start to cake if you powder too often, which will accent any lines you might have.

How can I determine which brow shapes are the most flattering to my face?

Cover your own brows with concealer, then pencil in various and new appropriate shapes. If you turn the lights low and stand back, you'll be able to determine if the proportions are right for your shape face.

My eyes are too close together. What can I do with my eyebrows to change that?

If your eyes are too close together, pluck out the hair between your eyebrows about an inch to an inch and a quarter.

How should I tweeze my eyebrows?

Tweeze stray hairs twice a week and your brow will look well groomed. Hold ice on the area to anesthetize the skin and tweeze from the inside nearer your nose and work your way outward; that way, you will have more control of the shape of your brow.

Can you advise me on the color of eyeshadows and eye highlighters that are appropriate for my eye color?

Eye Color	Day Shades	Evening Shades	Highlighter Shades
black, brown	turquoise	dark brown	ivory
dark brown	green, gold	charcoal	beige
brown gold	yellow, sapphire	midnight blue	yellow
green	turquoise	dark green	beige
hazel	apricot, gold	gray	pink
light brown	taupe, mauve	brown	yellow
blue	plum-gray	purple	ivory
blue-gray	blue	dark gray	pink
gray	silver, mauve	dark blue	white

In addition to using mascara, how can I get thicker looking eyelashes?

You can create thicker lashes by dusting loose powder over your own lashes, then mascara, then more powder, then more mascara. Work slowly. Once you have applied the mascara, do not repeat.

Can I trim my own false eyelashes?

Yes, by all means. False eyelashes can be thinned or cut shorter to make them appear more natural. Use a pair of straight-edged small cuticle scissors. Hold the lashes between your thumb and forefinger, keeping the pressure on the strip edge. If your eyelid is longer than the strip, cut them shorter at the inner corner or cut them in half so you can use them just on the corners of your eyes. This gives your eyes a wide-eye effect and makes them look like they slant up on the sides. For a dramatic effect, glue a half lash on the corners over the full strip.

Approximately how long does it take to put together an impressive professional portfolio that covers all the appropriate fashion categories?

Without some experience or help (such as from this book), it usually takes eight months to one year to get your portfolio ready for a complete presentation. If you use this book as a guide, you will be able to complete your portfolio within a two-month span. An excellent approach would be to aim toward one test shooting per week, because it takes two weeks to a month before the photographs will be ready to put in your book. Remember that the preparation of color prints takes two weeks at the very least.

What are the kinds of shots that I should have in my portfolio?

A complete portfolio should have 20 to 24 shots, but in the beginning strive for the 12 listed below and let the rest evolve naturally in the direction that complements your particular style.

1. a head shot showing casual, natural looking hair, waist-length
2. an evening gown shot in an editorial-type setting, full-length
3. a sporty, casual shot in a suit or pants, shot out-of-doors, full-length
4. a swimsuit shot or T-shirt and shorts, full-length

5. a double shot in formal evening or sports attire, editorial style

6. a head shot with a hat, showing your complete profile

7. a fur coat shot, three-quarter view, advertising style

8. doubles shot, catalog style with a model of the same sex

9. a three-quarter shot demonstrating a product

10. a well-styled head shot with accessories and perfectly groomed makeup and hair

11. an authentic sports clothes action shot, full-length

12. a dress shot, advertising style, full-length

How often will I need new pictures for my portfolio and how often should I test?

Most models, unless they have had an unusual break (like studying this book), take about a year to learn photo posing and to present an experienced looking portfolio. After that, every two months you should have some new pictures or tearsheets. Before you are actually going on shoots, you should be testing once a month at least and trying to improve on your movements, hair, or makeup style or bringing your book up to fashion date. Your photos should always look current and look like you. If you decide to change your hair color or drastically cut your hair, you will have to shoot a completely new book. Besides, this is a good way to meet photographers and build a working rapport. Photographers like to see how they can make a model look and move before they recommend her or him.

How can I get an interview with a modeling agency?

You can call them cold from the yellow pages and you'll speak to a receptionist, who will ask your age, (some high-fashion agencies tell you they don't take people over 24), your height (some agencies only see women who are 5′7″ to 5′10″ and men who are 5′11″ to 6′2″), your weight (they judge what it should be according to your height) and if you have pictures. If you don't have pictures, many agencies won't see you until you do.

Sometimes you can get photographers' names out of the editorial section of a fashion magazine and call them cold. You're bound to get a few to see you, and if one of them likes you and tests you, you could ask him to call the head of an agency and recommend you. That would draw more attention to you and is an opportunity for the agency to see the photographer's work as well. Also, if you befriend a model in good standing with the agency, she could introduce you to the agent at a social gathering. I have called the biggest, most prestigious ad agencies in New York City and Europe on my own and got myself booked for international ads.

After I'm accepted by a modeling agency, how long does it take to start earning money?

If you have a decent portfolio and have learned photo posing and grooming, it will most likely take four to six months to start earning some money. But in order to bring in any kind of substantial income—one that you can live on—plan on six months to one year. During this interim period it's best to have some savings or a second job you can count on until you become established.

What are the basic items that I need to take along on a booking?

Always take your portfolio in case the photographer or the client hasn't seen it yet. They may want to pick a particular hairstyle for the picture, and your portfolio should contain examples of the different ways you wear your hair. In addition you'll need these items: a nude-colored bra, a nude-colored body stocking or pantyhose; jewelry: 5 or 6 pieces of pretty costume jewelry; shoes: black and bone classical look pumps, cleaned and shined; two scarves: a long one to tie around your chest if it's a bare shoulder shot and a smaller one to wrap around your head to protect your hair while making-up and to prevent any makeup from rubbing off on your clothes; a hairbrush; a comb; a toothbrush; a cosmetic wardrobe; and your voucher book. An important reminder: carry as little cash as possible. Leave your watch or other valuable jewelry at home as you'll need to remove them, and most studios are not reponsible for your loss.

What cosmetics should I carry with me on a booking?

Listed in the order in which it should be applied:

1. astringent and cotton balls, for cleaning your face

2. moisturizer, so your foundation will go on more smoothly

3. foundation base (two colors—tan and light)

4. powdered eyeshadow (brown, white, and two other colors)

5. eyeliner, cake or pencil (black and brown)

6. eyeliner brush (thin)

7. eyebrow pencils (gray, brown, and black)

8. pencil for inside rim of eye (a soft, white pencil makes the eye appear larger)

9. mascara and mascara brush

10. eyelashes (two pair, thin and medium)

11. tweezers (for fitting eyelashes)

12. eyelash glue

13. lipliner pencils (light brown and two other colors)

14. lipstick brush (sable is excellent—you can get a great brush for every use at an art supply store);

15. lipsticks (five basic colors: red, orange, pink, coral and purple)

16. lip gloss (clear)

17. contour powder (light tan and dark tan)

18. face powder (loose and translucent)

19. powder blush (light pink, red, and orange)

20. highlighters (pink or white, used for accent)

21. Q-tips

22. tube of hand cream (small)

23. nail polish remover (small)

24. false nails, glue and emory board (if necessary)

25. nail polish (small red, light pink, orange, purple)

26. hair spray (small)

27. hair brush

28. combs (large tooth and rat tail)

29. hair pins and cloth-covered rubber bands.

30. prop-up mirror (two way, normal and magnified)

Carry in a smart-looking bag, with everything in the smallest container possible to avoid extra weight.

When can I expect to be interviewed for editorial modeling by the fashion magazines?

The agency will make appointments for you when they think that you have an impressive portfolio and have developed confidence and modeling skills. If you are free-lancing and you know you are ready, ask a photographer who works for a particular magazine to recommend you or make an appointment for you.

Of course, if you are a celebrity, a daughter or son of a famous movie star, a winter sports olympic champion, or from a known socialite family, it is fairly easy to get an interview. If you are not, however, you could send a letter and composite to the magazine and then call the day after you're sure they received it and ask for an appointment. When I was in the neighborhood of the English *Vogue*, I used to stop and talk to everyone at the coffee shop where I knew the editors had their breakfast. One day I happened to be talking to a *Vogue* editor. She wanted to take credit for discovering me so she took me back to the office with her and introduced me around, showing my book and leaving composites. Later, she personally called two of their top staff photographers and asked them to see me, which they did—that very week! And out of that interview I modeled for my first advertisement for *Vogue*. So, be inventive!

How much can I earn as a model?

Most steady working models make from $60 to $100 per hour and $400 to $500 per day. Packaging and special daily rates for star models are negotiated separately. Lingerie pays double.

How much can I expect to get paid for catalog modeling?

Department store catalog work usually pays 40% less than regular rates; but these are terrific accounts to have because they provide steady income. Sometimes you will be booked three to six weeks straight, six to eight times a year. Also, some agencies will pay you a minimum set income once a week, plus any over that you might haved earned that week. Other agencies will pay you once a month on all your jobs less 20%; or they pay you in full when they get paid. There are many different arrangements for paying modeling fees and many exclusive contracts as well.

What is a runway model?

Runway models are employed to present a complete line of couture designer clothes each season, which is four times a year. This kind of modeling can be a terrific way to be seen and break into fashion photography modeling. If a top designer uses you to model his latest designs on the runway, he may also recommend you to a magazine that will be featuring ads or an editorial spread on that designer's current line. That kind of publicity you just can't buy. After all, your chances are good because the clothes fit well and, in some cases, have been fitted just for you.

Can you give me some information on runway modeling? What heights and weight requirements are there and what fees can I expect to get?

Runway models must have measurements that fit a true standard size, such as a misses' 6 or 8 or a 40 or 42 for men. Females should be in the range of 5'7" to 5'10½" and weigh 115 to 140 lbs. Males should be in the range of 5'10" to 6'2" and weigh 135 to 185 lbs. (But, today, there are many exceptions: for instance, the petite model can weigh 95 to 105 lbs. and the big beauty or large woman model can weigh 175 to 250 lbs., depending on her height.)

You don't have to be photogenic to be a runway model, but you must be attractive or special and stylish in some way, with good hair, skin, and posture.

Runway modeling does not pay as much as photographic modeling. You are not paid by the hour, but by the show, which is in the range of $150 to $350 per show. Your agency will bill the client. Depending on how established you are, you can also be paid for fittings, usually between $50 and $200 an hour.

What kinds of specialty modeling are available to me?

If you have exceptionally long fingers and well-cared for hands with medium-length, well-manicured nails, you can demonstrate domestic commercial products. Of course, if you are demonstrating a product associated with glamour and sophistication, you'll need longer beautiful nails. For men, there's a lot of work for the husky, large, masculine-looking hand or the more manicured, elegant, long-fingered hand.

Occasionally, there's a need for a well-shaped foot and perfectly shaped toes and toenails. Women who wear a size 6 or 6½ shoe who also have good legs and feet can support themselves very well just by modeling for shoe manufacturers that show their line at showrooms or conventions. There is also a tremendous amount of advertising for stockings and various kinds of leg wear that requires thin-to-medium shapely legs.

Are the clothes that I use for tests and street wear tax deductible?

No, you can deduct your clothes only if you can prove they were used for the sole purpose of modeling and never for personal use.

Can I keep the clothes I model?

No, but very occasionally you are given an article of clothing when you are modeling for advertisers, but more frequently when you are working with designers. Some are very generous because it's terrific publicity for them.

Models do, however, have very exceptional connections to buy furs, ready made and designers' clothes anywhere from 50% to 80% off the retail price. If you become a favorite of a designer, he will loan you coats, furs, and gowns for evening parties or to be photographed in.

Advice to the Photographer

Can you give me an easy-to-remember formula for putting together my portfolio?

The most important idea to focus on is what the viewer or potential client would like to see. So, arrange or lay out your work with your client in mind. For example, if the client is a magazine editor, emphasize your work in editorial fashion. Likewise, if you are showing an ad agency your work, your portfolio should be weighted more toward advertising photography. Or, if your client is a department store that earns a sizable portion of its sales through mail-order catalogs, don't show off with all your high-fashion shots. Show some everyday-looking people modeling practical-type clothing or demonstrating commercial products.

Your portfolio can be small, but it should be fantastic. I've seen great books with very few photographs. In general, too many photographs are worse than too few, because the client can become confused, and none will stand out in his or her mind. It's a good idea to show several treatments of the same situation, because it shows you are not limited to one idea and not afraid to experiment.

What is the importance or necessity of model-release forms?

A model release is a contract allowing you to use a person's picture in specified ways in return for value received. A release protects you, your model, and your client, but it is no guarantee that you can't be sued—nothing is—but, it can keep you from losing a suit, if one should occur.

Any recognizable likeness—and the identifying feature needn't been a face, it could be a hand or a knee—calls for a model release, *unless* it is used as a news photo. Photos of unrecognizable subjects require no release.

A minor has to have a release signed by a parent or guardian. Releases are needed for pets, manufactured products, trade marks, and recognizable property.

Public display of your photographs in an exhibition constitutes publication in the eyes of the law, and the risk of invasion of privacy suits exists here.

Can you give me a few tips on what makes for a successful photo posing session with a new model?

The model is the creative force. I would suggest that the best way to start with creative photo-posing is by way of experimenting with the techniques I have shown in this book. Before you begin using the camera, try directing the model step-by-step, to get her relaxed and familiar with the surroundings before you get into the rhythm of a shoot. The method is basically simple once you are aware what to look for and yet the variety of results can be limitless. A number of different effects will be created. I experience them as quite magical and work with them.

Photo-posing will assist you in revealing the structure of natural forms, by using the model's body to show off the clothes as functional and natural forms. Remember that the camera reveals *everything* it sees, so look at every detail.

The photographer has to create a situation that feels natural to the model. Communicate, look at the model when you talk to her, look in her eyes, and be sure that she is looking at you. You can involve the subject in conversation that matches the feeling or mood you want to set, which will take the emphasis off the fact of being photographed. (This is particularly effective with children.) Another way to set up a mood is to introduce the appropriate music.

Some people, of course, are naturally more graceful and relaxed than others. If you are relaxed and fun to be with, your model will feel free and natural herself.

You can turn any new model into a professional by directing her body position to the poses you want. For example, you could physically demonstrate the poses that you have in mind; or you could have the model do a posing demonstration *before* she gets in front of the camera. Try to guide the model into the basic pose that will give the clothes she's wearing good lines. Arrange her position from the point of view of what's the best way to show off the garment. Once the model's arms and hands are moving or placed correctly, both she and you can then concentrate on the appropriate facial expressions. Photo posing should be very controlled, even if the model is walking or jumping, but the trick is to make it appear as if it's *not* controlled. When a pose is right, shoot 20 shots or so on that particular theme with small variations, then move on to another. Also, ask the model to take poses that she feels are right; sometimes the model will do something wonderful that you hadn't thought of.

How can I get the model and my camera shutter synchronized?

Try to set up a tempo for the model to make his or her transition from one pose to the next. As you begin to shoot, gauge just how long it takes the model to change positions, all the while making allowances for the style of shooting you are after (fast paced or slow) and any adjustments that need to be made on the garment. Then, once the model has established a consistent rhythm, you can begin the shooting.

Some photographers have the model change completely from one established pose to another, from frame to frame. This is a good solution if you want action shots; the predictable repetition of movement and timing will enable you to exercise control and at the same time will many times bring about the unexpected, exciting shot.

Can you give me some tips on photographing and lighting different parts of the face?

Cheeks: Lighting differs according to what you want to emphasize in a face. Naturally, the high-fashion type with concaved cheeks should be lit differently than the girl-next-door type. Sallow cheeks will benefit from blusher if you are shooting in either black and white or color. If cheeks are hollow, avoid strong side lighting or light from a great height. Full and puffy cheeks are helped by placing your main light high and almost directly in front of the subject. Men should shave just before the sitting to avoid five-o'clock shadow. Face powder can be helpful here as well.

Ears: Women can always hide their ears with hair, but a male model will be devastated if your photos of him show big or stick-out ears. And if you haven't given this troublesome feature some attention, it can be the first thing you see in the photo. To avoid this problem, do not shoot the face head-on—angle it sideways, between three-quarters and one-quarter view away from the full face; this hides one ear and the light from the side facing away from the camera will leave the one ear exposed in shadow. Or, you can also use barn doors on the lights to shade the area so that attention is not focused on the ears. In extreme cases, shoot at complete profile or tape the ears back.

Hair: To give life and sparkle to hair, add light. For an amateur set-up, a tiny miniature spotlight with a 150-watt lamp is easy to control. In pro studios, where the distances are frequently greater, a 500-watt spot is sometimes used. When taking an exposure with a reflected light meter, turn the spot off to prevent it from influencing the meter. However, it doesn't usually need to be turned off when reading incident light.

When photographing hair, make sure that there are no tiny hairs out of place and that strands stay in place. A spray bottle of water can help and should be set down nearby. To keep the hair from looking too dark, have the main light angled in such a way that a shadow from the

reflection isn't thrown onto the hair. Also, do not let the hair separate so that light spots shine through from the back lighting.

Chins: Prominent chins can be shortened by lowering the camera. A double chin can be minimized by positioning the model on a high stool and having him or her lean forward; if the model stretches his or her neck, he can get his real chin out, or you can get the same effect by putting the chin area in shadow. Although I have never seen a model with a double chin, I have seen several with prominent chins or a very large jaw and square face. Flat straight on lighting is very effective for this also.

Teeth: Teeth should look white so do not put them in shadow. If the model's lips are full and the overall lighting places the teeth into shadow, correct this by fill-in light directed at the mouth. If the model's teeth are not very attractive, shoot the model smiling with the mouth closed or with other expressions where the mouth is mostly closed.

Lips: Because the lips show a great deal of expression on the face, be sure to ask your model for various lips and smile expression before you begin. A very subtle expression of the mouth will change the mood of the picture greatly. Also, you can anticipate the model's next expression. One great way of getting the model to make a very relaxed mouth is to make him or her laugh wholeheartedly. Then, when he or she starts to relax the facial expression of laughter, you'll get a true liveliness in the face and a full, genuine smile. (Try to avoid a look with gums showing.) You can also have the subject wet his or her lips with the tongue; that helps the jaw and lips relax. I like the models to wear a rich red lipstick when I use Pan-X or ultraviolet film, so that her lips won't look washed out.

Noses: Long noses can be shortened by lowering the camera a little lower than head-on. Or the model can put his or her back very slightly. Remember, long noses look longer in profile or with the head angled forward. Also, a longer lens and more distant point of view can help.

Short, stubby noses can be made to look longer in profile when shot from above or from close up. If the model's nose is crooked or has a slight bend, place the main light on the side opposite the bend.

Eyeglasses: If you are photographing a model for an eyeglasses ad, glass reflection can be avoided by raising the lights high or by placing the lights far to one side, whichever looks better. The use of polarized light plus a polarizer on the lens can almost completely eliminate reflections, too. However, this technique may require a great deal of experience to manage successfully.

Eyes: The eyes should reflect the personality of the model, and they look most engaging and lifelike if each eye has a tiny catchlight. To do this, you can move the main or full light until the catchlight appears in the eye. Try to avoid two or more catchlights, however.

The Model's Portfolio

Because you must have at least a small portfolio before you actually begin to look for work, I've included the model's portfolio test here. The techniques shown are used to show the model and the clothes off equally well because the photos are taken for the model to show prospective clients so they can see what she looks like and how she projects in pictures. This is done at the beginning of a model's career and is updated as styles of hair, clothes, and makeup change. A photographer would also use this technique to update his or her portfolio. The test illustrated here shows a variety of styles and is best suited to fashion advertising. The main aim is to be creative with the clothes, getting different looks, expressions, and angles of the model's face and body in various moods. Any height, sex, and size model is appropriate.

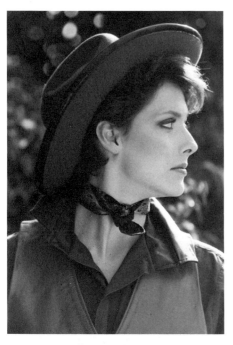

Do take a few profile shots if you have a terrific one. Keep your neck elegant and your shoulders back. Make sure it's a complete profile—you don't want parts of your face or eyelashes to show up from the other side. Note how the model's hat is set to the back of her head; this is an excellent position.

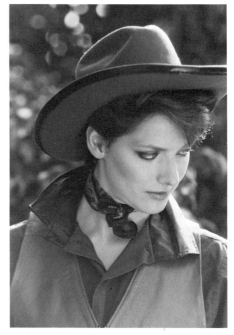

Don't lower your head this much in a head shot because your features won't show up and don't throw your eyes too far out of frame.

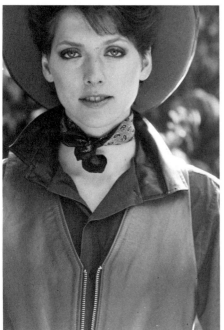

Do position yourself full-frame to the camera. Your smile should be sweet, and your hat directly back on your head. It's perfectly all right to crop off part of the hat in this type of photograph, since it's obvious what the shape of the hat is.

Don't bring your eyes up so high that you see too much of the whites. You may, however, bring your chin up.

Advice to the Model

Since this is a test shooting, you can wear your makeup and hair in any style you like, but I feel it makes more sense to style both in a rather classic manner so the photographs will stay current looking for a long time. This model's hairstyle is elegant, chic, and sporty. When you're going to be modeling for two hours, and especially when you plan to wear hats, use hair spray. Use a light foundation, pale rouge, brown eye shadow on half of the outer part of your lids, lots of mascara, and medium pink lipstick. Keep your eyebrows natural and use your cake powder often. Once you discover your best look, usually through trial and error and testing, keep that hair and makeup style for at least a year so that you look the same person in your portfolio photographs as you do in person.

The wardrobe I used for this shooting consisted of hats, scarves, and jackets to give you an idea how quickly and stylishly you can change a look around with just a few pieces.

Your posing style should be classical and graphic and your expressions should be varied: sexy, sultry, bright-eyed, elegant, and happy. This is the time to discover which expressions look best on you. For the pose, place your feet in the third ballet position, push your hip out to the side, use your arms to make interesting shapes, flirt with your shoulders, and project your feelings.

Advice to the Photographer

Take four hats, scarves and jackets, and mix and have the model match them in interesting ways. The model should stand very still, assuming a good, firm stance, with her legs placed two feet apart, in a graphic style and making an interesting shape with her legs and hips. Her shoulders should be relaxed and she should use her arms in an interesting and graceful shape, hands moving to one area only, one at a time and very slowly. Even when you're photographing her for three-quarter or head shots only, all the above is important although her whole body isn't being photographed because it helps project an attitude and makes her feel comfortable. The clothes will also look better if the model's posture is correct, even if

it's only a shirt or hat you're showing. Direct the model to project only those few expressions you feel are her best so she will have a variety to choose from. The model shown here could project several different styles, so I directed her to look bright-eyed with a happy smile; sultry and inquisitive; sex-kittenish (a sweet mouth with "come hither" eyes); and chic and elegant. If you're shooting in the sunlight, use a fill-in for the shadow side of the face for more illumination and a sunshade on your lens to prevent sunglare spots on the film. If your camera angle is lower than the model's solar plexus, her legs will look shorter than they are, so aim the camera toward her center.

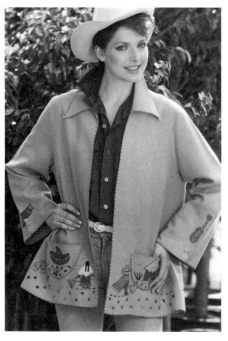

Do add a bit of personality to your photograph. Style your clothes so they have some charm, as the model in this photograph does. The waist of her coat is gathered in on one side and her thumb is gently placed in the pocket of the other. Both arms have a different feeling and the model's head is very glamorous.

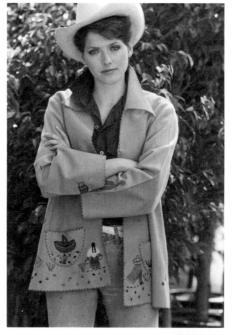

Don't tense your shoulders and don't cross your arms over the front of your jacket without being very aware of what you're doing (in this photograph, the model has distorted the line of the jacket). Always be sure your clothes are neat and crisp. If you tuck your hands into your arms, don't hide your hand because that makes it appear as if it were amputated and is not good photo posing.

Do assume an erect stance, keeping your neck long and elegant. You should also have a wonderful expression on your face. Cross your arms in front in an area that doesn't have any jacket detail. Keep hands and fingers open and elegant. Do occasionally cross your arms, but don't hide the merchandise.

Don't push the jacket back on one side if there is a different feature to be shown on the front. Don't hold your arm over your chest because that hides the clothing and makes it look sloppy. A hand on the hip is also not appropriate with this particular jacket.

Summary

There were many strong points in this session. The clothes were organized in such a manner that lightweight tops and hats were used first in order to keep the model's hair very neat for the following shots. The model maintained good posture while I was dressing and styling her, and she gave me the exact expression I requested.

I enjoyed this photo session very much. When we started, the model required very precise and constant direction, but as we moved on, she remembered all the instructions I gave her and applied them without much coaching. I did, however, have to keep correcting her on the use of her knees and hips. She kept her knees locked and her spine bowed, which made her appear as if she had a large rib cage and stomach, and of course she didn't. Relaxing her knees and pushing her hips forward corrected most of the posture problem because this threw her shoulders back.

I chose the photograph below to demonstrate the entire session because the model's pose is simple, classical, and straightforward. She looks relaxed and very pretty and the clothes look crisp and neat.

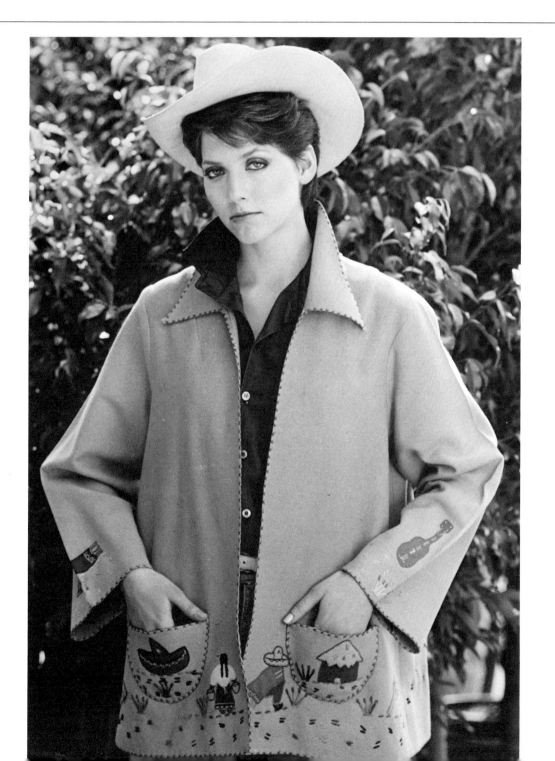

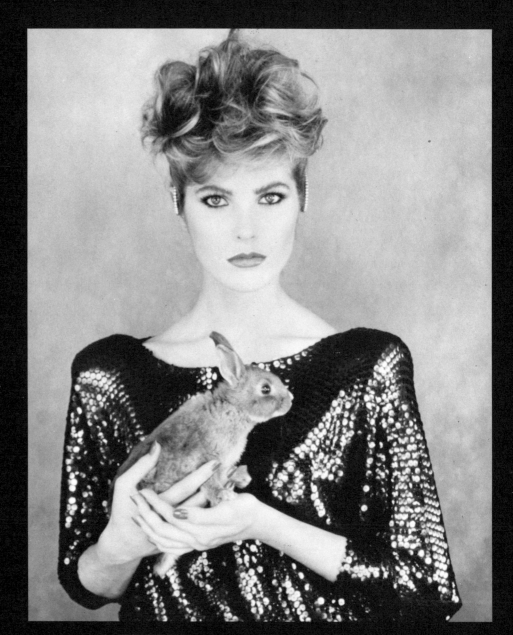

Posing Techniques

Cosmetics

Selling cosmetics is the main aim of this type of technique. Although it is directed toward editorial fashion and beauty product advertising, this technique may also be considered for commercial advertising even though the packaged product itself isn't actually shown.

The model used for this type of ad must, of course, have a beautiful face, excellent skin, lovely and exciting eyes, and a beguiling mouth. Since selling beauty products is the goal, all makeup used must be very expertly applied. The lipstick must be put on with very clean lines. The eye makeup must be evenly distributed and very, very pretty—the color of the lids should complement the model's face and there should be no hard lines. The model's hair should not distract from her face in any way: it should be swept up on top of her head or styled back behind her ears. The hairstyle can be short, but it should be elegant.

Advice to the Model

In this particular situation, the model is usually booked for a two-hour grooming session because her grooming is as important as the actual shooting. You must prepare for this session even before you arrive at the studio. Be sure you get a good night's sleep so you won't look tired and so your eyes aren't bloodshot. It is also your responsibility to have clean, well-trimmed, well-conditioned hair, and clean, well-shaped nails.

When you get to the studio, the hairstylist will set then comb out your hair. The makeup artist will apply a cream-colored base coat on your face (slip on the top you will be wearing for the shooting session *before* this to avoid getting makeup on your clothing or disturbing your hair). Your eyes are made up next: first the eyelids, then the under-eye. Next, your eyebrows are feathered and groomed, rouge and lipstick are applied, and, finally, your hair is styled.

For the shooting session, sit on the stool provided and turn your shoulders away from the camera for some shots, keeping them full front for others. In either case, elongate your neck, holding your chin even—not down too far nor up too high—for a long and elegant look. Also be sure to vary your expressions throughout the session.

The model in this example is holding a rabbit. When you work with an animal, don't forget that it's your responsibility to see that it is placed in a comfortable and proper position. Hold the rabbit firmly, from the bottom, because if it isn't held securely, it will start to fidget.

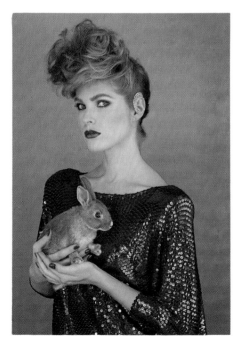

Do be sure your spine is straight when you sit on a stool, particularly in a garment such as the one shown in the photograph. Keep your neck long and elegant, but don't strain or tension will show in it. Keep your expression relaxed and alive and your eyes alert. Put both hands under the rabbit, showing some of your hand and nails to the camera.

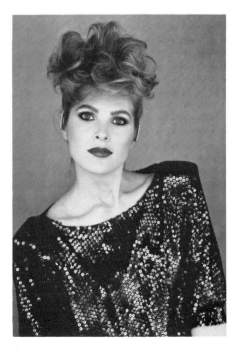

Don't hold one shoulder much higher than the other—this causes tension in your collarbone and your neck. Keep your chin centered on your neck. You can find the correct spot by tipping your head both ways and waiting until you feel a center of gravity.

Advice to the Photographer

The photographs in this chapter are more appropriate in color: you're selling cosmetics and the prospective customers want to see the color of the product they're buying. The best camera-to-subject angle is camera higher than subject, approximately two feet, so that the model's eyes will be wide open and looking into the camera. Of course, these pictures should be in sharp focus—not dark and moody with shadows but very evenly lit, bright, and clear. No motion is required. The model should fit into the center of the frame.

It's the photographer's job to communicate with the model to let her know what he needs. Seat the model in the position you want and direct her to move her shoulders to whatever angle is desired. I suggest you take some full-frame shots with her shoulders full front to the camera, some with her shoulders angled three-quarters to the camera, and some with her shoulders angled completely parallel to the camera.

After you have shot a few rolls of her alone, introduce the live rabbit into the photograph to familiarize the model with it and to get her into the mood of the shooting. The model should hold the rabbit close to her body and place it in her mid-chest to neck area so it won't hide her face.

Direct the model to position her head at several different angles to the camera so you will have a variety of pictures. For instance: full face, full front, chin up; face turned three-quarters, eyes to the camera; face turned

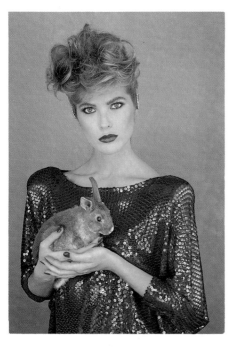

Do be sure your demeanor is very relaxed. Your shoulders should be straight to the camera and your posture erect. The model in this photograph has cupped her hands under the rabbit and is holding it close to her body so that the rabbit is comfortable. Her expression is sweet and gentle and her hair is neat.

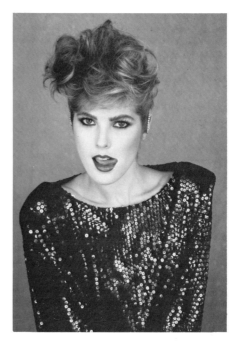

Don't put your hands together in front and automatically bring your shoulders up when wearing a blouse that has shoulder pads in it, because this throws the shoulder pads off. Keep your chin balanced in the center of your neck.

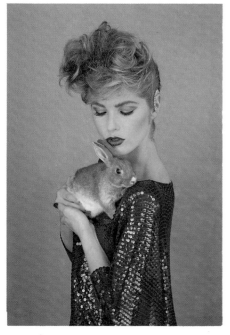

Do turn your body completely profile but your face to the camera. Make sure the rabbit's face is also turned. This is an excellent pose because the rabbit's ears are behind the model's lips and are in full view; this is important in a makeup advertisement in which lipstick is being shown. Casting the eyes down is perfectly acceptable because all the makeup on the lids is easily seen. Keep your neck long and elegant.

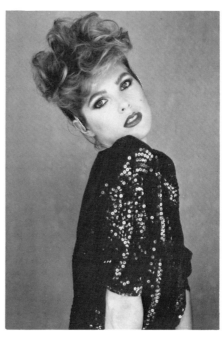

Don't raise your camera-side shoulder so high that it completely covers your neck if you do turn profile to the camera. This is awkward looking. In such a case, keep a long, erect, elegant head and neck and position your face three-quarters to the camera.

complete profile, with eyes to the camera. Remember that bringing the face slightly back so that the nose stays within the outside line of the cheekbone is very important. Don't allow the model to make exaggerated gestures with her body or her face. You must also direct the rabbit: make little hissing noises to get its attention. It will become alert and perk up its ears. During this time the model must stay composed and keep changing her expression, so that when everything comes together, she will be already posed, making the photograph very special. Above all, be sure that the model has enough expression in her face and the rabbit enough vitality.

Summary

There were no major problems in this shooting, but what I paid most attention to was how the model was handling the rabbit. She had to hold it securely close to her body and at the same time she had to be careful that it didn't stick its claws into the sequins of her blouse.

The photograph on page 32 was chosen as the best because the model's expression is absolutely beautiful. Her face is balanced in the center of her long and elegant neck, her hair looks very pretty, and the relationship between the model and the rabbit is excellent: it's close enough to her face, but not too close, and the rabbit's expression, with its ears straight up, is charming and alert.

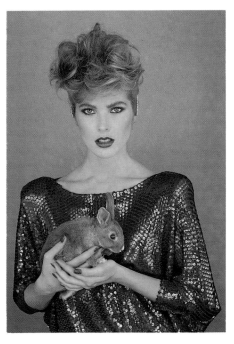

Do assume a straightforward attitude. Although the rabbit is held lower here, it is placed in an excellent position in the model's hands. Her neck is long and elegant.

Don't lean with one elbow on the table because this throws the shoulder pad to the side. That is the main mistake in this photo. The face angle could also be a little straighter to the camera, with the chin up a little more.

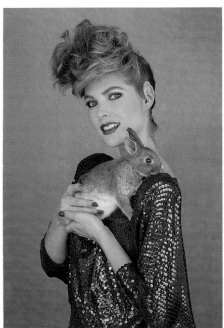

Do turn three-quarters to the camera and bring the rabbit up to your shoulder. Keep both hands under the rabbit to make it feel secure.

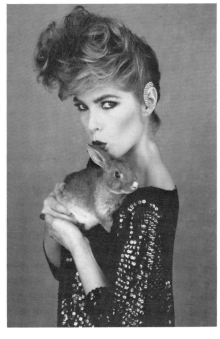

Don't hide your nails or lips because this is a beauty ad. Make sure that they are seen. The model here has turned her shoulders parallel to the camera, which is all right. The neck is still long and lovely but she's bending her chin down a bit.

Party Dress

Editorial fashion photography is usually used in what is called the editorial section of a fashion magazine. The main aim is to show the clothing in a fascinating manner, not to show its every detail, which is done in catalog or commercial advertising. This type of photograph is shot on location or in a natural interior, but is often shot using seamless paper where distinctive props are included.

The model most appropriate for this technique is approximately 18 to 30 years old and is in the range of 5'7" to 5'10" tall. The model I used here is 21 and weighs 120 pounds. She is 5'7" and has excellent skin and good hair.

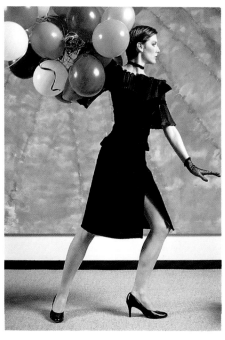

Do pose in a very feminine way. The image is well-balanced in this photo, there's movement and grace, and the clothes are easily seen.

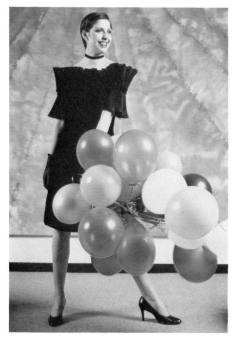

Don't concentrate movement on the balloons. They should move, of course, but the body has to move with the balloons or the balloons have to move separately while the body is gently rocking. In this photo, the model's knee is locked, her right leg looks awkward, and her expression is too exaggerated.

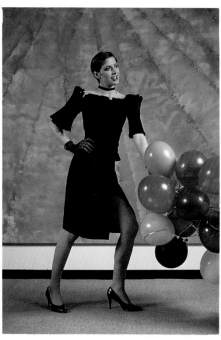

Do try to look light on your feet and to convey a lot of energy. Even though this is a graphic pose, you get a sense of movement in this photograph. The balloons and arms are off to the side. The model's hips are narrow to the camera, and the sides of her shoes are parallel to it.

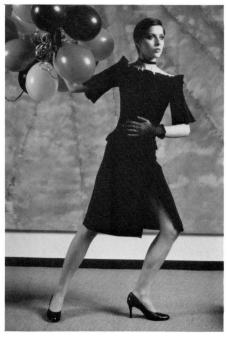

Don't keep the hand on the middle of your stomach flat. This model also brought the balloons too far forward and they cast a shadow on her face.

Advice to the Model

When executing a pose like this one, you should be very aware of your movements in relationship to the object you're using—in this case, a bunch of balloons. Be very careful not to cover your face or dress with the balloons or to use them in such a way that most of them are out of the camera frame. Ask the photographer within which particular framework you are allowed to move the balloons. Your stance should be wide and firm and one in which you'll be able to sway from side to side only. Don't sway to the front because if you do, your body will appear larger, and not to the back either, because then it will appear smaller and out of proportion.

Throughout the shooting, make sure that your body stays composed and that you use your hands and vary your expressions as you move the balloons around to different areas.

Expressions for this particular setting can be either happy (lots of smiles) or very moody and sophisticated.

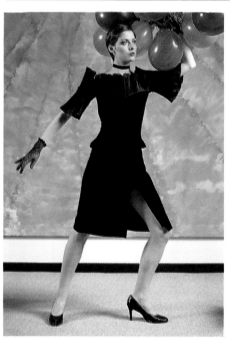

Do move the balloons up and down and keep a very serene expression on your face. This is very good photo posing. The distance between the model's hip and her free hand is excellent here because this balances the balloons well.

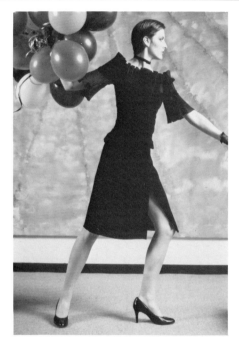

Don't show tension in your neck and don't move your hand so far out of range that part of it is cut off. Be aware of the frame you're given to work in and stay within it.

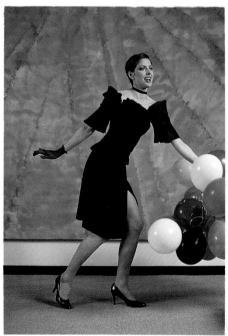

Do bend to the side, not to the front, and curve your spine slightly. Bend your knees, and hold your hands out just enough to add excitement to the photograph.

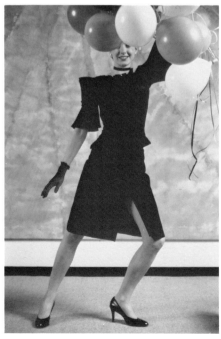

Don't turn your hips too flat to the camera. This causes the knee to automatically come closer to the camera, which enlarges the kneecap. The balloons should be bounced up and down at the side, not in front (that would cover the model's face).

Advice to the Photographer

This was shot on location in a very elegant apartment. Keep the photographs sharp and the lighting moody, with some shadows coming in on the model's face to add interest to the angles. Camera angle should be low to high and should be pointed at the model's stomach. Do some Polaroid tests first to determine the angle to which the model should direct her face. The model should fit into the center of the frame, but it's all right if the balloons are cropped off at different points. The most serious difficulties you will have in directing a shooting like this one will be in getting the model to move in rhythm with the balloons and to use them in proportion with her body. You might direct her to sway from side to side (not back and forth) and to work the balloons like a paddle ball, keeping them in motion and using them high or at her sides. Also instruct her to use her hands gracefully, positioning them so they appear thin and elegant to the camera while all this motion is going on. Be sure that the model doesn't make too many extreme pose adjustments. She should be directed to only move her body slightly, except for her hand holding the balloons. If she pushes off to one side and flexes her knee, the photograph will have movement and the model's face will automatically project exciting expressions.

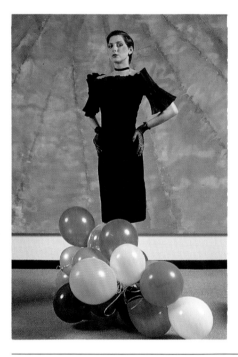

Do keep your arms out to the side and make sure your stance is straight and elegant. The expression on this model's face is in keeping with the mood of the photograph.

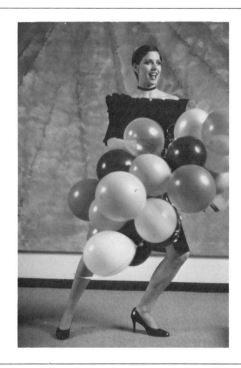

Don't move too broadly. There isn't enough control in this photograph: the model is bending her torso too much and the expression on her face is too exaggerated. The balloons and torso should move independently of one another, but should appear as if they are moving together naturally.

Summary

The major problems encountered in this shooting had to do with getting the model to sway from side to side rather than back and forth, and to look elegant, not stiff, while doing this. At the same time she had to hold one hand out to the side, with fingers narrow to the camera, and to work the balloons with her other hand in an energetic up and down gesture, to give more life and interest to this photograph. This was solved by having her sway with bent knees and by directing her to bring the balloons up about two feet and down about two feet in a very controlled manner (her tendency was to bring them up all the way over her head and down to the floor, which made her lose her composure).

The photograph shown here (opposite page) is the best one because it has wonderful balance and life. The model projects excitement, interest, and total elegance in her face and demeanor.

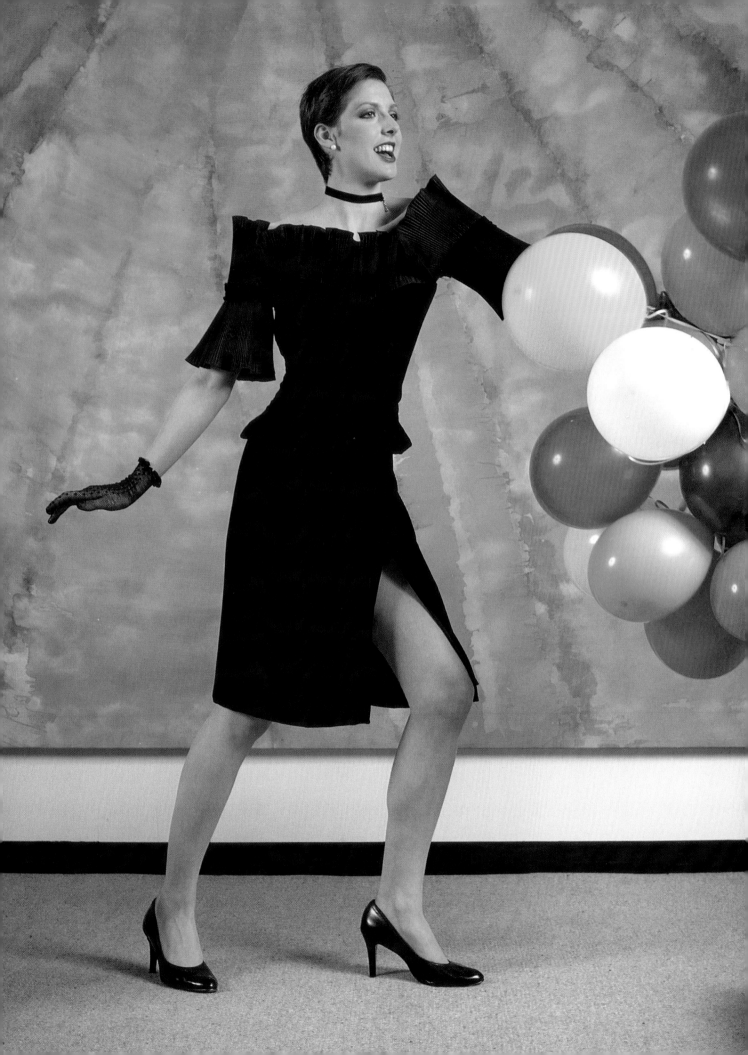

Junior Sophisticate Blouse

This technique is used here for a blouse advertisement that would normally have text running alongside the image. The ad would appear in magazines geared to young sophisticates. The photograph should be classical, but one that would be eye-catching from an advertising point of view. It should be still and composed so the prospective buyers could see the details and know exactly what they would be purchasing. Any props used must enhance the blouse, not distract from it.

The model should be from 20 to 23 years old and, since the blouse must fit her body frame proportionally, she should be at least 5′7″ to 5′8″ tall and wear size 6 or 8. Her hair and makeup should look neat and simple—not overdone.

Do make sure your posture is relaxed and erect. The model in this photo is turned away just ten degrees from the camera. Your blouse and hands should look natural. Direct your face and eyes to the camera. Your hair should look neat.

Don't hold your back shoulder up high. This shortens your neck and distorts the blouse.

Do turn your torso narrow to the camera. In this photo, a touch of the back sleeve can be seen, which shows a different design. The model's expression is warm and just the right amount of hair is on her shoulder.

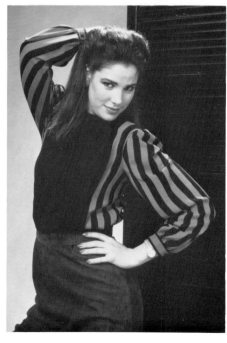

Don't push your hips out to the side; this makes the torso look awkward. It's not an appropriate pose because the clothes don't look neat and the sleeve on the blouse is distorted.

Advice to the Model

Make sure that the blouse is tucked in and pulled down so it fits smoothly and naturally. The front and the full sleeves should be well pressed, and when you tuck the blouse in, see that the pleats are all folded in the proper direction.

Your hair should not be teased or placed on top of your head. It should be neat, simple, and worn freely, whether long or short. Makeup should be kept to a minimum: natural-looking brows, eyelids, rouge, and base. However, the lipstick should be a strong, very evenly applied red to accent the red in the blouse.

In posing, avoid extremes. Assume a good stance, with your legs at least two feet apart and your hips angled 30 to 40 degrees away from the camera. Don't bear down on your hips with your hands because you want to avoid puckering or crushing the fabric. Your arm should hold its own weight. A sexy, sultry, kittenish look, or a slightly aloof one, or one in which you smile with your mouth closed is more appropriate for this shot than a toothy grin is.

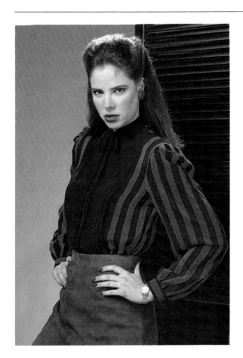

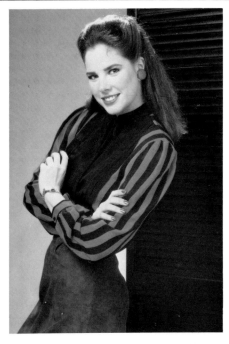

Do vary your hand and arm movements. Push your back arm toward the back for effect. This also shows the shape of the bib. Your hair should be neat and your expression warm.

Don't turn your hips too far away from the camera. Also don't fold your hands, covering the blouse. This model's flat hand is distracting. Her head is dipped too low, she is squinting, and her smile is too broad.

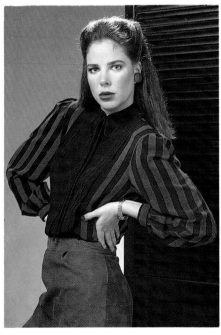

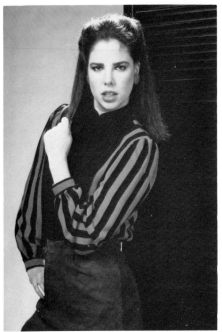

Do arch your back and move your arm to your rib cage to make a different form. Your elbow, however, should be kept off to the side, not pushed to camera front or back and your hands shouldn't be flat. Tilt your back shoulder upward; this brings the front one down. The position of the other arm in this photograph is good because it's pushed forward and has a design equal to the first one.

Don't cover the blouse up with a gesture to the hair. This pose also shows the flat of the hand, which is distracting and not feminine. The expression on this model's mouth is too severe and her head and chin are not centered in the middle of her neck.

Advice to the Photographer

In this case you probably won't need a sketch from your client—a discussion will do. Set up the studio and take a few Polaroid shots, using your assistant or anyone else available as a model, to test the lighting before your client arrives. Keep the techniques simple—a straightforward source of light with some fill-ins on the blouse and face should do. Avoid harsh shadows. For background, use a seamless backdrop that complements the coloring of both the blouse and the model.

Camera-to-subject angle should be directed right at the middle of the blouse. The focus should be sharp and the lighting a bit moody but bright and clear. The subject should remain very still, fitting right into the middle of the frame. For an interesting effect, you can crop a small part of the sleeve off. Not much extra room is required at the top of the photograph, but if the client has requested some extra space at top and/or bottom, be sure to allow for that.

The model's spine should be kept straight, with hips pressed forward. Her neck should be long and elegant, her head held high but not strained, and she should move extremely slowly and only within a range of 20 degrees from camera front. At the beginning of the session, the shoulders should be angled away at the same degree as the hips; later, direct the model to slowly start to rotate her shoulders toward the camera, until the other shoulder is slightly revealed. Then both sleeves are visible.

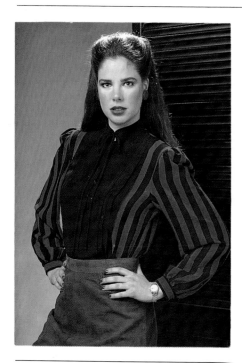

Do keep your hair to the back so it doesn't distract from the blouse. Hold your shoulders high so the blouse fits correctly.

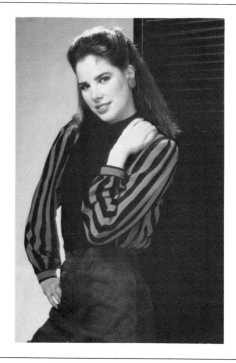

Don't tense your back shoulder; this foreshortens the arm and makes the hand look awkward. The arm moving up to the right shoulder in this photo is awkward for several reasons; it is an unnatural pose, it hides the blouse, and it brings the hand into the forefront. The model's face is not composed enough so the expression is not interesting and there is tension under her eyes.

Summary

I was very pleased with the final effect of this shooting because the red in the background brought out the red in the blouse and the black parallel-lined screen complemented the vertical stripes in the blouse's bib. The pose was simple so once it was set, the model and I worked together on improvising her expressions. She was careful to change angles only slightly to add more attitude to the photograph.

The photo on the opposite page is the best one because the shape is interesting, the model conveys elegance and charm, and the blouse is appealing. The clothing is neat and the lighting doesn't distract from either the model or the clothes.

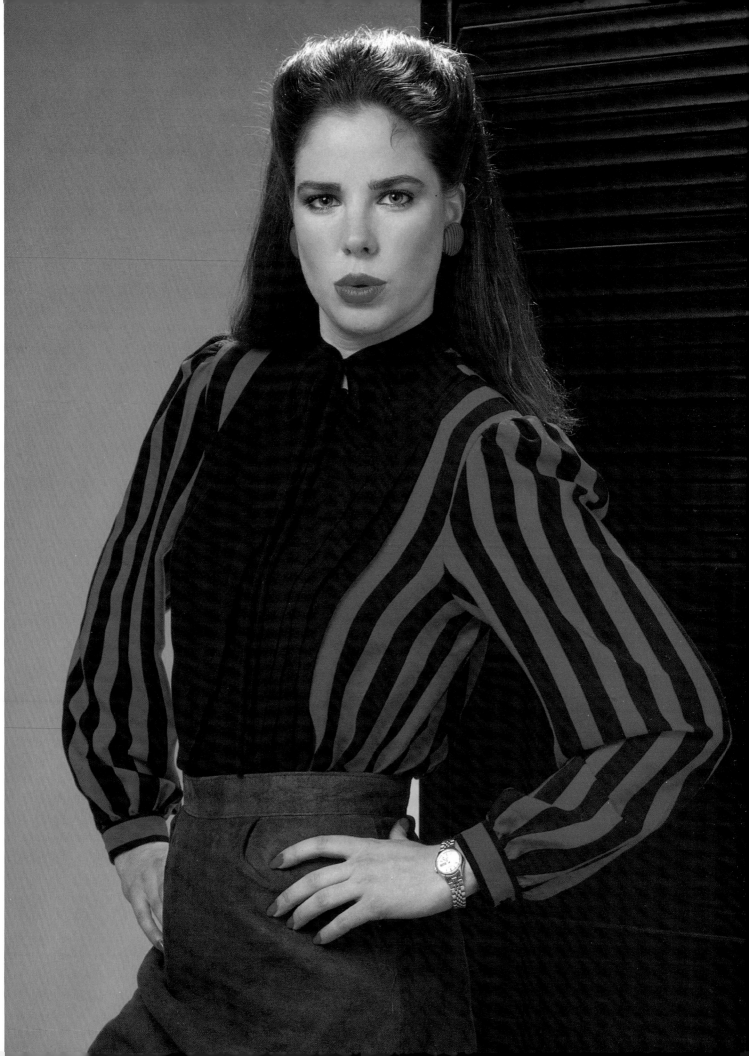

Lingerie

A photographer would use this technique for advertising fashion in which undergarments are featured. The aim is to show them at their best, in a clearly visible, graceful manner. The model most appropriate for this technique is between 5'4" and 5'10" tall. She may be petite in this particular case, as long as her proportions are perfect; this is very important because her figure is seen clearly. The model should have even-toned skin and no bruises. Her nails should be well manicured and her makeup should be neither too exotic nor underdone. Her hair should be soft and feminine and not short or boyish looking.

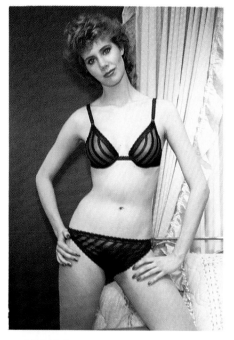

Do keep your torso flat to the camera. Place one knee up on the bed; this will automatically throw one hip out to the side. Put your hand on your thigh, keeping your elbows out and your fingers arranged in a feminine way. Tip your head to the side and make sure your expression is very pleasant. This is a typical classical approach and is acceptable in any photo posing.

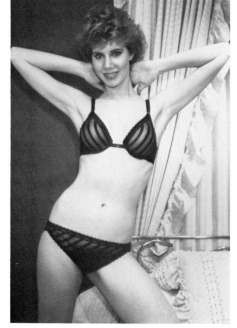

Don't exaggerate the pose by pushing your hips out too far or lifting your arms so high that your rib cage shows. Don't bring both arms up at the same time—this focuses attention on your underarms, which is not the point of lingerie advertisement. If you *do* bring both arms up, make sure that the palms of your hands don't show and that both arms are directed toward the side of your body.

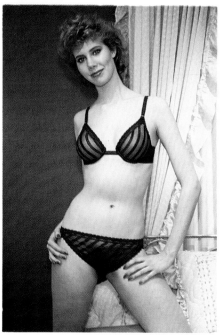

Do place one hand on your thigh, keeping your elbow out, and completely hide the other arm behind your torso line. This will leave a very clean body line on one side.

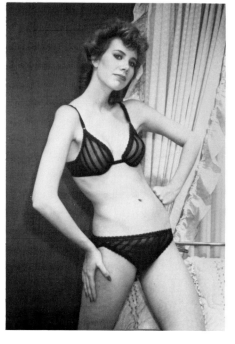

Don't keep your arm (the right one in this photograph) flat to the camera because this makes it look too large and out of proportion to the body. In this photograph, the left arm looks awkward with the fist on the hip, there is tension in the shoulder, and the chin is held too high. However, the torso angle is excellent.

Advice to the Model

As soon as you arrive at the studio, remove your undergarments and any tight belts or pants you may be wearing so that after an hour or so, all clothing marks will have disappeared. Your hair should be clean and your finger and toe nails well-manicured. If you are to apply your own makeup, remember it should be a little stronger than natural.

Your poses and expressions for this particular technique should be a bit aloof and sophisticated, with a touch of underlying sweetness. Stand in a graphic but relaxed manner. Use your arms and hands in a very feminine way. Don't ball your hands up into fists at your hips, or raise your hands to your hair, or cover the clothes with your hands.

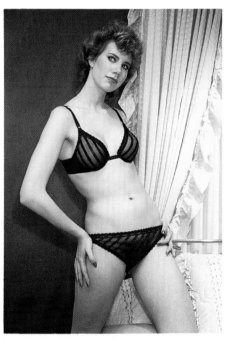

Do turn your back shoulder away from the camera and lean back, keeping your knee on the bed (this is a different approach to a classical photograph). At the same time, put your other hand on your upper thigh and your elbow out to the side. Your expression should be soft and warm.

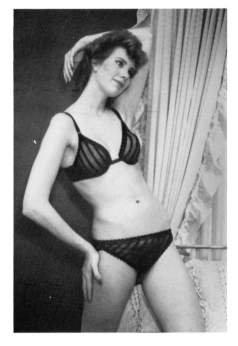

Don't bring your arm too far toward the camera; this enlarges it. Also, folding the hand down doesn't look natural. In this photograph, the arm behind the head is up too high, and the position of the hand is very awkward.

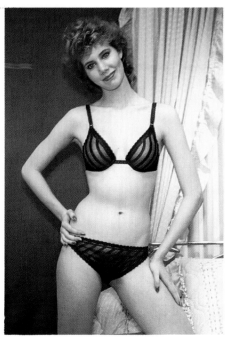

Do keep your torso straight to the camera in a very classic manner. Put one hand on your upper thigh and the other hand on your hip. This will give your arms a more interesting effect because it varies the angles. Tilt your head off to the side and project a small, sweet smile to the camera.

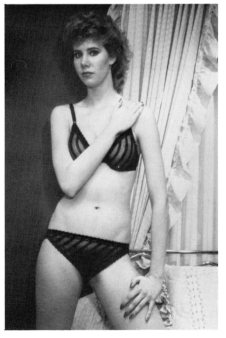

Don't push your torso out too far and don't hold your chin too low. In this photograph, the arm on the model's thigh is awkward because the hand isn't being used correctly and neither is the arm. The other arm shouldn't be covering the bra—this hides the merchandise.

Advice to to the Photographer

The set design here is of a bedroom, which is an appropriate choice for a lingerie shooting. It consists of a bed, drapes, a lamp, and pillows. There are no special lighting effects. The camera should be aimed at the model's solar plexus so as not to create distortion. As you are setting up your frame, see that you leave enough room for the model to use her hands on her hips so they won't be cropped out. Photos may be soft and moody, but should be in sharp focus. No motion is required for this particular type of photograph.

Make sure that the model's limbs and her head are in balance with her torso: direct her to place one knee on the bed while she's standing on the other foot and to swing her hip out to the side. Straight up-and-down posing would be boring and throwing the hip out gives a much better graphic image of this type of merchandise. Get the model to show you different variations of hand positions. If you *do* direct her to raise her hands to her head, make sure she does this very artistically—it can easily look like a cheesecake pose.

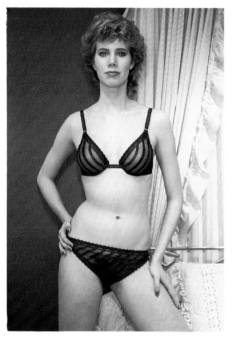

Do turn your hips and shoulders flat to the camera, keeping your body tall and erect. Place one hand on your upper thigh and keep one hidden behind your head, arm out to the side. Holding this pose, slowly turn away from the camera. Your arm and the hand on your hip will be too close to the camera at this point so bring them back slowly to your side.

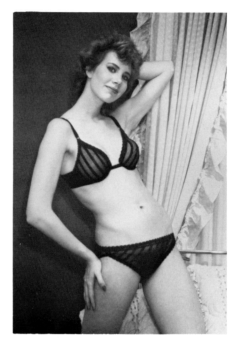

Don't jut your jaw out—this makes it look too prominent. Bringing your arm with your hand pointed down makes your arm and hand look awkward and enlarged in proportion to your torso.

Summary

One of the major problems in this shooting was getting the model to keep her pelvis pushed forward rather than her back arched. Another was helping her realize that when she hid her arm behind her torso, she had to bring it back far enough for it not to interfere with her torso line (if both the arm and the torso are visible, the waist looks thick since both are the same tone). This was solved by telling the model to assume a firm stance, pushing her pelvis forward, keeping her hips and shoulders flat to the camera, putting her hip out to the side, and placing her hands on her hips or thighs, then directing her to twist one side slowly to the camera.

The photograph on the opposite page is the best one because the model is in very good balance with the interior and projects elegance and grace. She is using her arms, hands, neck, and head very well in relation to her torso.

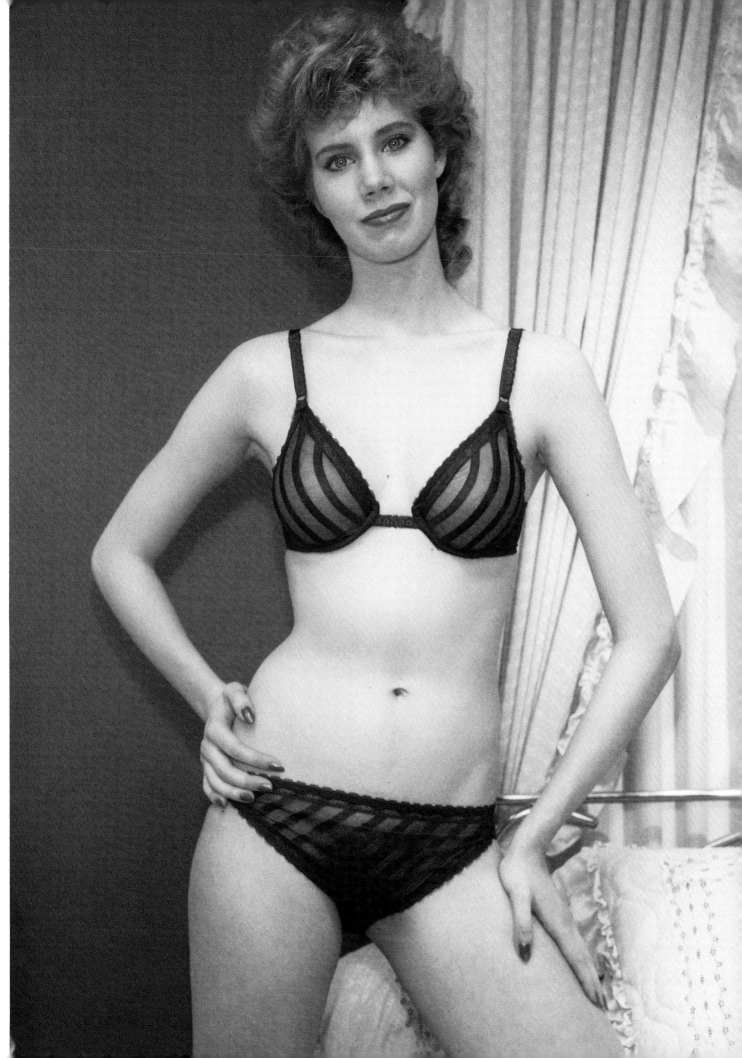

The Classic Dress

This chapter features a seated model in a dress advertisement. The photographer would use this technique when shooting an ad that must show the design and fabric of the dress. The model used for this technique should be tall (between 5'7" and 6') and slender (from 105 to 130 pounds). Her skin should have an even texture and the whites of her eyes should be clear. The model's hair should be neat and easily manageable and should be groomed in such a way as to show her neckline. Her nails should be manicured and her makeup should be soft, with emphasis on the eyes.

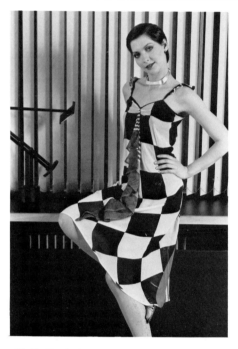

Do sit on the tip of the platform, keeping each leg in a different position and your elbow off to the side of your body. Your neck should be long and elegant and your expression both sophisticated and sweet.

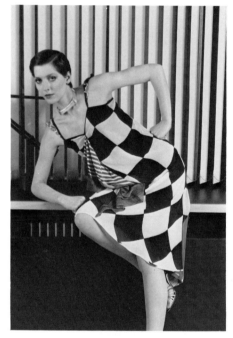

Don't lean over completely on one arm because this makes the dress look very full in the front and hides one of your hands. The model in this photograph is holding both hands in fists, which makes the pose look very masculine. She should also be showing a bit more expression on her face—she looks genuinely bored here.

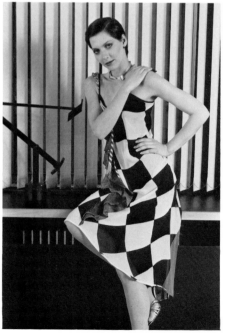

Do cross one hand over your front gracefully, making sure it's not pressing against the bodice of the dress. Hold your other hand on your waist, keeping the fingers long and elegant. Keep your legs in good relationship to each other and angle your head up in a position natural to the pose.

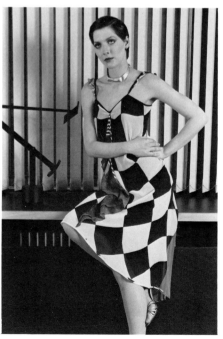

Don't cross your arm in such a way that it covers your dress—that's neither fashionable nor elegant. Here the model is also covering one hand with the other one, and the hand that *is* showing is very flat to the camera—not a very pretty pose. Notice, also, that her gaze is too high.

Advice to the Model

A model should approach a setting such as the one shown here thinking about what it looks like, what it feels like to her, and the outfit she's wearing. She might say to herself: "Well, I'm going to sit on that ledge and I'm wearing stripes and checks. That's very abstract so I should pose in a very graphic and abstract manner, not in a very soft and romantic or moody one," so take a good look at the area you'll be working in. Position yourself in relationship to the lamp—not too close or too far. Feel the space around you. Experiment with moving your arms up and down. One leg should be higher than the other, and it's very elegant to twist your toe around the corner of your calf (this brings the legs into one line). Since the dress shown here is very simple and graphic, you should keep your arms away from your torso. Make sure your posture is good, your neck tall and elongated, your expressions elegant. I would advise the model to use her arms and head in a graphic manner off to the sides, placing her hands flat down on the ledge and moving her head and holding her chin at different angles.

Hair and makeup should be sophisticated, and the hair should be off of the neck. The emphasis should be on the eyes. As you move, you will probably change the draping of the clothing, so glance down from time to time to check that it is neat and well placed.

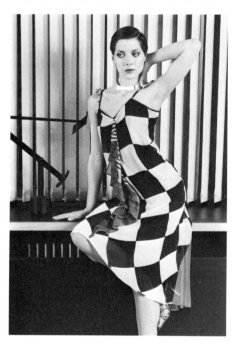

Do make sure that you hold the arm coming down to the ledge in a graceful pose and that you keep your hand flat. In this photograph, the arm reaching up is very well positioned; the elbow is going out to the side, not to the back or the front; and the model's eyes are looking off to the side of the frames, adding a very sultry feeling to the face.

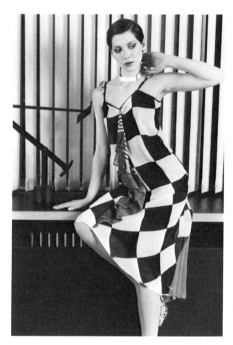

Don't put your arm up to your face in such a way that you still can see the hand and don't turn so close to the camera that your complete underarm is showing. Don't look bored!

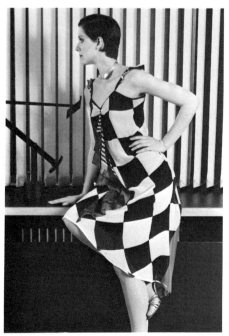

Do pick one leg up a bit and wrap the toe of your other leg around your calf for a very good pose. Your arm should be flowing down gently, and you should keep the hand you're leaning on flat. Notice that the model here poses her other arm up to add a different effect on either side. The hand broken at the wrist with fingers pointing to the waist is excellent. The profile evolves naturally from this pose.

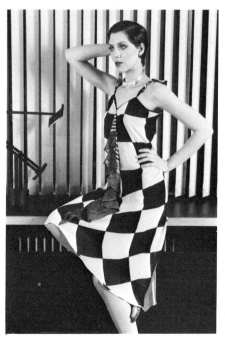

Don't bring your inside arm up to your head if your other arm is on your waist because that looks like you're posing for a 1930s calendar rather than for an elegant advertisement. Don't stare off into space—fix your gaze at the camera.

Advice to the Photographer

Both the set design and the dress are very graphic. The only prop is the lamp and it has its own graphic personality as well. You should therefore also use the model as a graphic "object." Direct her to make different shapes with her body and her arms. I would suggest you ask the model to sit on the edge of the ledge. Tell her to balance her body weight with one foot on the floor and to bring the other leg up, giving a nice triangular effect from the waist down; then ask her to wrap the toe of her shoe around her calf, keeping her knee away from the camera. She can vary her poses by keeping her spine straight, or by pushing her shoulders back and arching her spine, or by angling her shoulders away from the camera. If she keeps her hand on her hip, be sure she doesn't point her elbow toward the camera because that would enlarge her arm. Try different experiments with her back arm: hand on waist, for example, or hand on hip, or hand on the rib cage—or even hide the hand completely, in which case you will get a nice, clean line that shows off the dress. Try to get the model to relax, although that might be difficult because she is really using all her muscles in these poses.

There is no motion in these photographs but it is important that they have a sharp focus. The model should fit in the center of the frame in relationship to the lamp. Moody lighting would be interesting.

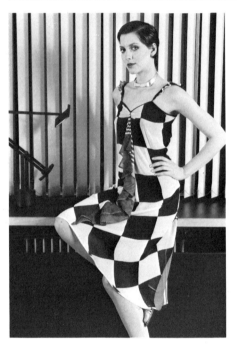

Do arch your back a little bit and keep your shoulders balanced evenly. Hide your other arm and hand behind your back. Twist your torso to the front so your back shoulder shows a little bit. Place your hand on your hip, pointing your fingers up to your waist—this makes your waist look slimmer. Turn your face three-quarters to the camera.

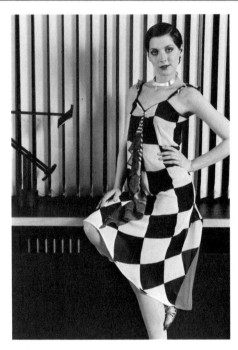

Don't push your spine into too exaggerated a curve; this makes the dress bellow out in front, so it looks too full and awkward, and your back arm look like it's just kind of there. Don't let your gaze be too high.

Summary

The major problem in this session was getting the model to feel secure that the simplest pose was the prettiest. Once I had directed her to an interesting graphic shape, the model wanted to use her arms up above her shoulders, which made the pose look rather cheesecakey and took away from its elegance. Or she wanted to bring her arm across her front and rest it on her shoulder, which covered the features of the dress. This is all right occasionally, if it's composed in a very graceful way. I have chosen one photograph to show you how it can be done correctly.

The photograph shown here (opposite page) is simple and elegant. It has shape, form, grace, and naturalness. And the naturalness makes it very interesting in this abstract environment.

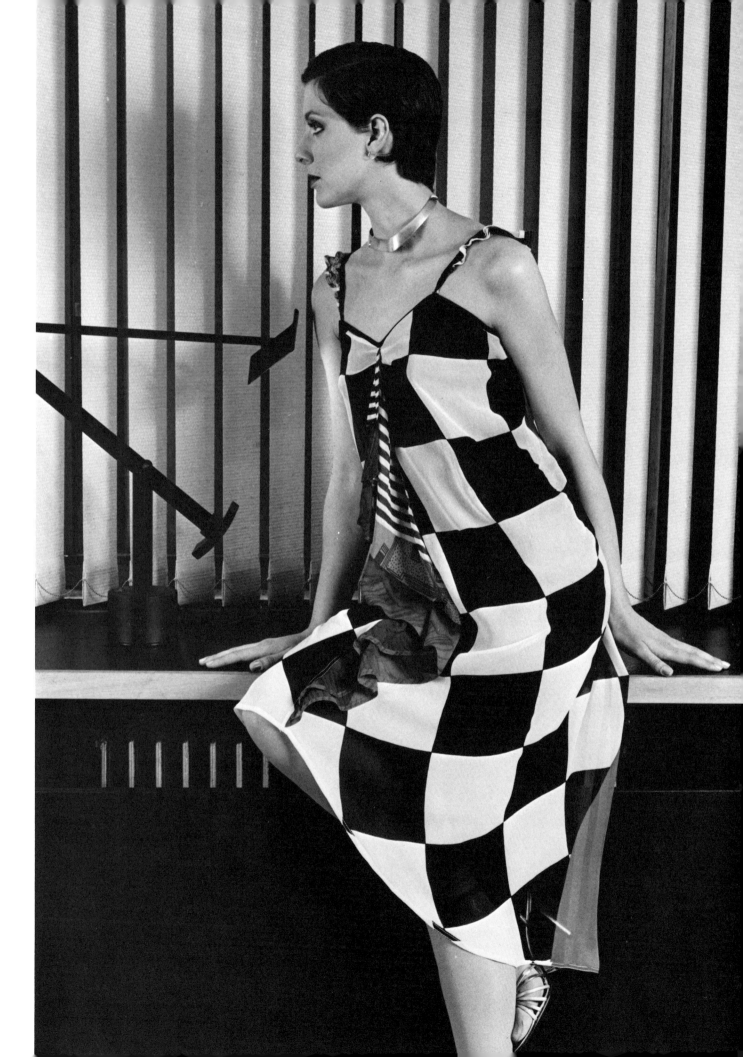

Miss Sophisticate Suit

An editorial fashion photograph of a suit must show it to perfection. The pose should be relaxed and one that will flatter the style of the suit. The model should be 5'7" to 5'10" tall, and slim, and she should have classic features, well-shaped legs, a simple haircut, and a pleasant smile. This suit is very graphic in its own right, so a simple background was chosen against which to display it.

Do keep your torso tall and your spine and hips rotated to the camera. Picking the top leg up adds dimension to the photograph, but do it correctly, as shown here.

Don't bring your arm up to your hat because, in this particular suit, the sleeves aren't roomy enough and pull very tightly in this pose. Also, don't show the palm of your hand to the camera. This is not good photo posing.

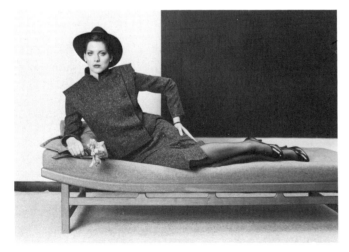

Do bring your bottom leg up to cross over the top leg. If your torso is long and straight, your legs will still look long and elegant. Keep the arm on your thigh out to the side of your torso for a good graphic effect.

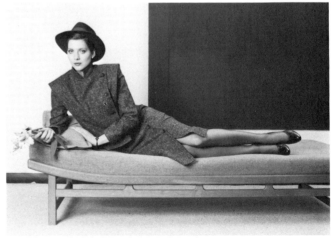

Don't ruin a beautiful classic line by dropping your torso down in the middle, twisting it too far forward, and bringing your arm down over the suit. As you see here, this cuts the line of the suit in half and makes the middle fall in.

Advice to the Model

Hair flowing down to the side or resting on your shoulders would not be appropriate because in this particular shot, it would hide your neck and also distract from the shoulders of the suit. Minimize your hair by putting it behind your head in a knot or under a hat. The hat should be placed to the back of your head so your face can be seen easily. Makeup for this technique should be medium to exotic and the emphasis should be on the eyes. A strong-color lipstick—red or orange, for example, but not pink or coral—should be used because in a black-and-white photograph, soft mouth colors cause an imbalance between the mouth and the eyes.

It's your job to see that your clothes fall in a natural manner after you assume a pose. Always check that they are placed correctly. No clothing preparation is necessary in this case because a wool suit stays very neat looking. When posing, think of your seating position in relation to the length of the couch and to your outfit, and seat yourself proportionally. It's important in a photograph such as this one for you to push one hip toward the camera front while actually resting on the other hip.

You must remember that the poses expected of you here will not feel very natural and you will not be particularly comfortable, so once you find a good graphic pose for the suit in relationship to the camera, hold that pose for as long as you can and use your own free arm and your leg to create different shapes and effects.

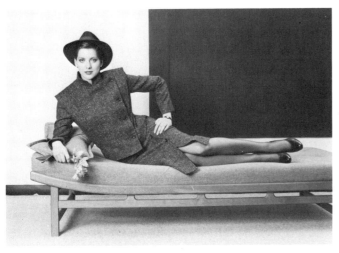

Do keep your torso tall, your hips flat to the camera, and the flowers turned inward. In this particular pose, you can keep the flat of your hand to the camera as long as it is graceful and looks natural. Break your hand at the wrist and make sure your elbow projects toward the back and side, not to the front.

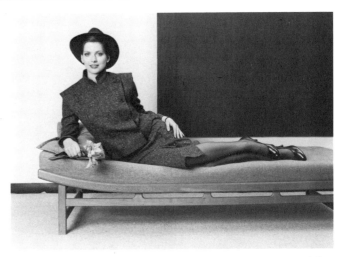

Don't slouch. Keep your spine tall and erect and don't let your hip fall back.

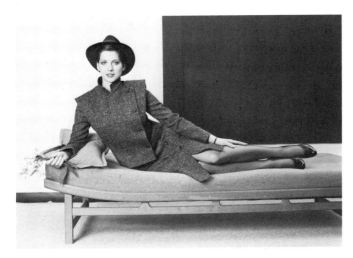

Do twist your torso to the camera, keeping it very tall and elegant. Make sure there is no tension in your shoulders and your neck. Hold your neck high in order to keep it visible in this type of suit. Hold the flowers in a graceful manner. The line of your arm coming down over the hip should also be very graceful, and the expression on your face should be in keeping with the theme of the pose.

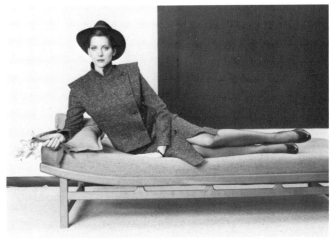

Don't distract from the classic line of the suit by bringing your arm forward over your hips. It's not only cumbersome, but also completely hides the model's skirt.

Advice to the Photographer

Shoot several Polaroids to make sure that the lighting shows the texture of the suit. Direct the model to use her face toward the main light source and camera front. Flowers were chosen as a prop to add a little softness to this photograph. Since all the tones in this photograph were black, gray, white, and brown, it was decided to shoot this photograph in black and white. Camera-to-subject angle should be low to high (the camera was balanced on two phone books on the floor and aimed at the model's waist).

The most serious problem you will have in photographing a suit in this type of setting will be making sure that the model is not collapsing her torso and is balancing on her hip. She must hold her body up with the arm on which she's leaning and hold her calf and foot up occasionally as well, neither of which are comfortable poses. The model must also keep her hips flat to the camera and twist her torso to it as well. This is usually one of the major problems in a semi-reclining pose. Once the body position is set, it's very important to direct the model not to move around or fidget. Most photographers feel that they have to direct the model to move around a lot in order to get poses and variations of poses. But I find that once you get into a shooting, you will discover the best basic pose for the body and the clothes and that you will get the posing variations you want by directing the model to move her arms, hands, and head slightly. Once one pose is finished, change it very subtly.

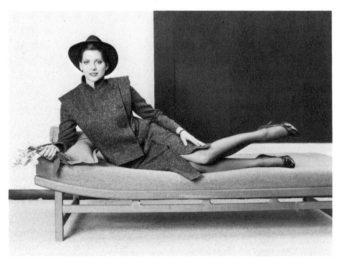

Do keep your hips and shoulders rotated to the camera. Hold the flowers in a graceful manner and make sure your arm is coming down over your hips in proportion to your figure as a whole. Raise one leg toward the ceiling; this adds extra flavor to the photograph.

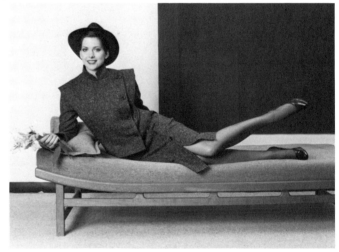

Don't hide your arm behind your torso: it's more elegant to show the complete arm of the suit. If you *do* hide the arm, be sure you do so completely to keep the graphic line of the suit very clean. Don't twist your hips too far forward; this changes the line of the skirt.

Summary

The main problem was getting the model to hold the pose for any length of time because she was uncomfortable, so I directed her to concentrate on her movements and expressions and she forgot about the discomfort. When she took a five-minute break, she simply rolled over and relaxed; she didn't leave the settee or move her hip position, so the pose was easily reassumed.

The photograph below was chosen because its classic style is appealing in every way. The lines are very clean, the expression on the model's face is warm and interesting, and the props are well balanced.

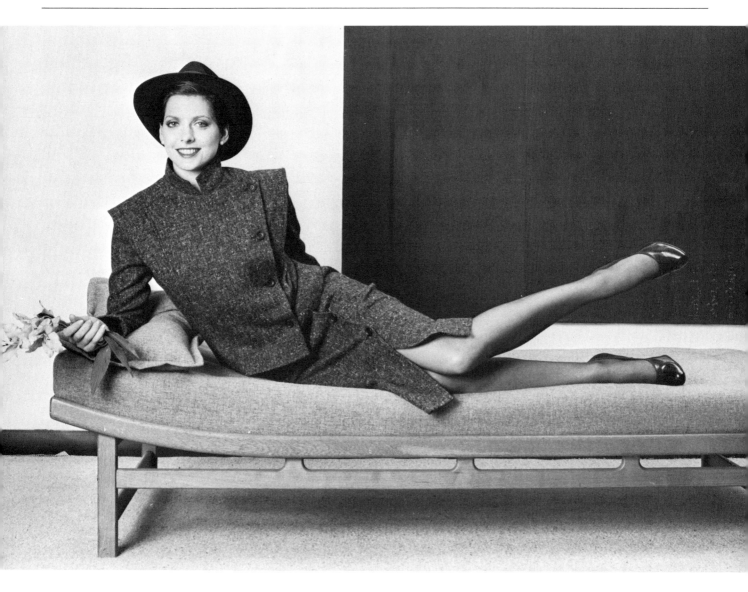

Misses' Sweater

The main aim in sweater catalog advertising is to show the sweater in a very simple, straightforward, clear manner so prospective buyers can see exactly what they're getting. The model used should be anywhere from 15 to 30 years old and 5'7" to 5'10" tall. She should weigh no more than 120 pounds since she must be very slim. The model should not be large busted—the lines of the sweater should be in balance with the form of her body. She must be pretty, with a lovely complexion and good-quality hair, which doesn't necessarily have to be long, but should be thick, healthy, and shiny. She should have even teeth because she will be asked to smile.

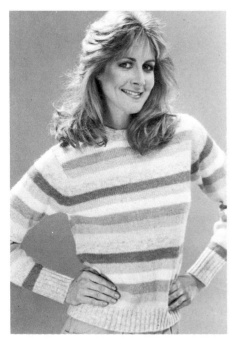

Do keep your spine tall but relaxed. A long neck adds to the elegance of the photograph. Keep your arms out to the side. You may raise one shoulder slightly to add an extra graphic effect and do keep smiling.

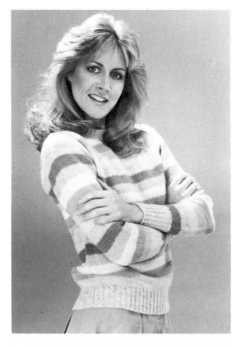

Don't keep your shoulders tense or round them. Your head shouldn't be angled so far to one side that your chin looks unnatural in relationship to your neck. Don't let your hair fall forward.

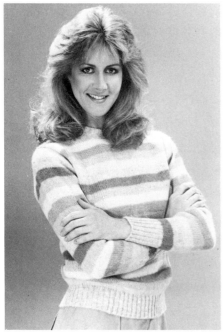

Do keep your stance nice and relaxed and keep your shoulders back. Cross your arms low on your body so you don't cover up the design of the sweater. Note that the model's fingers are open and long and elegant. Her neck is long and the smile on her face is cheerful. This is very good posing.

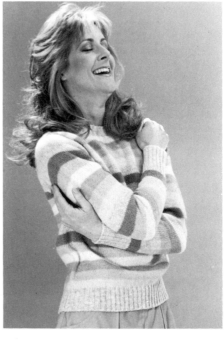

Don't cover your chest with both your arms because this hides the product and makes your pose look very awkward. Don't throw your head back too far or smile too broadly and don't ever close your eyes in a photographic shooting unless you're asked to.

Advice to the Model

The appropriate hairstyle for this technique is soft and pretty and does not cover up the sweater. If a model has very long hair and wears it in front, for example, it will cover the design of the sweater, which defeats the purpose of the photograph. So if you have long hair, make sure that it's pulled up on the side, dropped down the back, or styled in a bun or something similar on the head. Short hair is, of course, appropriate.

It's the model's job to see that the clothes fit the body correctly. If you're working with stripes, it's important to make sure that the stripes on the sleeve match up to the stripes in the bodice. And if the sleeves are too long, fold the ends up a tiny bit. The sweater bottom should be very smooth and fit well at the waist. In posing, don't hold your hand on your waist so tightly that you move the fabric of the sweater and change the natural line of the garment. Because you're being photographed from your hips to the top of your head, you should work in that framework, using your hands on your hips to show off the sleeves, keeping your fingers together, and bending your hand at the wrist. You can show the sweater with your arms up, but that must be done carefully, with long fingers showing, not with your fist and hands closed. I would also suggest that you angle one shoulder away from the camera slightly because this adds a little more interest to the pose. All poses used in this technique should be very controlled.

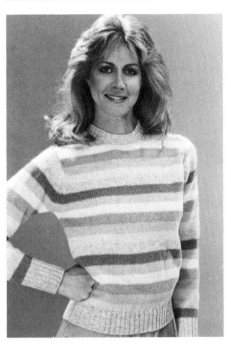

Do assume a natural stance, and keep your spine tall, neck long, and expression sweet. Place one arm down at your side. The other arm, with the fist to the camera, should be on your waist and off to the side to show a strong stance and good graphic posing.

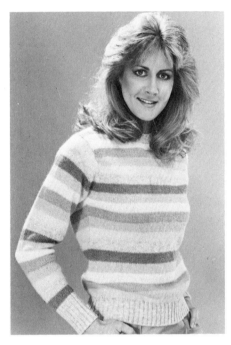

Don't put your hands very flat and deep into your pockets, hanging your thumbs outside. That looks very awkward. Don't slouch and don't let your hair fall forward and cover your neck.

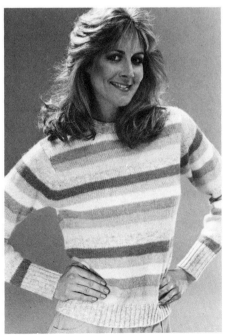

Do hold one shoulder a little higher than the other; this will add more interest to the photograph. Place both hands on your hips, with your fingers together and your palms back to the side of your hip, and break at your wrist. Keep smiling!

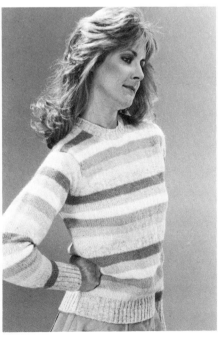

Don't turn your body so far away from the camera that the other sleeve is hidden and don't bring your left arm to camera front because that enlarges it. Your jaw should not be angled to the camera.

Advice to the Photographer

Know what your photographic style should be and which focus is more appropriate—soft or sharp. Also, decide whether you want the photograph to be dark and moody or bright and clear. Since this is to be a catalog photograph, there is usually no motion required, so I suggest that before the client arrives you take Polaroid test shots, to see if the lighting is perfect. If it's not, adjust it. The model should fit exactly in the center of the frame but if necessary, you can crop off part of her elbows because the design of the sweater will still be very clear. Put the camera on a tripod and aim the camera at the model's solar plexus; this will give you an even proportion in your final photograph.

While directing the model, it is very important to make sure she isn't holding her body tensely; you can usually spot this if the model lifts her shoulders or holds her breath. Be sure that you don't allow the model to make fists on her waist or to bring her elbows too far to camera front or camera back because this distorts the arms. Direct the model to keep her fingers together, to put her hands on her waist with her fingers angled upward, and to bend her hand at the wrist. She should project pleasant and cheerful expressions and smile (but advise her not to laugh too hard). Her torso should be full front to the camera, angling off just a tiny bit. Make sure the model doesn't stick her hand into the pocket of her skirt with her thumb hanging out—it's not attractive and distorts the garment.

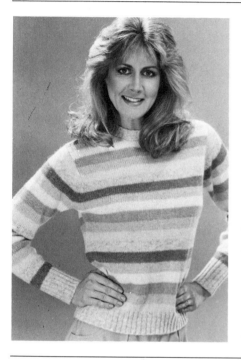

Do project energy with a lovely, winning smile and your face directed to the camera, as the model is doing here. Raise one shoulder and, with your fingers together, place both hands on your waist.

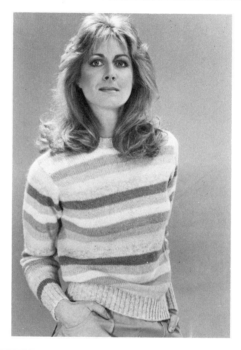

Don't slouch in a photograph. You shouldn't *push* your hands into your pockets with your thumbs on the outside. Don't lift your chin so high that it makes your face look out of proportion.

Summary

One major problem in this shooting was getting the model to keep her elbows off to the side but not to hide them from the camera's view. She wanted to push her elbows back and that foreshortened her arm. The other major problems were in getting the model to keep her hands long and narrow, with fingers together and pointing upward, not fists, on her waist, and to forget that she even had pockets, because that distracted from the sweater. Models love to use their pockets because it helps them to project a feeling and also it gives them something to do with their hands, which are the hardest parts of the body to deal with correctly in any photo posing technique.

The photograph (opposite page) was chosen as best because it conveys everything the client would want. First and foremost it shows the sweater in an even lighting where all the details of the design are clear. The model's arms are perfectly balanced, her hands are graceful. She looks energetic and appropriate for this type of sweater. And her hair is lovely and neat.

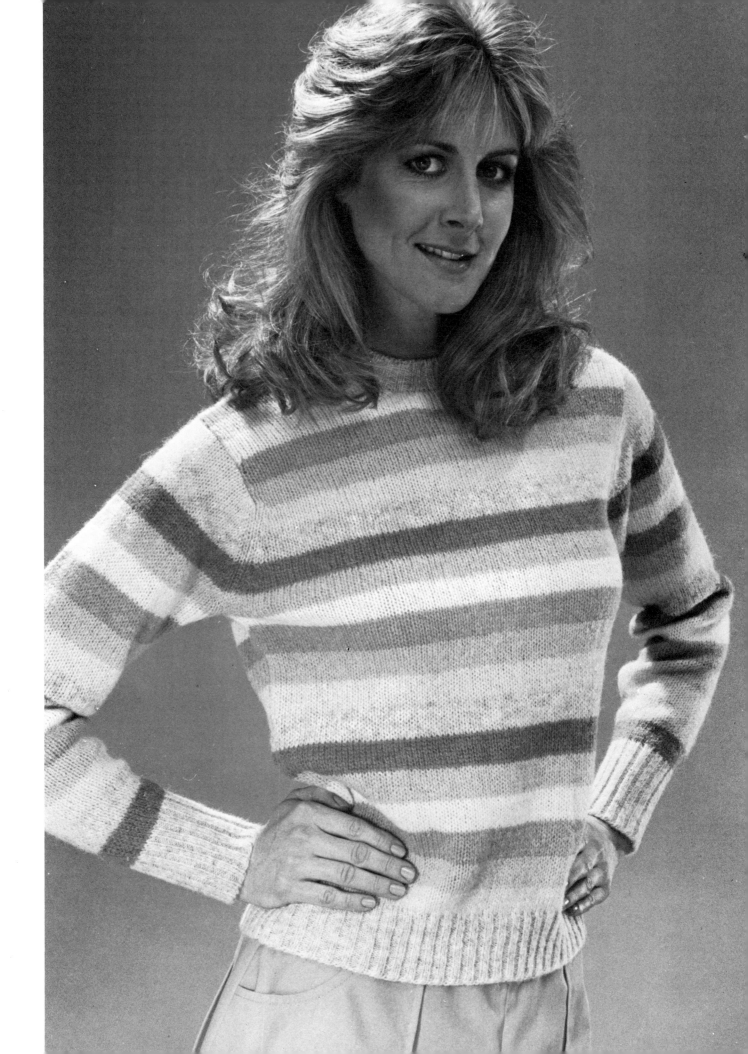

Boys' Junior Sportswear

This technique is used to show sports clothes at their absolute best and in an appropriate setting. That's why the basketball is used here. This photo technique can be used for advertisement. The model should be between the ages of 21 and 26 and should be 5′8″ to 6′ tall because that is the most appropriate height for sample sizes. He should be in good shape and have a clear complexion, healthy hair, and a happy face.

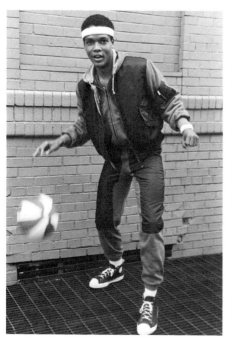

Do take a wide stride with one leg closer to the camera than the other. Flexing the knees is also good. Keep your shoulders low and dribble the ball, but bring your eyes and face to camera front.

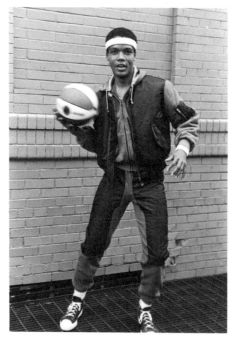

Don't lunge toward the camera with your knees while bringing your left arm too high. It throws your shoulders off balance and brings them too far back. Uncontrolled hand movement to the camera is not good posing.

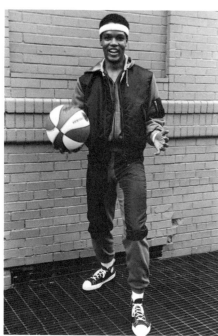

Do place weight on your front foot, which should be closer to the camera. Bounce the ball back and forth from one hand to the other, and keep changing your expressions. It's up to the photographer to catch the right moment.

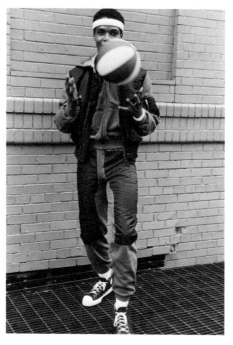

Don't throw the ball up in front of your face because it blocks the jacket and your face and gives your hands too much priority. Keep the ball off to the side.

Advice to the Model

In this type of posing, you will be expected to repeat the same movement from 70 to 100 times (that's about two to three rolls of film). There's usually a certain area that has been blocked for you to work in, so you should move in that area only. Since these are action photographs, you should work at peak performance, separating your feet at an appropriate angle; turning the hips away from the camera slightly and shoulders turned toward the camera; varying arm movements, perhaps one up, one down, or both out to the side; and registering excitement on your face—all at the same time. I advised the model shown here to stand in the designated area and to dribble the ball several times, keeping the movement in rhythm with the camera and the expression on his face, and keeping his arms open so he doesn't hide the jacket. No preparation is needed for these clothes; they are nylon and are wrinkle-proof.

Do direct your torso toward the camera. Dribble the ball off to the side and pick up your back leg; this gives the photographic image more energy and movement. Keep your arms away from your sides. In this photograph, the model's eyes and face are aimed in the same direction as the ball; this is good photo posing, because it's well balanced.

Don't dribble the ball to the front. This upsets the balance of the photograph and the ball visually cuts off parts of the body.

Do twist your torso to the front so that the jacket can be seen while you're dribbling the ball. Keep your expression electric and your chin up so that the photographer can catch the picture at any second. That's good photo posing.

Don't turn your body directly profile to the camera while dribbling the ball. Strict profile is dull and hides the garment, as you can see in the photo. The back arm is hidden and the front hand looks very large, which isn't attractive.

Advice to the Photographer

Shooting a picture such as this one on location is lots of fun. Pick an area that lends itself well to the clothing and to your chosen theme. If you shoot in daylight, out in the open and away from trees and high buildings, the lighting will be even. The best camera-to-subject angle is slightly low to high, with the camera aimed at the model's chest. These are action photos, so be very sure that if you are not using a tripod, you hold the camera very still, since you want these to be sharp-focus, bright, and clear photos. Direct the model to aim at working in the center of the frame; leave a little more space on the top of the image in case you decide to shoot the picture with the ball going upwards. Your model should perform when he reaches the designated mark. Ask him to separate his feet when he turns his hips to the camera and to angle his shoulders away. When his shoulders look right to you, direct him to angle his hips in profile to the camera from the waist down, and then ask him to twist his torso to the camera. He should hold one arm (the arm that isn't involved with the ball) out to the side, but not to the front because that would make the hand and arm look very enlarged. Direct him to use the ball in an imaginative and natural way, bouncing it from hand to hand or spinning it on his fingertips. In directing a photo shooting like this one, make sure that the model is holding and using the ball well with reference to his clothing, that he's using the ball in a natural way, and that at the moment the shutter releases, everything is balanced.

Do use your inside hand when getting ready to shoot a basket so you don't cover the garment. Don't forget the automatic torso twist to the camera.

Don't handle the ball in an unrealistic manner. Make sure to use props correctly. Otherwise, however, this photo pose is perfect.

Summary

In this session the problem of coordinating the photograph and the posing was solved by repeating the same movement in series of tens. The model will work into a rhythm and will realize more and more, through your encouragement, when the photograph is right. So when you like something, direct him to do it over and over again and just correct the small errors at that point. Remember, an action session such as this one requires overshooting because many mistakes tend to occur in shootings of this nature.

This photograph has energy and it's very well balanced and centered. There's a lot of life and motion in the photo on the opposite page, the clothes are easily seen, and the model's expression is appropriate to the game he is playing.

Accessories

The main aim of this editorial photograph is to show accessories, which consist of flowers, earrings, and a bracelet. The model used for this technique must have very well balanced features, with an excellent complexion and exceptional eyes. She must have a long neck and good hair. Her age range can be anywhere from 15 to 25 and she must have delicate hands and very well-manicured nails.

Do balance yourself well on the stool and make sure your spine is very straight. Place one arm on your hips so you get a firm feeling. Bring your other arm across your torso; your fingertips should be long and narrow. The model in this photograph is angling her hips forward a bit, which balances the picture.

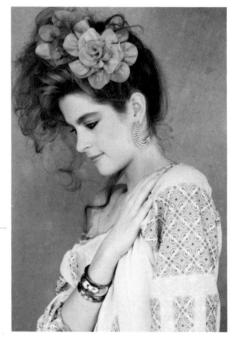

Don't turn your shoulders profile to the camera or hunch them, showing tension. You can see how the model's neck looks shorter here because she was not making a deliberate attempt to keep it long. Also her chin and eyes are directed downward, making this photograph very uninteresting.

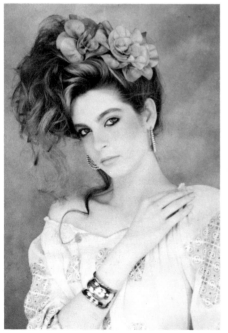

Do place your shoulders square to the camera. An elegant hand moving up to the shoulder and a part of the blouse falling off one shoulder add a different feeling. The model here turned her face and held her chin up just enough to the camera. All this, together with her beguiling eyes, make this a charming photograph.

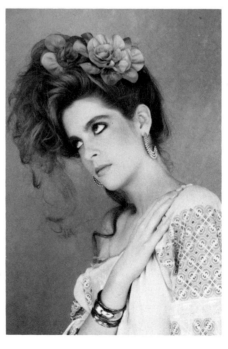

Don't position your shoulders incorrectly to the camera. In this photograph, they are hidden, as is the lovely blouse. The model is also holding her arm too close to her body, which makes the blouse pucker; she has lost that long, elegant neck because her chin is down too low; and she is lifting her eyes up too high.

Advice to the Model

You should arrive on the set with very clean skin, to which only moisturizer has been applied. Your hair should have been washed the night before and should be well conditioned and combed. You should bring a large scarf to wear around your torso while you're being made up and having your hair set in the studio. The makeup and hair shown here was styled by a top professional artist and it took approximately two hours. You should be patient and cooperative with the artist, sitting still, holding your neck up straight, and keeping your face pleasantly composed. It is important to be very disciplined even during the preparation part of your work so that the makeup artist and hairdresser may work swiftly and well. Your hair will be set first, then the makeup will be applied, then the hair will be combed and styled. Your face and neck will be powdered just before you go onto the set. The hairstyle should be classical and off the neck. Lots of hair is needed to attach the flowers. Short hair would look ridiculous with these large flowers on it— it would be more flowers than hair.

Posing that is needed for this particular shooting is concentrated mostly on the face. Sit in a comfortable position. Make various shapes with your shoulders. Bring your hand up, bring it down. Elongate your neck, bringing it in a bit to the camera then moving away slightly. Turn your face a little to the right, then three-quarters, then still more to the right. Think thoughts that will bring wonderful expressions to your eyes and your mouth.

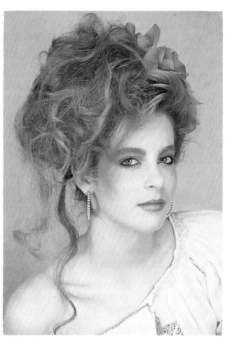

Do look up to the camera and keep your eyes wide open when the camera angle is high to low. This angle also captures the top of the model's lead shoulder in this photograph because she has kept it angled toward the camera.

Don't lose control of your expressions. The model here is overly animated and her jaw is too low, so you can actually see her tongue and lower teeth. The neck position is also incorrect.

Do keep your shoulders flush to the camera and your neck long and elegant. Also look up a tiny bit; this makes the photograph look very sophisticated.

Don't lower your chin and your eyes; this completely distracts from your long and elegant neck. This model's expression is much too animated. You can see her bottom teeth and her mouth and you don't see her eyes.

Advice to the Photographer

Use the type of model appropriate for this special technique. Camera-to-subject angle places the camera about two feet higher than the top of the model's head. Sharp focus is necessary and there should be no motion.

It's up to the photographer to see that he or she gets the proper type and style of makeup, so you should collaborate with the hairdresser and the makeup artist on lighting. In this case the makeup artist suggested that the photographer use a cream base for the lighting since it was very strong. Face and eye makeup colors should coordinate with the color of the model's eyes, her hair tone, and the clothing.

Since the hairstyle is complex, there's no need for props. However, a special background was brought in for this picture just to add extra special color and texture. I also placed a table in front of the model, who was seated on a stool, which was positioned high enough for the model to lean her elbow and arm on the table so that one shoulder could be lower than the other. Ask the model to sit up very straight, with a long, elegant neck, and to use the table—to lean on it. Tell her to start with her face full frame to the camera and then to angle it off to either side. Expressions should be warm, sensuous, and sweet at the same time. Be very careful that the model's head isn't cocked too far to one side, which would hide the flowers; neither should the profile be turned too far away from the camera or the chin held down too low. The gaze should not be too high, and her expression should be serene.

Do dip your shoulders slightly. Your neck should be long and elegant, your eyes bright, and your smile lovely.

Don't hold your head straight up and down—tilt it off to the side. This model's eyes are electric, but her bottom lip is protruding and her bottom teeth are showing, making the expression uninteresting.

Summary

The major problem in the shooting was working to get the hair and makeup exactly right. More time was spent in preparation than for the actual shooting, which is not usually the case, except for beauty or accessories photographs. The other problem was to persuade the model to express herself with her face and body, so constant coaching was required.

The best picture (opposite page) was chosen because it displays all three accessories—the flowers, the earring, and the bracelet—clearly. Also, the model's shoulder is at a good angle to the camera and the hair trickling down her neck is very classical. Her neck is long and elegant and the contour of her jaw line is clearly displayed. The expression on her lips and eyes is soft and sweet.

Women's Sportswear

This technique is used to show editorial fashion advertising at its best and to demonstrate to the photographer and model how to pose while modeling on the floor. The main aim is to make the clothes highly visible and to show the model in comfortable positions that suit the clothing.

The model most appropriate for this technique should wear size 6 to 10 so she'll be able to fit in sample size clothing and she should be 5'6" to 5'10" tall. She must be very slim, her body should have good muscle tone, and she should look like she's a sports enthusiast. The model should have thick hair that can be styled in a classical manner and her nails should be naturally long.

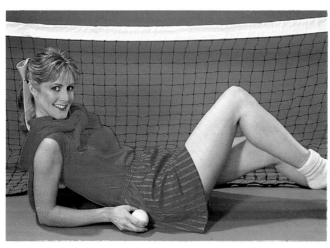

Do distribute your weight on your buttocks and elbows and lean back on your elbows. Hold your front leg up a few inches higher than your back leg; this gives a better dimension to the photograph. Also, keep your neckline long and swivel your chin to the camera.

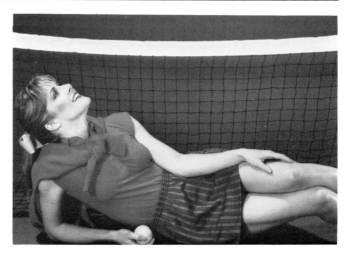

Don't bring the arm outlining the shape of your torso so far over that it becomes very prominent and hides part of the merchandise. This is awkward looking.

Do hold your neck up without tensing it and direct your face profile to the camera, pointing it at the ceiling. In this photograph, the model is holding her back leg higher than her front leg.

Don't lift your front leg up too high or hold the ball flat to the camera. Picking the leg up too high wrinkled the skirt, making it look messy.

Advice to the Model

Your clothes should all be pressed and neat before you try them on. I like the hair in a ponytail or pigtails in this type of photo because it has a sporty look and keeps the hair off the garment as well as off of the model's face and neck. The ribbon adds just a touch of color and femininity. The makeup base should be light and rouge should be faint. The lipstick can be cherry red to match the red of the blouse and the eyelids should be lightly colored. You will be expected to sit on the floor and to try out different poses that would show off the clothing and be appropriate at the same time. I suggest that you lean back on your elbows and at the same time twist your torso a tiny bit to the camera so you will actually be balanced up on your hip. This can be done by pushing your hips forward, or by holding your whole body more in profile. The top of the torso should be also at an angle to the camera. As a result, you will have one free leg and one free arm to move around. You can pick both knees up from the ground at the same time, or just pick one leg up to form a different shape. I suggest that you do several photographs with your free arm hidden completely behind your torso to keep the back line very clean. Also, if you do use your arm, move it up by your head or extend it the length of your body over your torso line, keeping it more toward the back than to the front. Your expressions should be cheerful and happy. Don't squint when you smile.

Do push your top leg back further than the bottom knee and make sure your spine is curved when you are sitting up. Place one arm on the side of your torso and, with the other one, reach out to the side with your hand flat on your thigh. The model's neck in this photograph is elegant and the expression on her face is appropriate.

Don't bring your arm up to the side of your head—it detracts from your face and is not graceful looking. Your back should be curved and your posture more relaxed. Keep the ball to the side of your skirt.

Do rotate on your hip, with your weight on your hips and arm. Let your top leg hold up its own weight so it doesn't sit too heavy on the bottom leg. The design the model is making is excellent—it's done with ease. The attitude of her neck and face is very pretty.

Don't gesture with your hand toward your collar—this is awkward and doesn't look natural. This model's bottom hand should be turned with her palm up and her expression should be brighter.

Advice to the Photographer

If you are shooting with color film, pick a backdrop color that will complement the outfit the model is wearing and will also be flattering to her skin tones. The props used in this shooting are a ball and a tennis net, so be sure to pull the net taut to add a different and more interesting effect. Position the model four inches in front of the net. Center her perfectly in the frame, from her lower knee up, leaving a couple of inches of space on the other side of the model. I would not include the whole figure in the photograph because it's more interesting to see the clothes up close.

Ask the model to lie down in profile to the camera and then to come up and rest on her elbows. Shoot some shots like this with her head in profile and then turned three-quarters and full front to the camera. Her neck should be long and elegant. Ask her to vary her back leg positions by lifting it up higher than her front leg, then by putting her front leg up higher than the back, and then by crossing her legs at the knees. Ask her to vary her arm angles by bringing her hand to her face in a normal position or by lifting her head up very, very high and then bringing her hand to her face. The camera-to-subject angle is high camera to low model. Place your camera on a tripod so you can get the same image in each shot—once it's set, you won't have to look through the viewfinder while directing the model.

This type of photograph takes a lot of direction and it should be sharply focused, with no motion. The most

Do rest on your outer arm, making your torso look long and elegant, as it should be. Pointing the bottom knee toward the camera gives a good graphic effect. In this photograph, the back arm lifted up to the head is in exactly the right position; it's neither too low by the neck nor so high that you see the hands. The hand coming up from underneath, holding the ball, is also very well placed.

Don't gaze too low, holding too much tension in your neck. The arm on the model's hip is positioned awkwardly: her elbow is pointing upward and her hand doesn't look graceful.

important thing to watch for is that the torso is turned enough to the camera to make the photograph interesting and that the clothes are falling in a neat, natural way.

Once the body position is set, work with the model's facial expressions, which are always an important part in styling a photograph.

Summary

The major problem in this shooting was getting the model to use her back arm in a simple manner, or not to use it at all. Simple poses sometimes are the most classic and the best. The model and I worked together to get her to project happy, high-energy facial expression.

The photograph below was chosen because the clothes are neat and stylish and because the model has rotated her hips to the front and put both knees together, which gives a very clean torso line. Her neck is long and elegant and I like the way her face is looking up toward the sky. The ball is held exactly in the right position and adds a little dot of color and glamour to the photograph.

Women's Junior Dress

In showing any type of catalog fashion, clothing should be highly visible. No lighting, props, or posing should compete with it. You would not use this type of approach for editorial or illustrative fashion because for those, you want to tell more of a story.

The model used should photograph young. In a final print she should look between 15 and 19, although she may in fact be older. Height requirements are 5'7" to 5'9". Waist and hips should be narrow and bust not excessive, so her figure should be slim. She should have clear skin because the base makeup used for this type of shot is usually liquid so it will appear natural. Rouge and eye makeup should be kept to a minimum and her short to shoulder length hair should be well cared for. Her smile should be pretty and her teeth white.

Do assume a wide stance and leave a substantial amount of space between your feet. The effect you're trying to achieve here is a good graphic pose with a straight spine. In this photograph, the model is keeping her hip out to the side, she's breaking at the elbow, her fingers are long and feminine, and the hand coming out to her head isn't covering her forehead or actually going through her hair.

Don't lean heavily. Hold your own weight and fake the lean. The model here is leaning too hard, which makes her elbow lock and tightens her hand; this, in turn, pulls the fabric of the dress down. The model has her hand in front of her forehead, with the palm open, which is unattractive and distracts from her face.

Do break at the knee; this pushes the hip out to the opposite side. The model's shoulders are flat to the camera here, which is very interesting and is acceptable with this type of dress. Her elbows are out to the side in a perfect graphic pose.

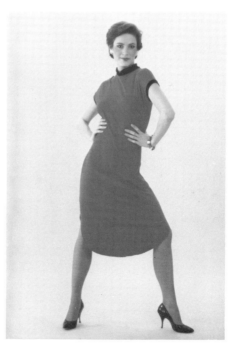

Don't twist too much; this will bring your front elbow too far forward to the camera, enlarging your front arm, and your back elbow too far away, foreshortening your back arm.

Advice to the Model

Catalog technique is used to show off every feature of the clothing so take a direct stance with your legs about two feet apart so you have a firm foundation. Point your right toe at the camera, hiding the heel, and don't lock your knees. Then place your left toe exactly opposite the heel of the right foot, also pointing it to the camera and holding all your weight on your right foot. If you bend both knees slightly, you will be able to push your hip to the side more readily to make a shape. That's your basic foundation. Your arm, hand, and head variations are demonstrated in the photos you see here. Use your arms and hands at the upper thigh to chest level and make different shapes to the sides of your body. Occasionally bring one elbow back and one shoulder forward, if this feels natural, and slightly bend your wrist. Keep your fingers flat and together, and pointing upward to give the effect of a smaller waist. Keep the sides of the hands narrow to the camera. Your neck should be elongated, your shoulders dropped. Now vary the head angles and project sweet facial expressions. Turn your face to the side only as far as comfortable and don't feel or show strain. Move very slowly, always controlled but relaxed. Be graceful. Let your movements flow. Be sure your dress is smooth and flat and that you're not pressing your hand down hard on it. Your garments will show you if your stance is too wide, so adjust it if your dress is stretching too much. The clothes should always dictate the pose.

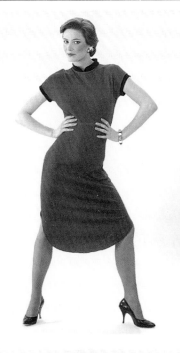

Do pick your shoulders up a tiny bit because this adds more shape and interest to the pose. The model's head is turned slightly away from the camera so you can catch the outline of her lovely jawline. Her hands are positioned slightly above her waist, which is perfectly acceptable in a sheath dress. Her fingers are interesting looking because they are a bit separated.

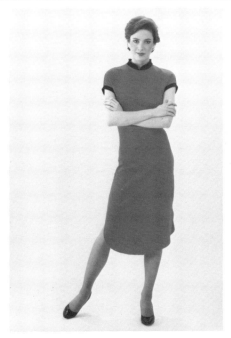

Don't cover your dress with your arms; this is not good photo posing because the client likes to see the merchandise. Also use your legs enough to make an interesting shape—here the model doesn't.

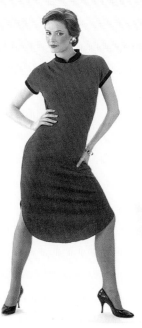

Do position both elbows straight off to the sides, which is perfect posing for a two-dimensional framework. For variety, instead of keeping your fingers to the camera, reverse your hand pose so the thumb on your thigh points toward the camera, which will automatically raise your shoulder on that side. This model's uppper arm is pushed slightly toward the back, which is excellent.

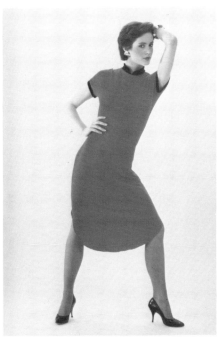

Don't bring your hand up to your head and bring it out to the side rather than to the front of the camera.

Advice to the Photographer

Use a color seamless backdrop that has good contrast to the garment. The most difficult set in which to pose a model is on a seamless with no props. This will come up often, so it's important to learn how to handle it properly. The one direction you should get across to the model to enhance movements is that she should be extremely slow in changing any position and should move only one area of her body at a time. Tell her to "freeze" when you see what you like and direct the small corrections from there because you want every detail in the dress to show. The model should be perfectly balanced in the frame—exactly in the center, with a little more room at the top of the frame than under her feet (but don't cut these off).

Be sure that the model is making an interesting shape with her body and doesn't bend too far back or too far forward, but that she keeps her hips to camera center. If her hips are larger than 36 inches, I would suggest you have her angle them slightly away from the camera since this will slim down her hips and waist. Work her arms to the sides—not in front of the dress or over her head. Do not allow her to throw her arms too far back (this causes foreshortening) or too close to camera front (this causes enlarging). She should smile and her expressions should be sweet and friendly.

The grooming preparation is simple. Direct the makeup artist and hairstylist (or the model herself) to keep the hairstyle simple and with clean lines, her makeup soft and natural looking.

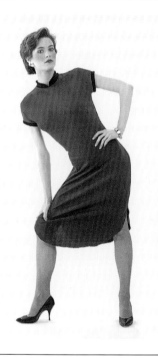

Do lean over and rest one arm on your knee, keeping your thumb to the camera. Point the fingers of the other hand to the camera. This adds more interest to the photograph.

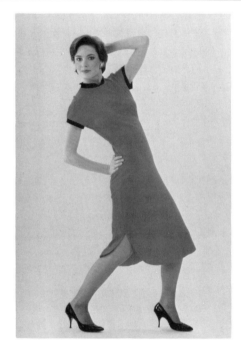

Don't bend back too far. This model has and the pose makes her look awkward. She has turned her torso to the camera so her upper arm and shoulder also look awkward. Keep your poses simple.

Summary

It was a joy working with a model that took directions so well and moved with grace from one pose to the next. The only problem was getting her to be aware not to actually lean on the garment because this would leave wrinkles that would be seen in the photos. The model quickly caught on to making shapes with her hips, so there's a constant shape to the form. To add more interest to that, she worked her arms in a graphic design, always off to the side of her body, not to the back or front. So it was just a matter of accentuating her pose.

This photo (opposite page) was selected as the best one because it has a graphic perfection: the lighting is balanced and the model comes across as strong yet relaxed at the same time. The use of the arms and hands in relation to the feet and legs is perfectly balanced as well, and the model's gentle facial expressions and neatness add to the overall effect.

Loungewear

This chapter shows loungewear, photographed for advertising brochures, fashion magazines, or newspapers, in a relaxed, editorial manner. This technique is not appropriate, however, for catalogs or strict illustrative modeling. The main aim of the shooting is to photograph the model relaxed in a natural environment that's associated with the garment she's wearing and to show the garment in such a way that it will be appealing to the buyer.

The most appropriate model for this technique is in the age range of 18 to 35. Height should be the standard model size—which is 5′7″ to 5′10½″—because the clothes used are made for sample sizes models and would fit a size 6, 8, or 10 model best. Her weight should be between 105 and 125 pounds. It's all right if the model looks a little plump—she doesn't have to be very, very slim, as this one is. The model should be pretty and have good hair and nails.

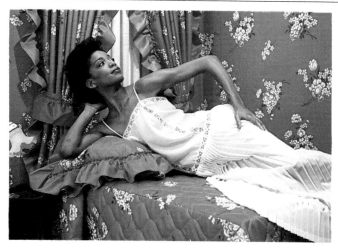

Do rotate your hips to the camera and your shoulders so that the gown can be easily seen. Keep your arm up to your head and use your arm at different angles to make the photograph more interesting.

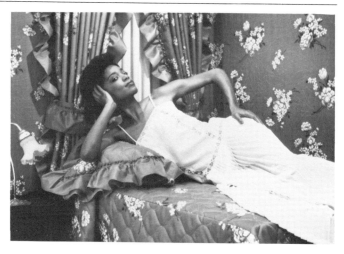

Don't position your head in such a way that it looks strained. This model looks like she's trying to peek over her nose to camera front. The arm on her hip is fine, but the other arm is pointed too directly at the camera.

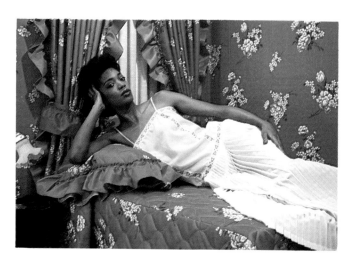

Do turn the top of your torso and your shoulders to the camera; your hips will follow. Leaning on your hand is pretty in this particular photograph.

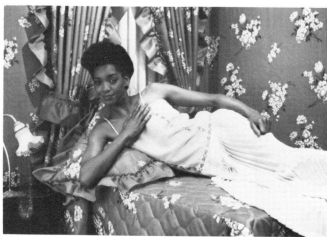

Don't bring your hand up to your chest. Also, in this photograph, the arm that's running along the model's hip isn't relaxed enough and the hand is closed. Open the fingers.

Advice to the Model

When you arrive at the studio, you're expected to try on the gown and model it for the hairdresser and makeup artist so they can get an idea of what would be the appropriate hairstyle and makeup to apply (in the event that you can't try it on, you should simply show it to them). If there is no makeup or hair artist or stylist to dress you, you should always take a look yourself so you know the correct makeup to apply and the kind of hairstyle to furnish. In this case, since the focus is on loungewear, hair should be casual but neat. Makeup should be pretty but minimal.

The necessary pose requires you to lounge, so lower yourself very slowly and very gracefully into position and check to see that the folds of the gown are falling in a soft, natural manner. Rotate up on your hip so that the clothes can be seen. Don't use your arms or your hands in any way that would distract from the design. You will have to use some energy to hold your head up, even if you are leaning on your arm, and especially if you're not. You shouldn't actually be lying down flat. Your expression should be soft and dreamy.

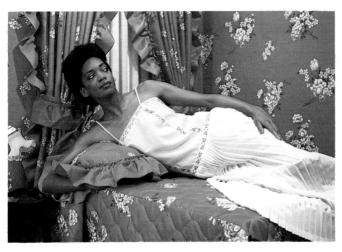

Do arrange your gown elegantly once you are into the pose. Here the model is holding her head up and has placed one hand under the pillow. Her other arm is following the line of her hips in a very feminine and pretty way.

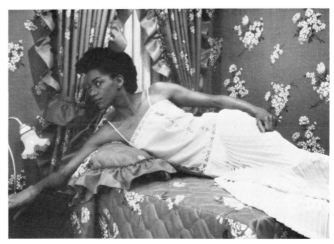

Don't reach out to the table with a flat hand and open fingers while keeping your other hand closed in a fist. The model here is staring too far off into the distance.

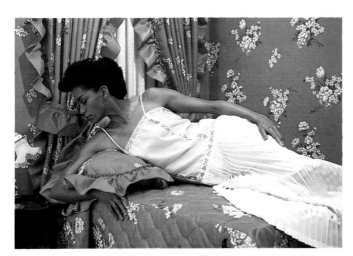

Do assume a natural pose on the bed. Your arm should run along the curve of your hip, but don't push it out too far to the front of the hip. In this photo, the model's arm is caressing the side of the bed and her fingers are nice and elegant. She is projecting a lovely profile.

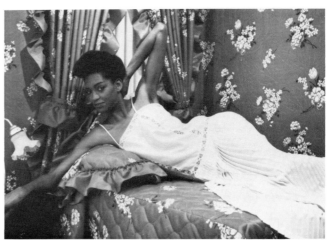

Don't drop your chin too low, and don't put too much strain on your neck. This model's reach isn't good because her fingers drop off to the side of the table. And the elbow at the side of the neck is a little too stiff.

Advice to the Photographer

Choose a location that has color and design contrast to the gown that you're showing. Opposing or complementary colors are flattering. If you're shooting on location in an interior, call ahead to make sure your time is confirmed. Always specify how long you will take, exaggerating a little bit because shooting sessions usually go longer than you expect.

At the beginning of the shooting, direct the model to lie down on the bed in a very gentle manner so that the gown falls in a very graceful way. You can have the model adjust her torso as she rotates over on her hips. You or your assistant should adjust the lower part of the gown and see that the pleats look neat because the model can't reach that area. After the model is in position, direct her to put her arm partially under the pillow; at other times, to lean on her arm; or not to use her arm at all, simply to hold her head up with her own neck strength. The other arm looks best when it is softly following the curvaceous line of her figure. Her hands should be feminine and narrow to the camera, fingers together. The expression should be moody and dreamy. In this particular situation, she can close her eyes occasionally and lift her head back.

In shootings such as this one, it is important that the proportions of the model in relation to the set and to the camera be well balanced. So be sure you direct your model into the right position even if you have to move her several times.

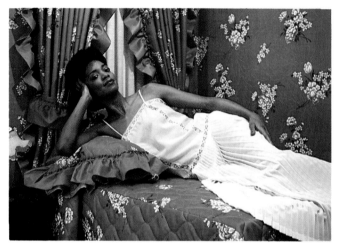

Do look relaxed and elegant. Camera angles of both arms and hands are excellent in this photograph.

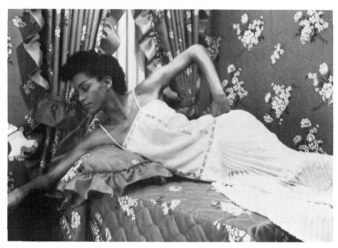

Don't bend your hand and wrist toward your arm, or your wrist toward the camera. This is very awkward looking and should never be done.

Summary

The major problem encountered in this shooting was getting the lighting balanced so that there would be no shadows on the clothing. However, if you want to have some shadows on the model's face because it would add a different moody effect, do so. The other major problem was getting the model and the gown to fall in perfect proportions to the framework she was working in as well as to her body-to-camera angle. This was solved by trying different positions with the model's cooperation.

The photograph below was chosen because the gown is seen clearly, the lighting was evenly balanced, the model looks comfortable, and the graphic way she uses her arms, neck, and face is elegant.

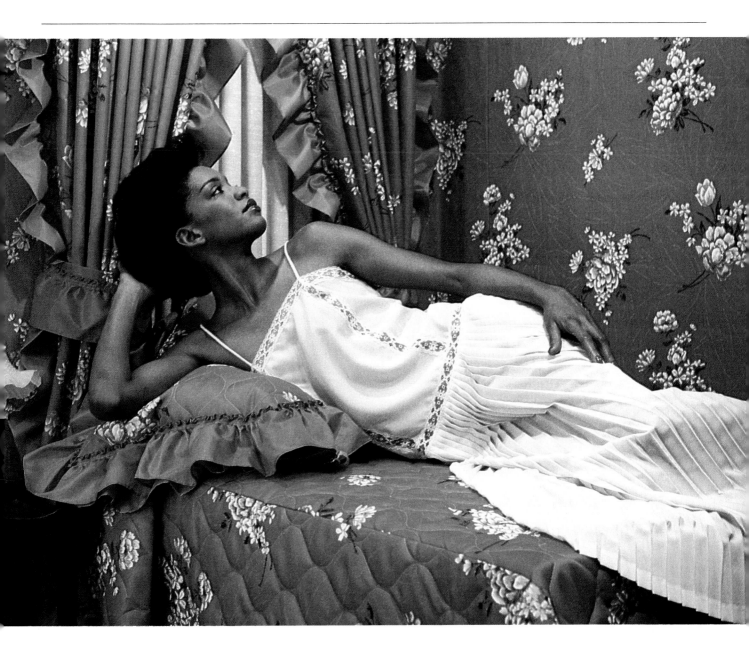

Full-length Doubles

Illustrated advertising is very different from commercial advertising, editorial, fashion, or straight advertising because it shows the model in an unmanipulated, natural situation. Usually copy is run with it, not to advertise a suit or a wine, but to get across a concept—having a good time, in this case. The main aim is to create a stylized, and at the same time real, moment. The models most appropriate for this technique are within the same height range; 5'6" to 5'7" is good. The woman should be between 23 to 30 and the man can be from 35 to 50. Both models should be slim. The female model's hair isn't important since it does not show, but the male's hair should be thick and very well groomed.

Do strive for a well-balanced photograph, but keep the center of focus on the pedestal. The models here are separated enough and are creating an interesting design. You get a feeling here that the models are relaxed and genuinely having a good time.

Don't be so exuberant that you bring your hands too far to camera front. As you can see in this photograph, this makes the shoulders appear smaller and the hips much broader. And the female model is holding her glass too close to the black so it has nearly disappeared.

Do react to each other realistically. In this photo, the glasses are held well and you can see that each model is really aware of what the other one is doing.

Don't look like you're posing. Here the female model has thrown her eyes out of frame and she's too much into a pose. The tops of both models' bodies are too close together. The male's pose is basically good, but he's throwing his arms too far out of frame.

Advice to the Model

The style of posing expected for this type of shooting is very different from those used in nearly any other category of modeling. Rather than posing and seeing that your body is classically positioned or that every piece of clothing looks absolutely perfect, it's very important here that you project a mood: the idea is to get your body into a good graphic balance in relation to your prop and to the other model, and to convey a communication with the other model. If you take turns talking and really react with body language in a very slow, sensuous way, the expressions, the angles of the body, and the mood will come automatically. You can vary your poses a bit by separating much more, leaning on the pedestal, for exam-ple; or the male model's shoulder can be angled to the female's middle chest (he still has to have his head turned around looking at her). But don't stand back to back because that's not a believable situation. You should actually pretend that you're at a party—make up fantasies to talk about and react to those.

Clothes should be pressed and neat. The shirts should be crisp and the model's grooming should be very elegant. The emphasis of the female model's makeup should be on her eyes, and her mouth should be cherry red so it really stands out in a black-and-white photograph. The male model should use pancake makeup on his face and neck area to even out his skin tones.

Do act out a scene when posing. Here you can plainly see that the female model is flirting with the male and he's listening intently while sipping his wine. This is very charming and good for illustrative modeling.

Don't forget your posture. Here the female model's spine is curved and her chin is down too low into the wine glass. She makes the man look a little bewildered. This is not good photo posing. Keep your pictures exciting looking.

Do leave an appropriate amount of space between each other. In this photograph, holding one glass down and one glass up adds to the separation.

Don't lose track of each other. Here, the models aren't interacting with each other. The male model looks like he's posing and bored and he's staring off into space. The female is adjusting her clothes. She has lost her neckline and has lowered her face too far forward.

Advice to the Photographer

Choose a location appropriate for a party setting—a settee, or a settee with flowers, or a pedestal with flowers on it, such as the one shown here, or a bar. Do not try for any special effects with your lighting here. Take some Polaroid tests, positioning the models at different stations; show them the test so they can see which way is appropriate for them to turn their faces to the light and away from the light and how well they're balanced in the center. When considering the subject to camera angle, it's a good idea to have the camera on a tripod that's aimed at the models' chests. The models must be still in their actual poses, so you should direct them to move very slowly—everything they do should be held for at least a count of five seconds. Tell the models that you want them to work with the separation between their bodies so they can both bend forward or so the man can angle his shoulder around to the woman. Another direction would be to have both standing in profile to the camera while they're toasting. Ask them to use their glasses in a realistic manner and not to do the same thing at the same time. In a shooting such as this it is very important for you to watch closely that the models have natural expressions on their faces. The way to get this is to ask them to actually talk to each other: one should talk while the other reacts with body language and a facial expression. They should take turns doing this. To help them out, you can relate any kind of story, ask any question, get any kind of conversation going —what you want to do is create the natural moment.

Do be aware of each other. Here the female model is advancing a little toward the male and he's reacting to this. Again, there's a separation between the glasses and between the heads.

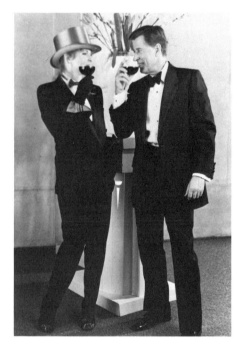

Don't cover your face with your props. In this photograph, the female model has brought the wine glass up too high and is covering her chin and her mouth. The male model has brought his back shoulder a little too far forward, dropped it a bit, and brought it too far camera front so it makes the front of his jacket open too much.

Summary

The major problems encountered in this session were getting the models to take turns holding conversations, to not overreact, and to move very slowly and hold each pose for a few seconds. The latter was solved by asking them to slow down so many times that they really finally understood what was required.

This is the best photograph (opposite page) because the models are truly relating in their facial expressions. Their shoulders are relaxed, they are properly angled to the camera, and the glasses are in clear view but not lost against the blackness of the suit nor hiding their faces. The man's hand is elegant as are the angles of the legs. The model's proportion in relation to the pedestal is good and they are neither too close nor too far apart.

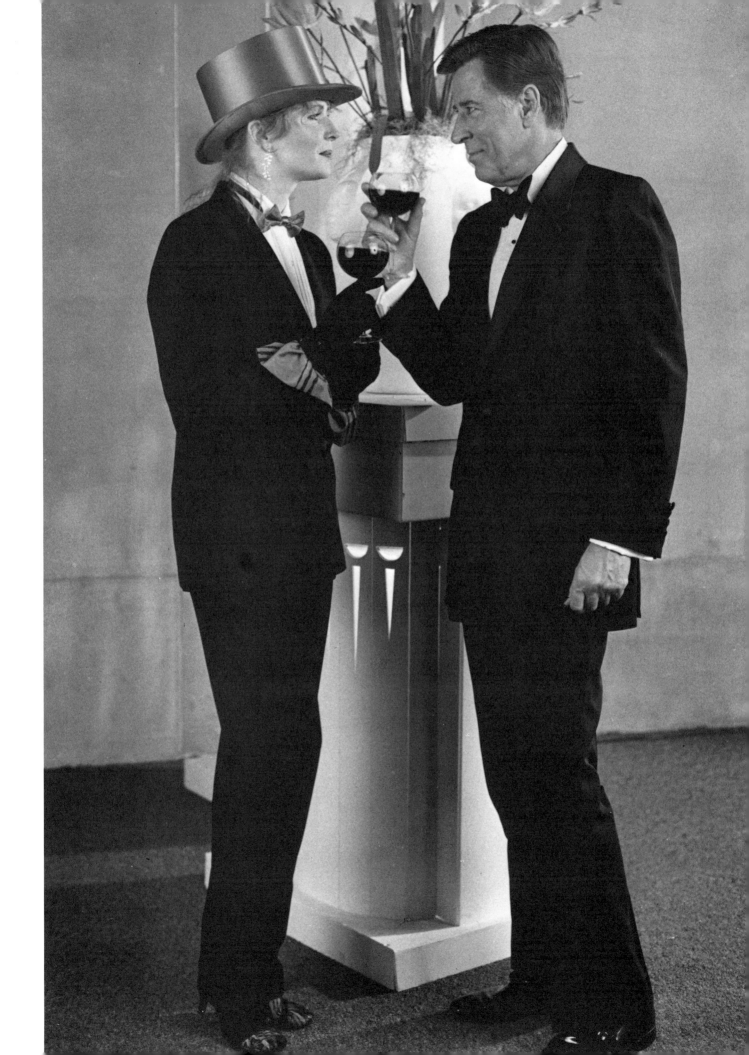

Women's Junior Dresses

There comes a time when a photographer is asked to use two models together on a seamless backdrop and the first thing he or she should ask is: "How can I get two models to relate to each other and look good together at the same second?" Your object in this catalog advertising technique is to show the clothes and, at the same time, to keep the girls looking natural, playing to the camera, and relating to one another.

The models should be between 18 and 21 years old.

Both should be within two inches of each other or exactly the same height; 5'7" to 5'10" is a good choice. Their looks should be complementary—either both sweet or both classical looking. I chose different color hair for the photographic difference. Hair, makeup, skin, and teeth should be healthy and fresh looking. Keep the clothes highly visible; even if you're using small props to add interest, but by no means use anything that will distract from or compete with them.

Do complement each other when you're working doubles. One model can take a definite stance and attitude, and then the other model can fit her stance and attitude to the first model's. Do vary the position of the feet and the attitudes of the body. Props should enhance the photograph, not hide the clothes. Use them in an area where there is no specific detail in the dress.

Don't stand with your knees or feet so close together that there is no separation. The model on the left is an example of "do" and the model on the right is an example of "don't." Placing one arm around the other model's shoulder is good if you hold your own body weight and drop it down a little lower so it doesn't interfere with the other model's line.

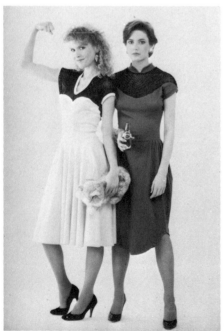

Do vary your stances, but make sure they relate to each other. Here, both dresses are clearly seen, and there's humor in the photograph.

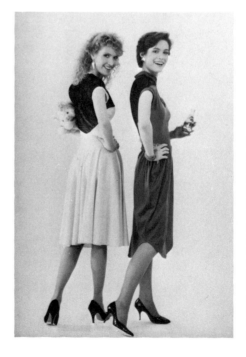

Don't point your shoulder and arm directly at the camera, as the model in the pink dress has; this foreshortens the arm and makes the shoulder look very large. The shoulder should be pushed off to the side. The model in the green has turned so far profile to the camera that the detail on her clothing can't be seen.

Advice to the Model

This technique is used to clearly show mail-order buyers how the clothes look so they must see precisely what they are buying. Your job as the model is to see that no matter what pose you take, you don't hide the dress behind the other model or make the clothes look distorted. So positioning yourself in relation to your partner is as important as correct posture. Start by placing your feet in a natural or a good graphic pose about a foot apart. Don't take the same position as your partner does because, photographically, that looks boring. Don't stand so close that you cover up her dress or so far apart that you don't look like you're together or relating. If her hips are flat on, turn yours narrow to the camera. You should be aware at all times of what your partner is doing with all of her limbs and make shapes that complement and make connections with what she is doing. The photographer will set the mood. Be sure that your clothes are not wrinkled or sloppy looking. Check them quickly, get into the mood, and always keep your composure. Keep your hair and makeup simple and light.

Do relate to each other through body language. Also, you should change the position of only one arm, leg, or shoulder at a time.

Don't stand off balance. Both models here have moved too much and have actually stepped out of the main working area. One model has pulled the other model over, so one foot is coming off the ground.

Do make sure that your arms are varied and that they are both telling a different story. Here, the models' body contact is in perfect proportion and both are showing their dresses well to the camera.

Don't just stand there—pay attention to your fixed stance. The model in the green has relaxed one leg too much, which distorts the skirt of the dress. The model in the pink dress is stepping back too far, which makes her arm look out of proportion.

Advice to the Photographer

Before you decide on the photographic attitude, consult the art director. See if he or she has any composite sketches or preferences for location and lighting to find out exactly what is needed and where this material will appear. If advertising type is to be placed on the photograph, be sure that you are aware of that too, because you will have to make extra allowance for space; if it isn't, center your models in the frame. Don't crop off the feet or the head in the frames.

Lighting can be either studio lights or strobe, or a combination of both. Avoid harsh shadow on the models' faces and place them exactly in the right spot. A camera-to-chest angle is preferable. Take as many Polaroids as you need, changing the light until you get the desired results. Set the camera on a tripod so every frame will be uniform. You'll be less distracted and will be able to devote your attention to your models. Choose a color seamless backdrop that is best suited to your client's needs. Tape the bottom of the models' shoes (only if they have been used) so you won't get any dirt on the seamless. Make sure the clothes are pressed.

Do be sure the models aren't too close together or too far apart. They can be touching or nearly touching, sometime at the hips or only at the shoulders. If you particularly like one model's pose, have her hold it for ten frames while you work with the other model's changes.

Do project humor from time to time when posing. The models in this photograph do, but their arms and hands still look elegant.

Don't stand so far away from each other that you leave a big gap. Keep the contact very close. You should relate to each other when posing—through your expressions and/or through actual physical movements.

Summary

It was fun to photograph and direct these young girls together, although it took constant coaching to help them perform in the same mood and theme at the same second. The main problem was to get them to work in a balanced proximity to each other—neither too close nor too far away—and at the same time to tell a story with their gestures, relating to each other and the camera as well in each photo. This was solved by posing one model, correcting the pose while she held it, then directing the other model to move around her.

The photograph on the opposite page is terrific because it projects warmth, joy, and friendliness and at the same time shows the clothes off well. The body angles are well proportioned and in correct relation to individual movements and to each other. The models have wonderful facial expressions, a sense of style and humor, and very importantly, a sense of timing coordinated to each other's movements and to the camera. Finally, the clothing looks neat and falls gracefully.

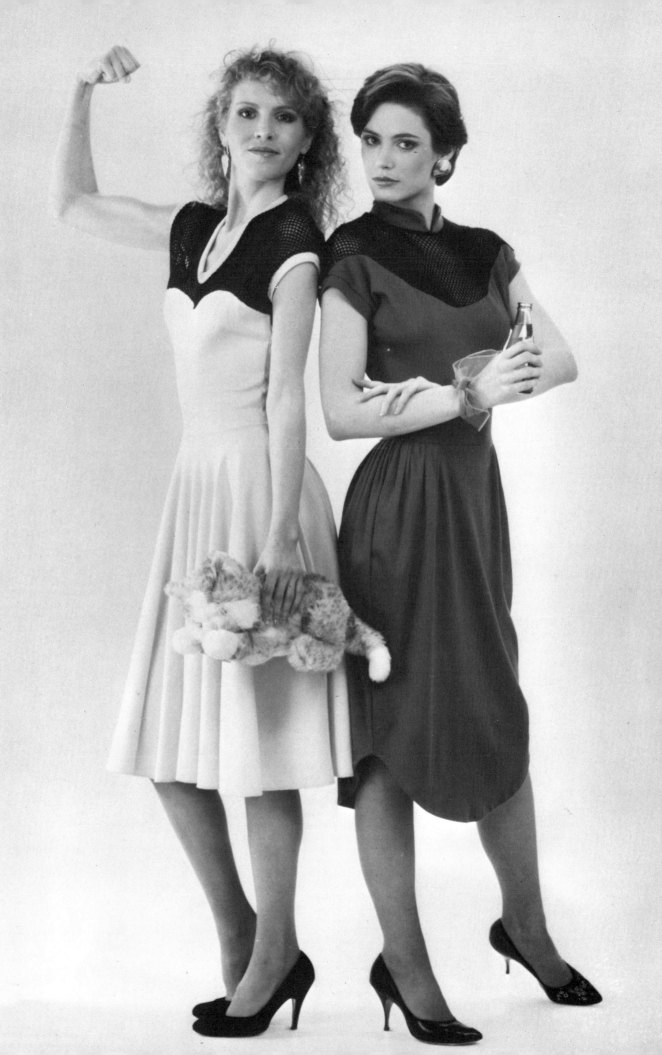

Boys' Junior Sweaters

Photographing doubles is a challenge. Graphically, you must see the outline of two bodies as if they were one. And since the sweaters in the ad will be purchased by mail, the buyer needs to see plenty of detail.

Models should be chosen to fit the junior category, so they should be from 16 to 20 years old. However, both should look about the same age and have the same style.

Their height should range from 5'8" to 6 feet (again, they should be about the same size), and they should have thin to medium figures, clear skin, and good haircuts. These models *must* have attractive teeth because juniors are usually asked to smile. Showing models with little or no experience some photos from other catalogs will help them understand what is expected of them.

Do position yourself correctly in relation to each other. Here, the model in the back is perfectly positioned in back of the front model. The arms and hands of both models are similar and show good photo posing. The model in front has crossed his arms over the sweater but, both hands are showing.

Don't tense your body too much. The model in the back is doing this on his right side. His shoulder is up too high and he's leaning a little too far toward the center so his posture isn't erect enough to make the sweater look neat. The model is in the front has collapsed his chest a bit, which doesn't show the sweater off to its best advantage, and he's grasping his arm, which doesn't make for a relaxed picture.

Do vary your poses. The model in the back has his left shoulder slightly higher than his right one, which adds movement and interest to the picture. Both models use their hands differently and their heads are touching slightly, which is correct as long as the hair of one model isn't covering up the forehead of the other model.

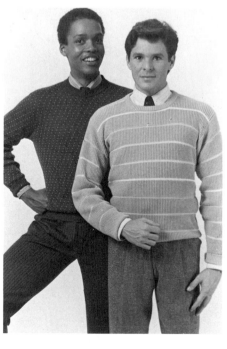

Don't tense your hands. Make a fist and turn it toward the camera. The arm of the model in front is also dropped too low. It would be better if it was in the center of the body.

Advice to the Model

Your clothes should be perfectly pressed for a catalog ad. The poses should be kept simple and graphic. Don't hide your clothes by standing far behind the other model. Posture should be relaxed but very erect and shoulders should be pushed back to fill out the sweater. Even if you do have a dresser, check your own cuffs and seams. See that the collar fits properly and that the tie is centered. Sometimes a small amount of makeup is appropriate—a whitener under the eyes to smooth any discoloration and a powder to eliminate shine, for example. Hair should be trim and neat. The mood should be happy and pleasant, and your arms should be used to make a suitable shape and add interest to the sweater. After each move, check to see if the sweater still looks neat, and if it doesn't, rearrange it. You should establish a rapport with each other. One model will be the leader and move first, but you may take turns taking the lead. Once the main pose is set, the variations are obtained with changes in arm and head angles. Each model should do something slightly different to complement his partner's pose. Work very slowly and don't put your weight on your partner.

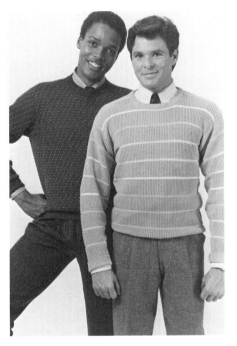

Do keep your shoulders down and relaxed, and your posture erect. Both these models are in good physical relationship to each other. The head of the model in the back is slightly turned toward the other model, which is excellent and projects a friendly feeling. Their hands and arms look very good and graphic and simple, and the hands of the model in the front are excellent because the fingers are closed.

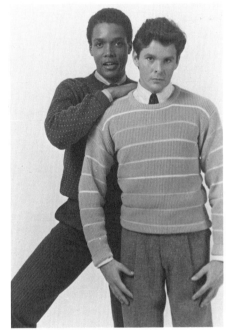

Don't stand too close to each other. The model in back is standing too close to the model in the front and is leaning his weight on him. He is also hiding too much of his sweater, which is bad merchandising.

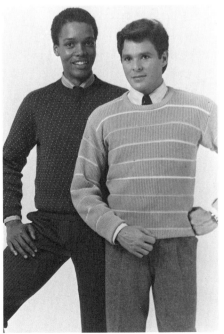

Do vary your hand and arm poses. The model in the back has his hands on his thigh for a change; he still looks relaxed and masculine. The hands of the model in front are in balanced relationship to each other. Both models look friendly and happy.

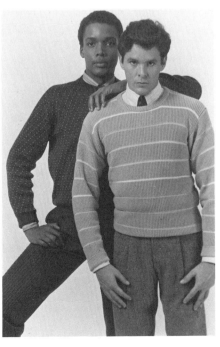

Don't allow one model to lean on the other model with his arm. It draws the eye to the shoulders rather than to the sweater. Place your hand so it doesn't look like it's coming out the neck of the model in the front. The model in back is holding his hand on his thigh, which is awkward. The model in the front has his left arm close to his body, while his right arm is too far away. Both expressions aren't lively enough.

Advice to the Photographer

Since the session is aimed at catalog advertising, its standards are much more rigid than in other types of advertising. The camera should be aimed at the subjects' chest and the lighting should be flat, with no shadows, since there should be no distraction from the garments. Do see that the details are very visible. Test with a Polaroid and change the lighting until you are completely satisfied.

While you are directing the models, pay strict attention to where you place them in relation to each other. Be sure that one model isn't standing too far behind the other. Models should be positioned so both sweaters are seen, showing half of one of the sweaters is acceptable because buyers can still see all they need to and photographic shape is more interesting. Direct each model to pose in a slightly different manner. Contrasting use of their arms lends more interest to the sweaters. The models should look cheerful, so make sure they both have similar expressions simultaneously.

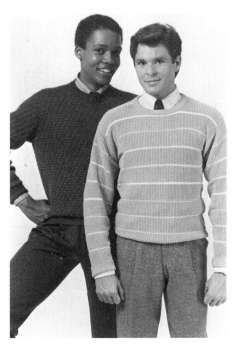

Do use your legs to make good graphic shapes. The model in the back has propped his leg up on a box and has it to the side. Both models look relaxed.

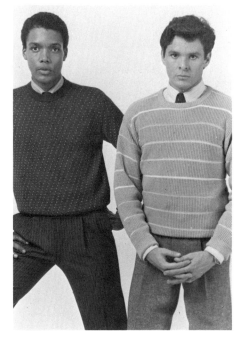

Don't work too far away from each other. Here, the models should come in so close that about a third of the sweater in the back is covered up. Both models look bewildered and the hands of the model in front are completely wrong—he's holding his fingers together, which is not interesting posing.

Summary

The major problem encountered was getting the models to look and stay relaxed yet at the same time to keep perfect posture, barely moving the torso. The problem was solved by telling them to take deep breaths and to exhale slowly. A walk around the studio during a break will also help the models relax. Both models' height was perfect for doubles. If they had been exactly the same height, the model in the back would have had his sweater, shoulder, tie, and neck blocked by the model in the front. The models were cooperative in projecting happy and pleasant expressions for the same picture and they caught on to the posing very quickly.

The photograph shown on the opposite page meets all the requirements. It has charm, a youthful happy attitude, the sweaters are highly visible, and detail is excellent due to the manner in which the models display them and to proper lighting. The hands are masculine-looking and there are no distractions.

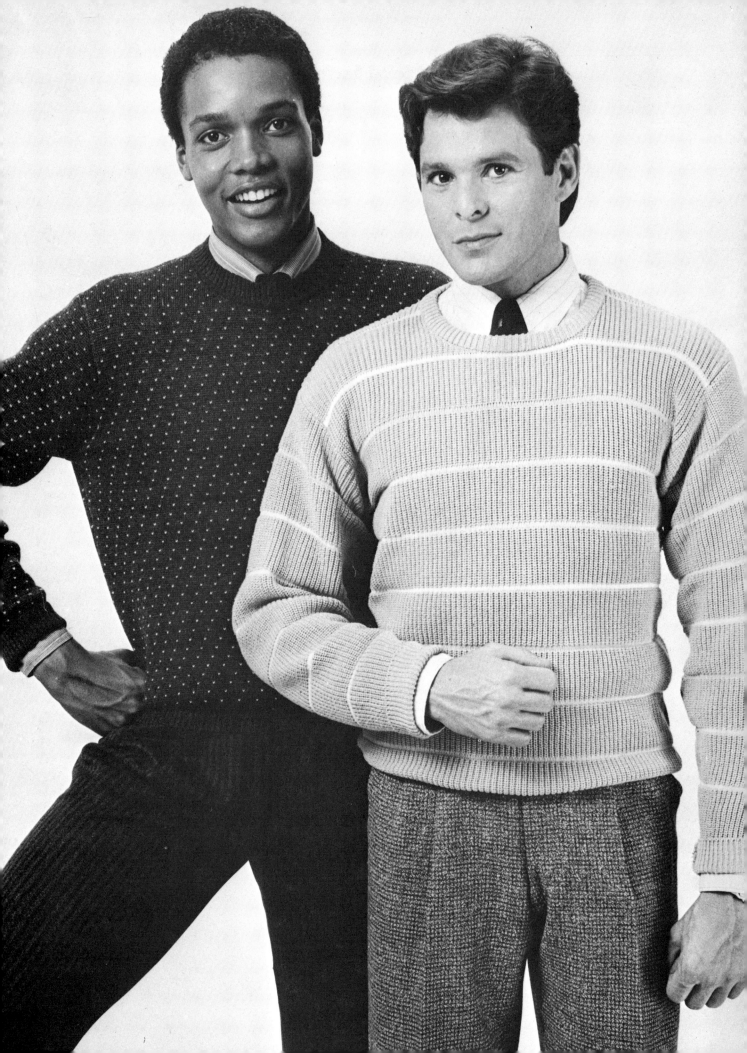

Men's Outerwear

A photographer would use this technique when shooting an editorial advertisement. This example shows two models who are posing as businessmen and the photograph would appear in the editorial section of a magazine. The main aim is to show the clothes in a natural way and in an appropriate setting.

The models most appropriate for this technique should be 5′8″ to 6′2″ tall. Their weight should be in good proportion to their height (healthy but trim) and they should be from 20 to 28 years old.

Do keep an appropriate separation between your bodies. Use your hands while you're talking and animate your expression. This is good photo posing.

Don't stand so close to each other that there is no separation. The model on the bench should keep his hands closed and should not slouch so much—this hides his jacket, not showing it to its best advantage. The model standing has lost one arm completely and looks like a doll standing and staring at the camera.

Do converse with each other about an appropriate topic—in this case, since the models are posing as businessmen, they should be talking about something that has to do with the business world.

Don't separate so much that you leave too wide a space and don't lock your knees, as the standing model has.

Advice to the Model

Take direction from the photographer. He or she will have you both standing, or both sitting, or one standing and one sitting. Choose a design that you think is interesting. Ask one model to sit and one to stand. Since you are portraying businessmen, you should pretend that you're having a meeting, discussing Wall Street stocks or buying a building, for example. You should actually be discussing something so that the photographer can get actual, natural reactions from your faces. It's up to you as models to project this kind of image, while at the same time maintaining good body posture, tall spines, long necks,

and relaxed demeanors, with your heads either three-quarter or in profile to the camera. Don't stand too close to each other because the separation makes it a much more interesting photograph. Also, don't project expressions that are too exuberant or wave your hands about. If you're the one holding the briefcase you should position it so it's obvious what it is. Don't play with your hair or touch each other during the shooting. The leather coats should be neat, so smooth them before the shooting. If it's a windy day, it's a good idea for you to carry a little can of hairspray to keep your hair in place.

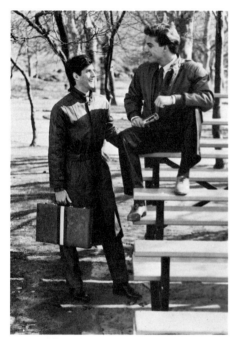

Do relate to each other. Here, the models are talking about something funny and are both laughing at the same time. Their stance is excellent, as is the separation of hands. Note that the model holding the briefcase has turned it at a good angle to the camera.

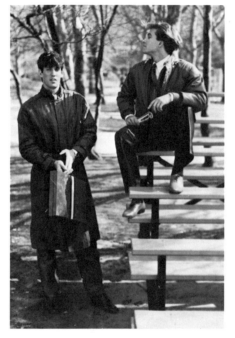

Don't change your briefcase from one hand to the other without asking the photographer if he or she thinks it would be appropriate—it would look very awkward if the photographer were to catch you while you were making the change. The model on the bench has picked his chin up too high; this makes him look stiff and shows tension in his hand.

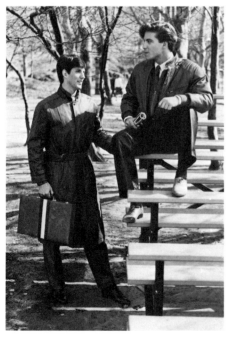

Do look relaxed when you're posing outside. Keep your spine tall and separate your feet. Talk about something that will keep your face animated.

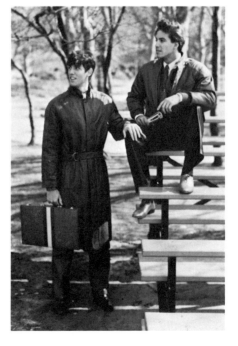

Don't both stare in the same direction because, even if you are touching, you don't look like you're relating to each other. Don't touch the other model in this particular situation and do look into each other's faces while you're talking. It's more believable

Advice to the Photographer

If you're shooting this on location, pick a natural environment like a park or woods and choose props appropriate to the young businessman (use bleachers and benches or a rock formation, for example, not slides or swings). Camera-to-subject angle should be medium height camera on a tripod to the middle of the model's solar plexus. There's no motion here and the picture should be sharp and clean and in focus. The model should be slightly off to one side of the frame since the bleachers used here dominate one part of the photograph. It's important to show that they are bleachers, so keep in mind that if you put them exactly in the center, you would cut too much of the sides off and it wouldn't be clear what they are. Ask one model to stand and one to sit. Be sure to keep a separation between them. Ask the standing model to gaze out into space, to use his hands while talking to the other model, to lift his face up, to angle his briefcase a little to the camera so you can see it is a briefcase (if he shows only the narrow part, it won't be clear what he's holding). The seated model should keep his hands and shoulders and arms off to the side of his body. Don't let him bring his arms around, cutting off the center of his solar plexus, because he'll hide the merchandise. Make sure that the models aren't just posing—they should be talking to each other the whole time they're working.

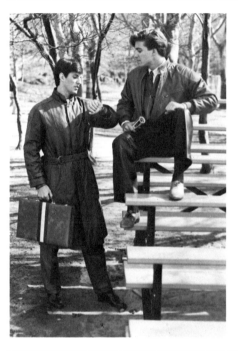

Do project expressions and use your props well. The model standing is looking at his watch, thinking "I have to go, I have another meeting." The other model looks concerned. The clothes are appropriately shown, as are the props. This is good photo posing.

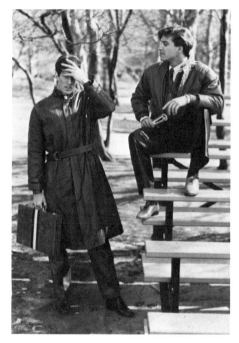

Don't fidget. If your hair is falling in your face or the sun is too strong in your eyes, ask the photographer for a break rather than change the position of your body. In this photograph, lifting the arm has brought the whole front of the coat around full face and this looks awkward. The model seated is showing tension in his hand.

Summary

The major problem encountered in this session was getting the models to appear naturally animated and this was solved by having them actually think up a fantasy and talk about it (if they run out of subjects, it's up to the photographer to introduce new ones). This photograph (see opposite page) was chosen as the best one because both models have good facial expressions. One model is contemplating what the other model is saying. The design is good. The sitting model has his legs at a different level, which makes the body shape more interesting. You can see both coats very clearly, but they don't jump out at you. Also the model with the briefcase is holding it in an area appropriate to his coat and to the shooting as a whole.

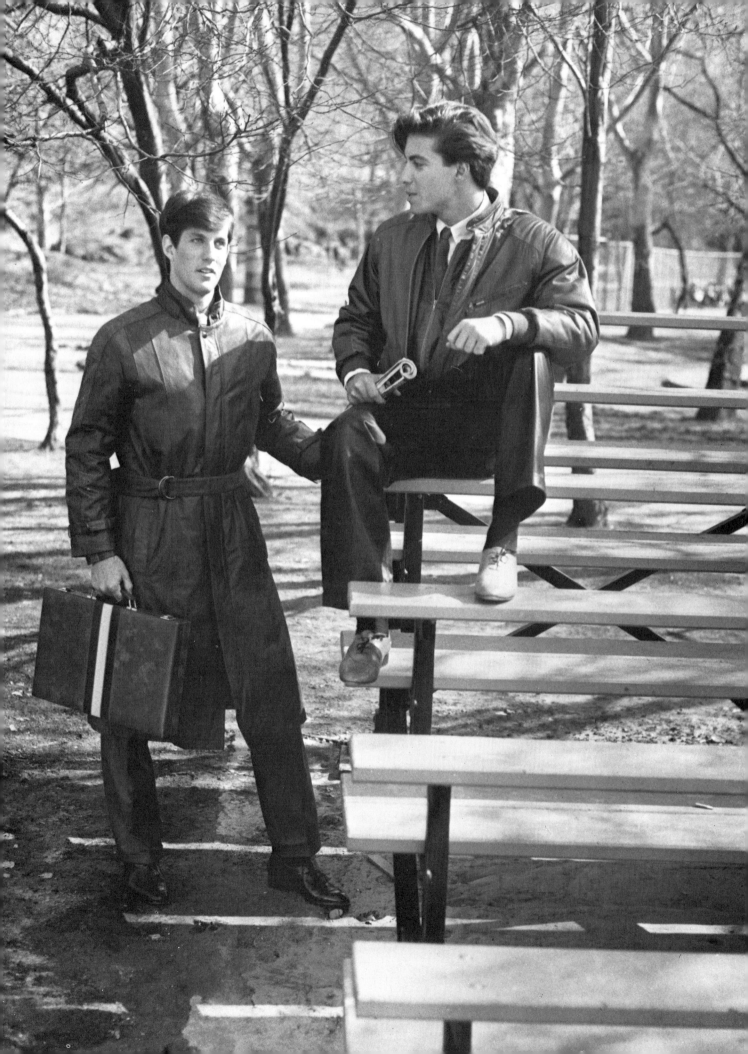

The Big Beauty

Clothes for women's sizes 14 to 28 are much in demand, so it follows that there is a need for women who can model these sizes. A photographer would use this technique for any dress advertisements or for editorial fashion photos featuring these larger sizes. The model appropri-ate for this technique is in an age range of 20 to 35. She should be 5'7" to 5'10" tall and her weight is usually between 175 and 250 pounds. Her skin should be beauti-ful and clear and her hair healthy.

Do take a firm stance, with only about a foot of sepa-ration between your feet. Put your weight on your back foot and just touch the toe lightly to the floor, turn your arch, and hide your heel. Practice in front of a mirror. Holding your hands on your waist gives a very good effect because it flatters the sleeves. Turn your face pro-file in this particular picture. Looking toward the light source is very good posing.

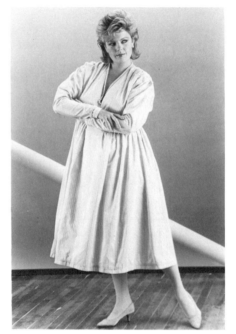

Don't cross your arms in front; this makes one shoulder drop lower than the other, which in turn makes one hip go out to the side fur-ther than the other.

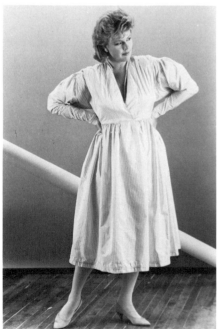

Do tilt your head to the side to add to the mood of the photograph. The model is putting her weight on one foot, the other foot is just touching the floor, and the heel is hid-den. Her hands are well placed on her waist.

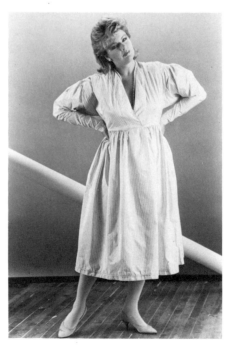

Don't bring your chin down too low or your eyes too far away from the cam-era. In this pose, too much of the top of your head will show if you do.

Advice to the Model

The appropriate posing for this technique is very simple and classic. Take a firm stance, usually with more weight on one foot than another, so you are free to arch your other foot, hiding the heel or even picking it up off the ground. This will automatically throw one hip off to the side a little more than the other, which helps shape your body form. You should vary your arm, hand, and head positions as well as gracefully rotate your whole torso slightly away from the camera. Also try working full front to the camera for a few frames. Holding your hands on your hips works well with the dress shown here because this displays the lovely sleeves.

Makeup should be simple, with more emphasis on the eyes. The hair should be well groomed and sprayed so it will stay in place. The dress should be completely ironed so that it is very neat. Use few accessories so as not to distract from the dress. Simple pearl beads and earrings work well here.

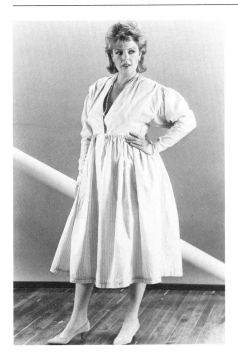

Do turn three-quarters away from the camera. Push one hip out to the side and place one hand on your waist, pointing up. This gives the illusion of a thinner waist and shows the features of the sleeve. The expression on the model's face is sensuous and that's interesting.

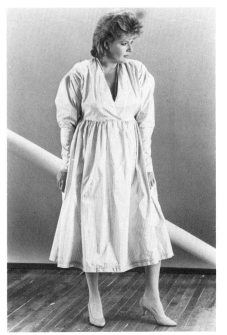

Don't lead with one knee brought up too high; this will lift your heel off the floor. Here the model is slouching slightly. She has brought her face and head too far forward to the camera and her head is too low.

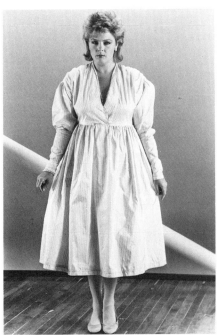

Do face the camera straight on in a very elegant pose, with your ankles together and one leg bent slightly. Keep your hands turned narrow to the camera.

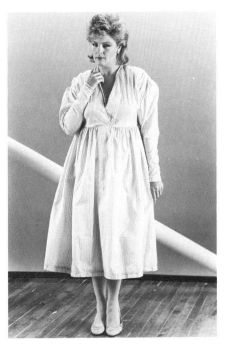

Don't relax your torso so much that you completely change the mood of the photograph. The photograph shown here doesn't have the feeling of elegance it could have had. Also, the model has brought her arms in too tightly to the torso, which makes them look enlarged.

Advice to the Photographer

Photograph this ad in the studio and use one simple prop to create a graphic design in the background. If your floor has a design of its own, it will enhance the photograph. Camera angle should be straight on to the model's hip area. These are not motion photographs, so advise the model to strike a basic pose and to hold it so that you can change the feeling by directing her arms and head. Center the model in the photograph, and ask her to work towards the front or off toward the main light source. Direct the model to take a firm stance, putting her weight on one foot so the other foot is free to angle in a classic design. Ask her to arch her foot and hold the heel up so that the heel is hidden behind the toe, which gives the shoe a good line. Tell her to use her arms off to the side with both hands on her waist at the same time, or one hand on her waist and the other one playing with the skirt of her dress in a very feminine manner. Also ask the model to vary her head and eye angles, mostly working toward the main light source. Finally, be sure that the model holds her chin up high enough so that you see a long, elegant neck.

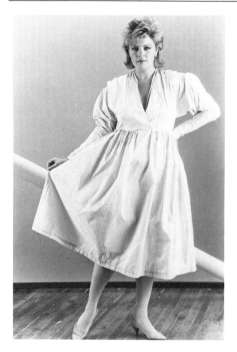

Do bend your back leg slightly and hold the weight of your body on it. Your other foot should be gently touching down and arched in such a way that your heel is hidden. The movement of the dress is very pretty in this photograph. The arm held up to the waist adds to the dimension of the photograph.

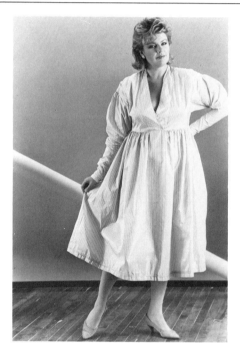

Don't pose with your chest not fully expanded. Bringing it up would add more strength to the body structure. The model should be more in the center of the photograph.

Summary

The major problem in this fashion shooting was getting the model to keep her chin up and getting her to vary her expression. This was handled by simply reminding the model to pick her chin up and directing her expressions by asking her to drop her jaw, smile with her mouth closed, wink at the camera, or look intensely into the lens.

The best picture (opposite page) is well balanced, has a charming directness, and the model looks lovely. The gesture of putting her hands on her waist shows the sleeves off.

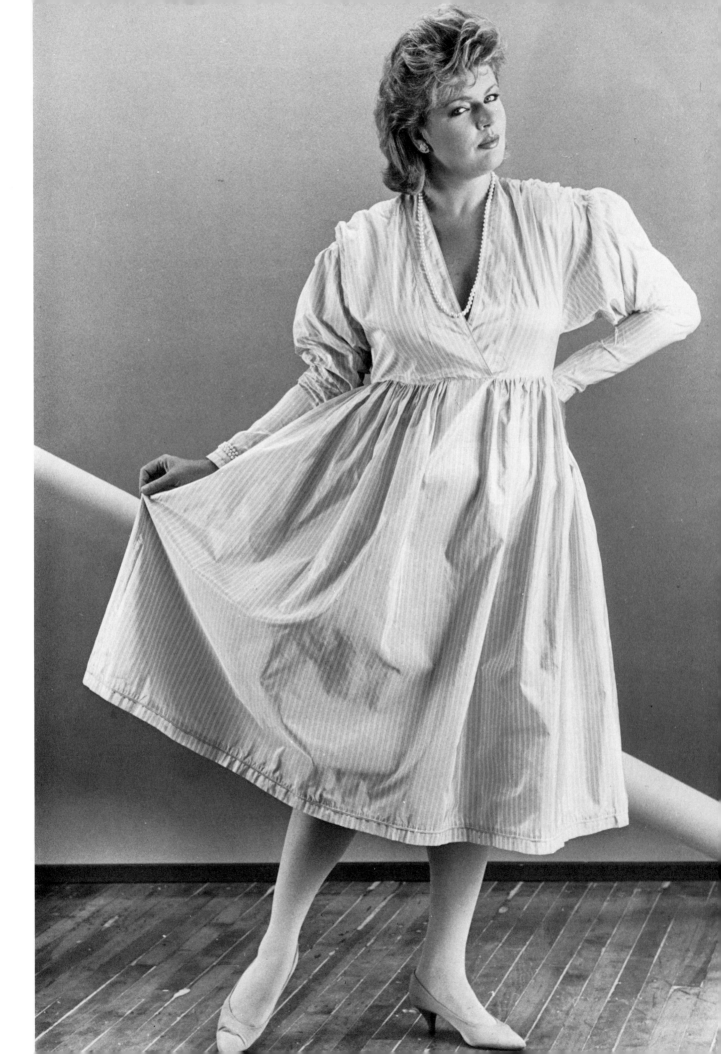

The Petite Woman

This technique is used to show the petite model in either editorial fashion or advertising photography. The main aim is to show the clothes off well within the confines of the design, so the model must be aware that she must work in a particular space only.

The model most appropriate for this technique is petite. However, she must be perfectly proportioned so that her lack of height does not show in the photograph. The model's height range is from 5′2″ to 5′5″, her size, 6 or 8 petite. Her weight is low, of course, in proportion to her height, and her figure should be slim-to-medium. She should have good nails and a clear complexion as well as healthy and well-cut and styled hair. The hair should not be longer than shoulder-length; otherwise it will distract from the model's height and proportions.

Do center yourself correctly for the desired effect. Keep the arm that's resting on the box some distance away from your torso so there is a separation between your clothing and your arms. Keep your knee angled out to the side. Projecting a smiling and an exciting expression is appropriate.

Don't point your knee at the camera because that enlarges it. Keep the arm that you're balancing on relaxed and don't lock your elbow. The model here should throw her head back in this particular pose to add more excitement.

Do balance on your toes, slightly twisting your torso to the camera so the back leg can be seen as well. Resting on your arms is acceptable in this particular photograph, but keep your hand flat on the box.

Don't bring both arms up together. It would be better to have one stretched out and one doing something entirely different. Don't cup your hands in a gripping motion; it's not feminine looking.

Advice to the Model

The only preparation that is needed in this case is that the clothes come from the designer packed correctly and are steamed if necessary. The makeup base, lipstick, and eye makeup can be medium to heavy, but the rouge should be applied lightly. The hair should be curled tightly before the makeup is applied and afterwards it should be teased and groomed.

The poses that are expected of the model are varied. I advise you to take a look at the area that you'll be working in and think of poses you feel would be graphic and would fit well into the space. The boxes used as props in these photographs are extremely lightweight and they can't be leaned on, so that's a limitation in this case. I would suggest that you assume a wide stance inside the empty space and twist your torso to the camera. That way you can use the boxes that are in the back by reaching out to touch them. Keep your hand narrow to the camera. After you work that pose, you could turn your side to the camera in the center of the open space and bring the other leg úp in an arched position, stretch one arm out, and use the other hand on your hip. But it's important to hold one leg out to keep the space filled. Try various poses, making exaggerated gestures with your body and arms. Make an effort to fill in the space with your poses.

Do balance in the center. Here, the outside leg, with toe touching down, adds to the shape of the photograph. Reaching out to both boxes adds to the design, and arching the hand on the box is good because it adds to the movement of the photograph.

Don't grasp your hip, as the model in this photograph is doing. Also, don't separate your thumb from your hand.

Do point your arms and elbows out to the sides. This model's stride is wide and her legs are flat to the camera. The twist of her torso displays the clothes well.

Don't forget that you're working on a two-dimensional plane and inadvertantly turn your elbow to the camera. Keep your elbow off to the side and don't lock your jaw.

Advice to the Photographer

Set all your boxes in the space before the model and client arrive in the studio. Check your lighting by shooting a Polaroid of anyone in the studio to see that it's correct, and adjust it as desired. No special effects are needed here, just good, balanced lighting. Shoot your picture from a slightly low-to-subject angle. The camera should be aimed at the model's solar plexus, and should be in sharp focus. No motion is necessary and you may vary the model's position within the format of the picture. She can be strictly on center or balanced from the center to the front or balanced from the side to the middle of the photograph. Ask the model to start by assuming a wide stance to fill out the empty space in the center, then ask her to rotate her shoulders and hips to the camera so you can see the garment. Now ask her to reach forward toward the boxes or use the space directly over them. She may actually bend forward at her waist or arch her back. Then move her into two other positions: keeping her feet together and body profile to the camera. While bending over, the model should use her arms over the box in front of her, but at the same time keep her body profile to the camera. You could also direct her to lean on the boxes behind her with her hand. Don't have her sit on the boxes, just lean on them, holding her actual body weight on the foot that's on the floor, and at the same time twisting the top of her body and her face to the camera so it can be easily seen. You must see that the model uses the space well and works basically in the center of the frame.

Do balance your arm on your knee, narrow to the camera, while holding your weight on the foot you're standing on. This is a good, creative pose.

Don't relax your leg too much while breaking at the knee. Here the model has brought her back knee up too high, which threw her torso off. She should have twisted around to camera front. Notice that by pushing back too far, she has taken her arm out of camera range.

Summary

The major problem in this shooting was getting all the graphics to work at the same time: not only getting the model to use the correct stance and to angle her torso to the camera, but getting her to use her arms in a way that would incorporate all the space and at the same time project and hold her wonderful expressions. This is not difficult to direct, but it took a lot of concentration on the model's part, so the photographer was constantly coaching. The photograph on the opposite page was chosen as the best one because the model is in an interesting graphic form in relation to the form of the boxes.

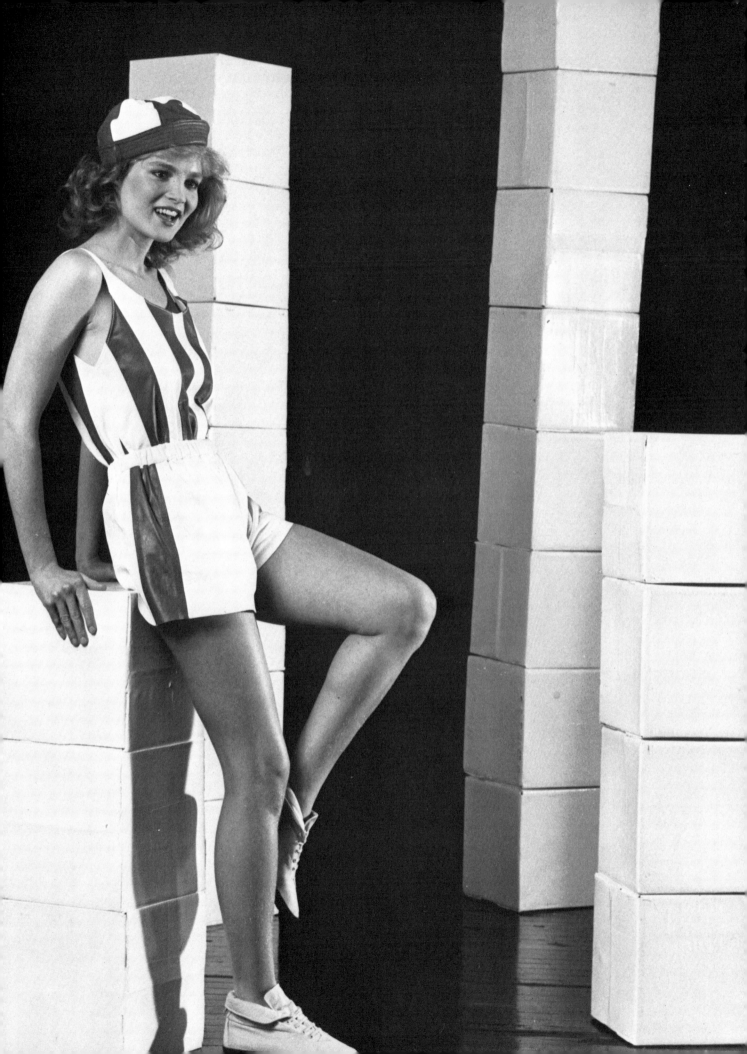

The Classical Woman

Using the classical woman in advertisements is suitable for brochures, newspapers, magazines, and catalogs. The main aim of this photographic shooting is to show the gown and the coat off in a way that is elegant, high-styled, neat, and appropriate to the clothing.

The type of model for this technique is a woman between the ages of 50 and 60. She is lovely because she has exercised, always cared for her skin, and has main-tained her weight. She should be slim, with pretty skin, healthy, thick hair (it can be partly or entirely white or dyed a natural-looking color), well-shaped hands, and cared-for nails. Her height should be between 5'6" and 5'10½". Her weight (which is in the range of 120 to 135 pounds) should be proportioned to her height and bone structure.

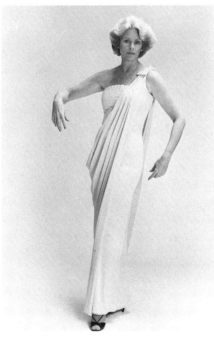

Do keep one foot in front of the other one; this enhances the line of the gown. The model's hand on her hip balances the other hand, which is in space.

Don't turn your front knee too far away from camera front—this detracts from the hour-glass line. Don't hold the panel in the back with a stiff arm because this makes the gown look unattractive.

Do use your hands out to the side and your fingers in a lovely position. The arms should be re-laxed looking.

Don't spoil your pose by bringing your elbows up. Keep your fingertips long and narrow rather than expose flat hands to the camera.

Advice to the Model

For these particular types of photographs, you should always assume a firm stance on the floor, with 12 to approximately 18 inches between one heel and the opposite foot, in some of the classic ballet positions—first, third, and fourth. Keep your pelvis pressed forward and your spine straight, with a long and elegant neck. You will find that this basic pose will work for clothes of the classical type. I would advise you to use your hands on a two-dimensional plane near to you or within an area of a foot off to the sides of your body. You should rotate your hips from side to side to generate movement from the loose panel in the back of the gown. Your expressions should encompass a wide range of moods: warm, aloof, sensuous, happy, for example. Be sure your hair is cut for a neat but stylish hairdo and that your makeup is cream colored and evenly applied up to the temples, but emphasis should be on the eyes and lips. Your nails should be well manicured and polished with a light color.

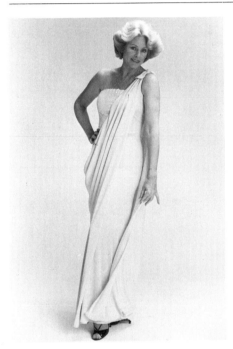

Do angle your face and hold your hands so that they are well displayed.

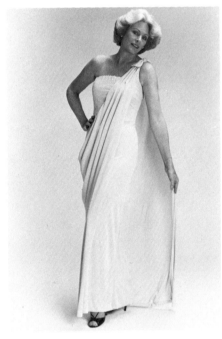

Don't hold the panel on a dress of this type. It is meant to flow straight. Don't lock your knee or bend your head over too far to the side.

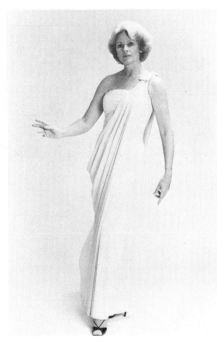

Do stand very erect, with one leg in front of the other. Hold your weight on your back leg and just touch down with your front toe. This model's shoulders are relaxed and flat to the camera. She's using one arm off to the side.

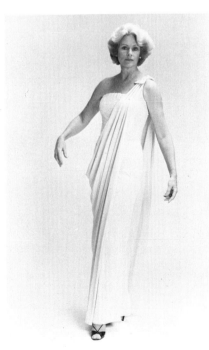

Don't keep one elbow stiff and bend the other one too much, keeping your wrist limp. Be aware of all your joints and how you use them.

105

Advice to the Photographer

Use seamless paper for this particular shooting and check with your Polaroid test that you're not getting strong, distracting shadows on the garment or on the model's face. Your camera should be approximately at the height of the model's chest, so that there is no distortion in the garment. Keep your photographs in sharp focus, but your lighting soft. The model should fit directly into the center of the frame. Ask her to stand in third or fourth ballet position hiding the heel or the toe that's pointing to the camera. This is always an elegant stance. Direct the model to turn her hips and shoulders narrow to the camera, bringing her head and neck back to it, and ask her to use her hands and arms on the sides so they look very relaxed and lovely. Make sure that the model has her hips turned slim to the camera. It is important that you watch how the model uses both hands. The fingers should be separated only slightly and the narrow side of the hand should be aimed at the camera. Have the model use her arms in such a way that she is bending her elbow and showing energy in her arms, not just allowing her arms and wrists to dangle in space. The arms should be used creatively in conjunction with her body.

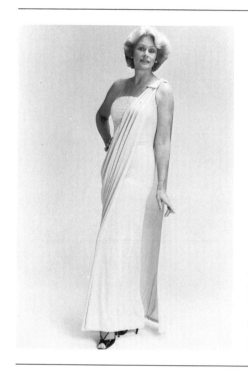

Do hold one arm on your hip and the other arm down to the side with an open hand. This is a straightforward projection to the camera.

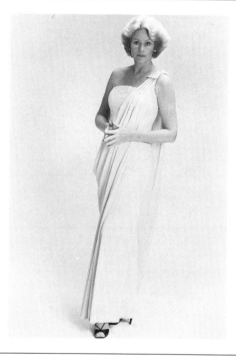

Don't lock your hands in front of your gown. This cuts the line of the gown and is bad photo posing.

Summary

The major problem encountered and solved in this shooting was directing the model to use her hands in a very feminine way. At times she felt strained because she was trying to hold her fingers in exactly the right position; then I would have her shake her hands and arms out to loosen them up and then strike the arm pose again. Just through the effort of relaxing, they would often go in exactly the right position.

The best picture (opposite page) was chosen because it has a true graphic balance. The model looks elegant and lovely and the gown is lovely and easily seen.

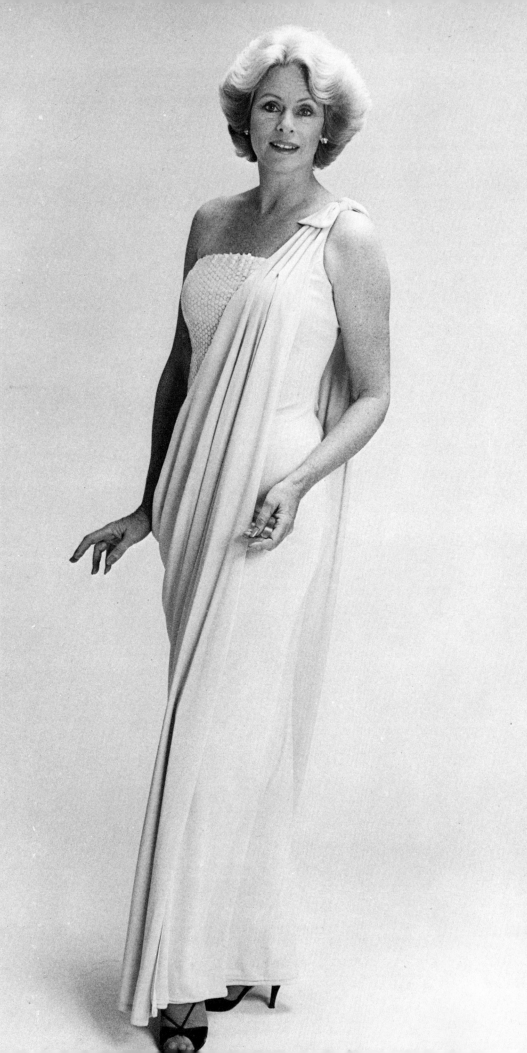

The Classical Man

This kind of advertising is always used with lots of copy running along the side or underneath, either to sell the product or to sell a concept. (In this example it could be "CALL YOUR INSURANCE MAN TODAY"). Photographically, both the product and the model are seen as equal. This type ad would run in newspapers, brochures, or national fashion and business magazines.

The model used should be between 45 and 55. He should be between 5'10" and 6'2" tall and weigh around 175 to 200 pounds. His hair should be thick, his face strong, and his demeanor elegant. The image should be that of a business executive rather than of a rugged, hardhat or suburban husband type.

Do place one leg on a box to provide separation. Turn your torso slightly parallel to the camera, just giving a hint of the back shoulder. The model here is holding the phone in excellent relationship to his body and hand. He is also gesturing toward the phone, which adds extra attraction to the product. His nose is inside his jawline. The direct contact with the camera and interesting expression on his face add to the excellence of the pose.

Don't cover the product with your hand. The model in this photograph doesn't seem to be aware he's doing this. His chin could be higher and the expression on the mouth could be improved. Also note that the inside of his jacket is gaping too much between his thighs and waist.

Do hold the phone and cord in a graceful manner. Here, the phone is displayed and the cord is held in a relaxed, masculine way. The expression on the model's face is warm and charming.

Don't turn your face too far away from the camera and don't hold your arm in an awkward position.

Advice to the Model

Appear on the set looking crisp, neat, and very well groomed. A little face powder will keep the shine down. You should project interest and concern while looking at the phone or at the camera.

Motions should be slow when you rotate the torso to the center, pivoting the back profile to front just 30 degrees. It's not a good idea to expose the full front of the pants; instead see that more of the jacket is shown. As you rotate around toward the front, keep an eye on your jacket because it's a good guide for letting you know when you have the correct angle to the camera. Your next step is to consider how you will handle the phone. You should use it in a natural way and keep it visible, so hold it to your side or even forward a bit and don't turn its back or front flat to the camera. The photographer will tell you how much emphasis you should place on the phone as a prop. Consider how you will handle the cord so that it also makes a statement.

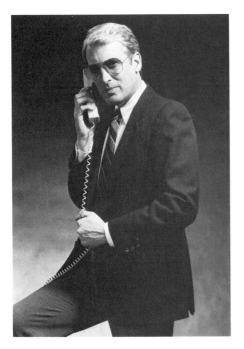

Do pay attention to the position of your hands. They shouldn't be hiding the product and should be held in good proportion to the phone.

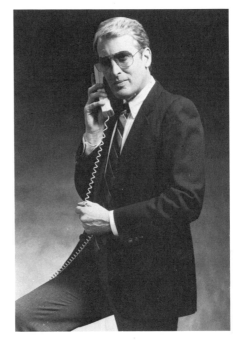

Don't hold the phone awkwardly. Here, the model's fingers are too open, the palm of his hand is exposed, and the phone should be tilted more toward the camera so you can actually see that the phone has buttons.

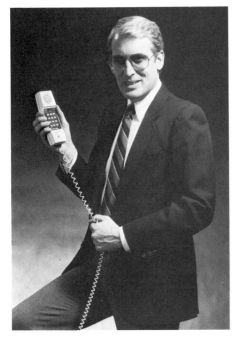

Do make sure the product is shown in such a way that it is interesting and easily identifiable. The hand holding the cord in this photo is placed in a good graphic position. The model's expression is interesting and the end result is elegant.

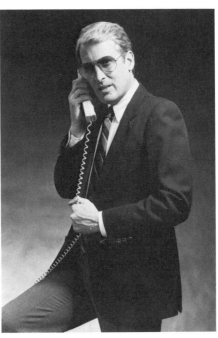

Don't pull the phone into the center too harshly. Note that here, the phone is hardly identifiable.

Advice to the Photographer

Set up the studio in advance. Use studio light, a strobe, or a mix of both for lighting. I used both—strobe to soften the hard lines and studio light to add depth. Look at the edges where the light falls on the subject to judge if it's too hot or too soft and adjust it accordingly. Avoid harsh shadows when using black-and-white film. Your camera should be aimed at the subject's chest for true proportions. Place him close to center in the frame, allowing a little more space on camera left so the use of the phone in that area is creating a balanced image. Look out for poses that hide parts of the phone and always be sure to ask for the appropriate expressions. The model's face should be turned three-quarter to the camera. This angle works best here because you can feel the subject relating to you and to the phone equally. Also, ask him to use the phone and cord in varying degrees and angles.

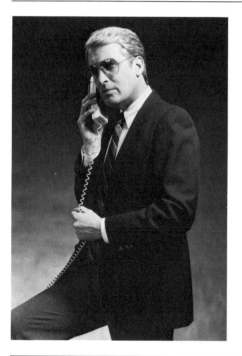

Do use the product naturally and make sure that, even if you are using it, it is clear what the product is. The model's stance in this photograph is elegant, the clothes are neat, and the angle of his head and the placement of his arms are excellent.

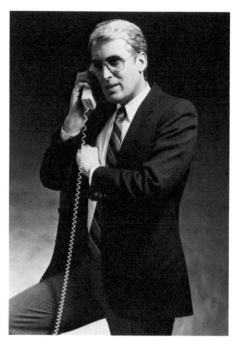

Don't place your hand into your inside pocket; it's an awkward gesture and wrinkles the sleeve too much as well. The head should be a little higher in this photograph and the top of the phone more identifiable.

Summary

There were no major problems in this session because the model is a professional and he knew how to handle this type of situation. There are several typical mistakes that could crop up in a shooting of this type, however. Inexperienced models have a tendency to overact with their facial expressions and to overuse the prop phone. They will also have a tendency, once the photo is structured, to project extreme moves after each shutter release, so instruct the model on each variation.

The photo on the opposite page was selected as best because the balance is perfect in relation to the subject, the frame, and the product/concept. The model is relaxed, the expression is appropriate, his grooming is neat but realistic looking, and it is clear as to what he is handling. Everything is well lit and there are no harsh shadows on the model's face.

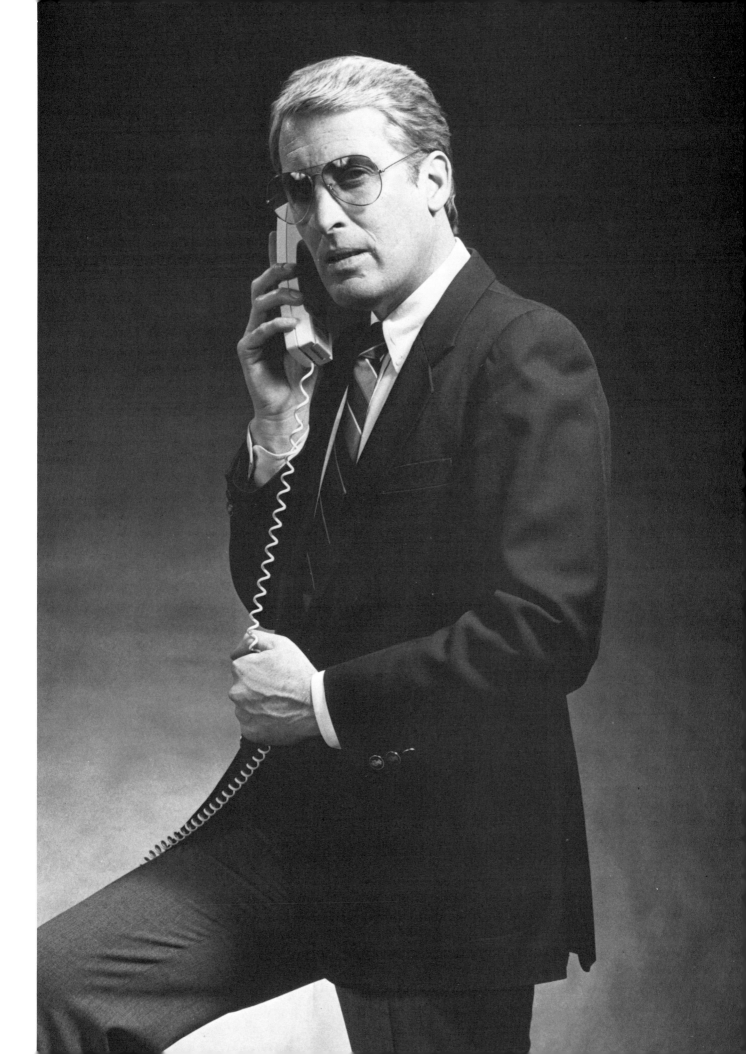

The Red Hat

This technique is used to show a hat to its very best advantage in an editorial or, possibly, in an advertising photograph, so the hat should be the feature of the story. The accessories added should complement the hat and the theme of the hat rather than distract from it. The kind of model used for this particular shooting should be an 18-to-30-year-old and should have good to excellent skin (it's not necessary for it to be absolutely perfect because there are excellent cosmetics on the market today). She should be 5'6" to 5'10" and her weight should be in proportion to her height. The model used should have graceful-looking hands without scars and pretty nails all the same length. The length of her hair is not important because it will be hidden under the hat. The makeup base should be heavy and will cover any imperfection, but the model should have beautiful eyes and full lips.

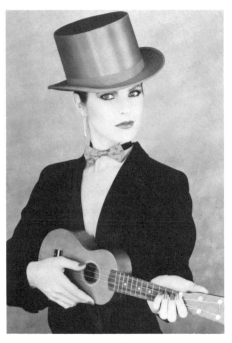

Do keep your shoulders relaxed and your hands in an appropriate relationship to the instrument. Notice how the model's chin is well balanced in reference to her neck, as her face is turned away just slightly enough to show the clean outline of her cheekbones and jaw.

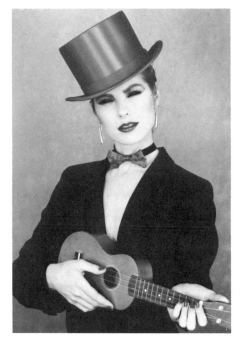

Don't, after you take a perfect pose with your body and your shoulders, distract from the photograph and your natural beauty by squinting your eyes. Expression and feeling come from within, not from overt physical change.

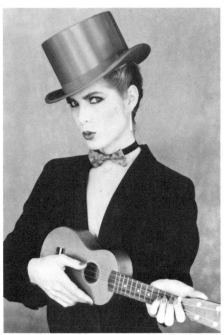

Do hold your cheekbone and jaw so that they are outlined well. The model's body position is excellent here. The expression on her mouth and eyes is charming.

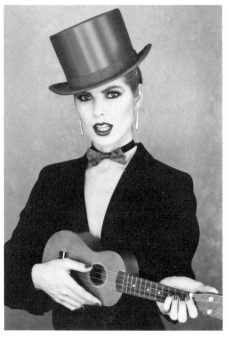

Don't let your expression become so exuberant that you show your bottom teeth as obviously as you do the top.

Advice to the Model

In preparation, you should arrive at the studio with clean skin and hair. The makeup is applied at the studio, so you should be cooperative with the makeup artist while he or she spends time making you up because this procedure takes approximately an hour. The eye makeup should be applied in a strong fashion and the color chosen should be appropriate to your eye color and the clothes you're wearing. The lipstick should be very strong and should be a tone of red that matches the tie in the hat.

The style of posing, expressions, and looks that are expected from the model are very varied in a controlled way in this particular shooting. You should think of it in terms of elegance and sex appeal. Angle your back shoulder away from the camera very slightly so that your shoulders appear more narrow and don't distract from the hat by being too obvious. You should hold the prop in an appropriate manner and vary your expressions and face angles to the camera. Don't turn your face too far away from the camera—the tip of your nose should stay inside your jawline so that a clean line is presented. Work mainly with your face straight on to the camera or tilted slightly to the side. Profile is not appropriate for this type of shooting.

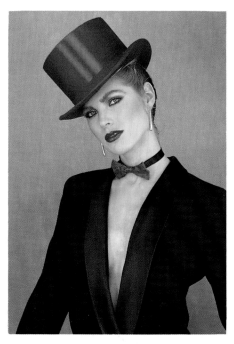

Do keep your expression relaxed and make sure that the outline of your face is just at the correct angle where the earring can be seen peeking through the other side. Notice how the model has added to the charm of this picture by dipping her head.

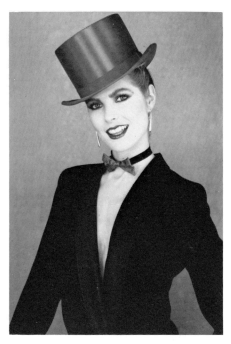

Don't project too large of a smile. Notice how this model's tongue and teeth are showing, which is not good photo posing.

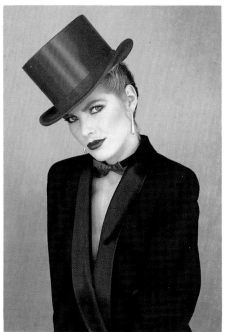

Do keep the angle of the face lively. Here the model has raised her shoulder a little bit by pressing down on the table, which adds to narrow shoulders and presents a new feeling to the photograph.

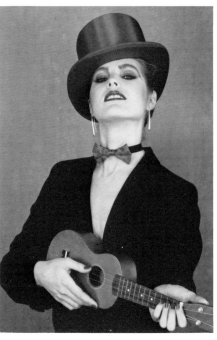

Don't lift your chin up too high or hold the instrument down too low. It is not attractive to see just your neck or into your nostrils. Keep your face on an even plane or just a little lower to the camera.

Advice to the Photographer

There is no set design in this particular photograph because it would distract from the model's beautiful face and lovely hat. However, an exciting backdrop was chosen to accentuate the model's loveliness and to add a little more texture. Be sure your lighting is well balanced so there are no shadows and the lighting on the model's face is flattering. Take several Polaroid test shots, directing the model to turn her face to different angles. On a shooting like this one, I usually test the night before, but if that's impossible, take some tests even while the model is half made up, so you'll have plenty of time for changes if needed. If the makeup artist absolutely objects, or if you feel interrupting their session by doing this would be too disruptive, use one of your assistants, but it's best to use the model. Camera-to-model angle should be camera high, model low because this encourages the model to keep her face up and her eyes lifted to the camera—plus, it's very flattering beauty lighting. Focus should be sharp, bright, and clear with no motion. The model should be balanced directly in the center of your frame and you should allow more space on the bottom than you think you actually need so you'll be able to crop at a later time. Do make sure that the model keeps her pose very elegant. It's important to see that she holds the ukulele flat against her body and that she's not pointing the neck to the camera. Ask the model to rotate her face very slightly from side to side while you're photographing her, using mostly her front face and a three-quarter angle.

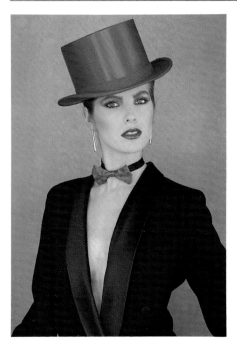

Do keep your shoulders angled a tiny bit away from the camera, a pose that adds to a look of slimness. The model has a long, elegant neck and a relaxed mouth, which also adds to the beauty of the photograph.

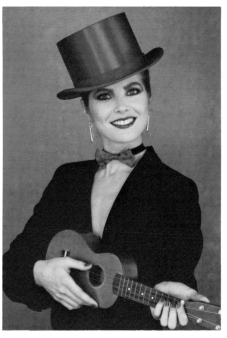

Don't stare into the camera. This is a usual mistake made by new models. Keep your eyes relaxed and close them for a while, look away, if necessary and then look back to the camera front. Staring is unattractive.

Summary

The major problems in this shooting were getting the model to hold the musical instrument flat against her body on a two-dimensional plane rather than aim the neck to the camera. She had a tendency, when she was drawing her shoulder back, to bring the neck of the instrument to the camera, which is normal, but which is not good posing. So direct the model to get into her pose and then ask her to adjust the instrument after she is in the correct body position. The model started by raising her chin up much too high, but this was solved by simply advising her to keep her chin down at a more natural angle.

The best picture (opposite page) was chosen because it is strong: the angle of the head is charming, the face looks beautiful and soft, the hat is balanced perfectly and both the earrings and tie are visible.

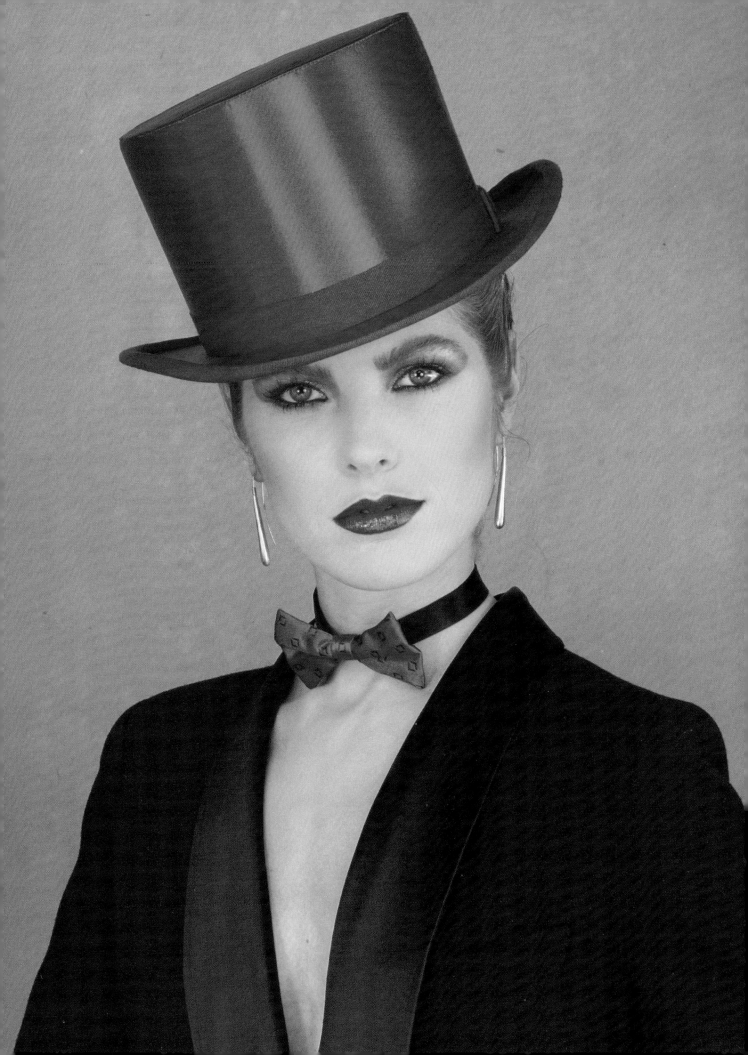

The Miniskirt

The aim of this technique is to show a cheerleading miniskirt editorial for a fashion magazine in its best light. Although there is no copy on the actual picture, there will be some to the side of it.

The most appropriate model is one with lots of vitality, who can really project to the camera. I would look for someone with a happy nature who talks a lot, has a sparkle in her eyes, and has some dance background or experience in modeling. She can be between 16 and 25 and should be healthy looking, not pencil-thin, so her weight should be in proportion to her bone structure, her age, and her total look. The model's hairstyle should not be fancy—it should be worn in a casual way. I picked a model with short hair for this shooting because the pompoms were going to be flying around, and I didn't want the added distraction of hair flying in the model's face. I like the clean lines that we have here.

Do balance on your back leg while picking up your front leg. Your hips should be narrow to the camera. The model here twisted her torso to the camera. She has a wonderful, gleeful look on her face and the pom-poms are well balanced.

Don't bring the pom-poms across the outfit—the garment must be seen. This model's smile is not genuine enough.

Do stand on your toes to give the feeling of jumping. This model's clothes look neat and her hips are narrow to the camera. The pompoms are full and not too close to her face, nor are they covering up her clothing.

Don't bring the pom-poms in so close that they hide your arms and also cover part of your face. Don't close one eye.

Advice to the Model

After you are dressed in the neatly pressed outfit, it is up to you to see that your blouse is tucked in your miniskirt securely. Don't put your shoes on until you get to the seamless backdrop because you don't want to pick up dirt on them while walking from the dressing room to the studio and then transfer it to the seamless. Hold the pom-poms by the handles in a firm grip and experiment posing with them. I would suggest bringing one knee or leg up while arching your back because it adds a different dimension to the photograph; kicking one leg out is fun, too. Arching the back makes the picture more exciting, as does bending the waist a tiny bit to the camera and at the same time shaking the pom-poms. The pose should be still, but the pom-poms should be moving. I suggest you use the pom-poms one up and one down, then both up, then both down to get different-looking photographs. Be sure that your sweater doesn't slip back tightly against your neck, because you'll lose the effect of a long, elegant neck. Lean forward with your face flat to the camera and smile energetically. Makeup should be colorful. Use rouge on your cheeks and bright lipstick.

Do pick up your legs and arch your back, still with hips narrow to the camera, and shake the pom-poms. These are far enough away from the model's face in this photograph to make the picture exciting.

Don't cross your arms completely while shaking the pom-poms because this makes the top of the arm look thick, covers up the product, and the pom-poms don't look electric enough. This model's smile is too broad.

Do pick up your outside leg to the camera—this is the best leg to show because the line is very clean. Your hips should be narrow to the camera. The model here has arched her back a bit and is shaking one of the pom-poms hard enough. Also notice that the position of the other pom-pom is very good because it doesn't cover her face.

Don't move out of the area you are assigned to work in. If you're going to assume a more exuberant pose, move back to the side so when you do pick your knee up higher than usual, it won't go out of the frame. The model here looks like she's ready to fly off. Keep the arms lower so that the pom-poms don't go out of the frame.

Advice to the Photographer

It's not necessary to use any design props in the studio because the model is already handling props that add enough variation to the pictures. Shoot some test Polaroids to see that you're getting what you want. Camera-to-subject angle should be camera slightly lower than model. Sharp focus is appropriate. These would be considered motion shots and should be bright and clear—not moody looking.

Direct the model to start by standing a little off center of her mark: the torso will be over to one side of frame in the camera because she will be bending back and the pom-poms will fill in the other area, the higher and side area of the frame. When the model gets on the set, ask her to turn her hips narrow to the camera—she should, in fact, be in complete profile—and to swing her torso around to the camera front. This makes it look as if there's more motion going on. You should ask the model to shake the pom-poms very hard and as you begin to work in a rhythm with your model and your shooting, she will feel that rhythm and automatically perform for you. Ask her to vary the position of the pom-poms: she can be holding one high up over her head, one down by her waist; or holding both out to the side of her chest; or holding and shaking both of them out at hip level. This will give your photographs more variety. Also ask her not only to pick up her leg, bringing her shoe back, but also to kick her leg up in front, still keeping her face to camera front and her head high.

Do use a kicking gesture while keeping your hips narrow to the camera and angling the top of your body around to the camera a bit. Shaking the pom-poms one up high and one lower gives the photograph a very interesting effect.

Don't hide your garment with the pom-poms, as the model here does. Both of the pom-poms should also be shaken and should be off to the side, not in the front.

Summary

Two major problems that were encountered in this session were getting the model to shake the pom-poms hard enough to make them look very full and getting her not to turn her shoulders semi-profile at the same time that her hips were in profile. These were solved by constant coaching. Other problems included making sure that she wasn't holding the pom-poms so high that they were going out of frame and that she wasn't using them so close to her body that they covered up her clothes so there wasn't any graphic space between the body, her arms, and the pom-poms.

The photograph on the opposite page was chosen as best because the model is very well centered in the frame and the balance of her knee to her torso and the pom-poms is excellent. The pom-poms are moving and the model looks as if she's flying as well. The energetic pose with the leg up is wonderful. Her shoulders are turned and her hips and waist appear narrow to the camera. Finally, she has a wonderful, happy look on her face.

Men's Sportswear

Advertising boots, jeans, and a sports jacket can be done in an editorial manner. The main aim is to show the clothes in a relaxed, natural way. A photographer would use this technique when shooting editorial pages for a fashion magazine.

The model should be in the age range of 21 to 30. He must be tall (between 5'10" and 6'2") and slim, matching the appropriate weight to his height. He should have thick, good-quality hair, a photogenic face, and fit into men's sizes 38, 40, or 42.

Do keep one leg down and one leg higher up; this gives variety to the pose. The details on the jacket here are easily seen, the hand is masculine, and it's believable that the young model is looking through his binoculars.

Don't spread your fingers out to cover your whole thigh—it's distracting and not good photo posing. Turn your back shoulder slightly forward and hold the binoculars up so that it's obvious what they are.

Do turn your face three-quarters to the camera and lower the binoculars to contemplate what you have just seen.

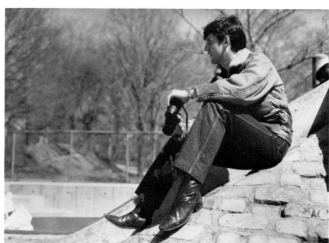

Don't spread your legs out too much and don't bring your knee up so high that your arm is resting on it; this covers the front of the jacket.

Advice to the Model

This style of posing is unusual because the setting is a slanted wall. You should be aware of the space you're working in and hook your feet into the bricks so you won't slip around. Don't crouch, because that's unattractive, or bring a knee down flat to the camera, because that covers the other leg up too much, which is also unattractive.

Find a pose that's in keeping with the theme of your clothing. Use the binoculars in a comfortable way. Your expressions and motions should follow the natural use of the product. The preparation necessary is simply neat grooming.

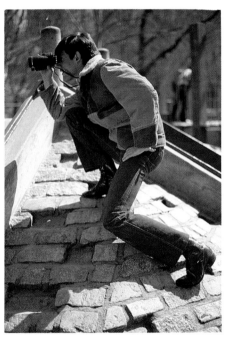

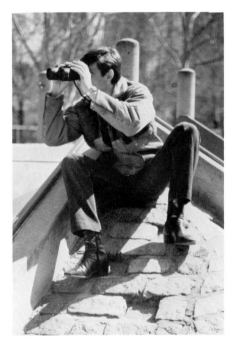

Do make sure your legs look long and lean; this helps create a good shape. The jacket in this photo is visible and the model is using the product appropriately.

Don't face the camera so directly that your crotch is visible—this is not attractive design. This model's torso is twisted and his arm covers the jacket. Also, keeping both hands on the binoculars covers up the jacket and the model's face.

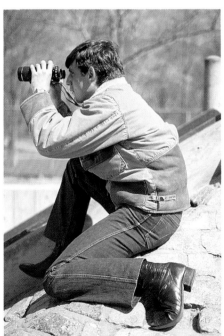

Do look relaxed and make sure the merchandise is neat. In this photo, the model is preoccupied with using his product, so it's a believable pose.

Don't turn your face so far away from the camera that your features are unidentifiable.

Advice to the Photographer

The best subject-to-camera angle is camera much lower than model, and you should be aiming at the model's hips. Unless you've come prepared with special ladders or climbing apparatus, in which case the whole approach would be different. Then you could photograph the shot straight on. However, be sure to discuss this with the art director so that you know ahead of time which angles are preferred. This was shot outside in a natural environment. No reflector or bulbs were used.

The model should sit more or less in the center of the frame, so that there is good graphic balance with the background. The most serious error you will have to look out for while directing a shooting like this one is the model's position on a slanted wall. See that his torso isn't directed to you in an awkward way. The binoculars should neither cover his face nor be too far away from it. You will have to give the model directions on how to use his legs and torso and how to position his feet. Be sure that you don't slant the camera and that the model isn't off balance or leaning too far away from the camera, as this would create distortion.

Do angle the merchandise you are displaying well. The binoculars in this photograph are far enough away from the model's face to show it and the intensity of his expression is believable.

Don't crouch up too high—your weight should be on your back legs, as if you were sitting. This model's hand is too low and he's staring into the camera. The entire photo is too forced.

Summary

The major problem encountered in this session was preventing the model from sliding down the brick wall. First we found a couple of nooks he could put his heels or toes in so he wouldn't fall. Then he started to feel uncomfortable because he couldn't hold the pose for such a long time, so we varied it by having him crouch forward more and took a few photos with him sitting profile to the camera as well.

The best picture, shown on the opposite page, was chosen because the model is graphically centered, the merchandise can be seen clearly, and the hands are well used. Also, the model is handling the binoculars in such a way that they coordinate with the expression on his face—and the whole scene is believable. Finally the background pole is in a good place, not conflicting with his body.

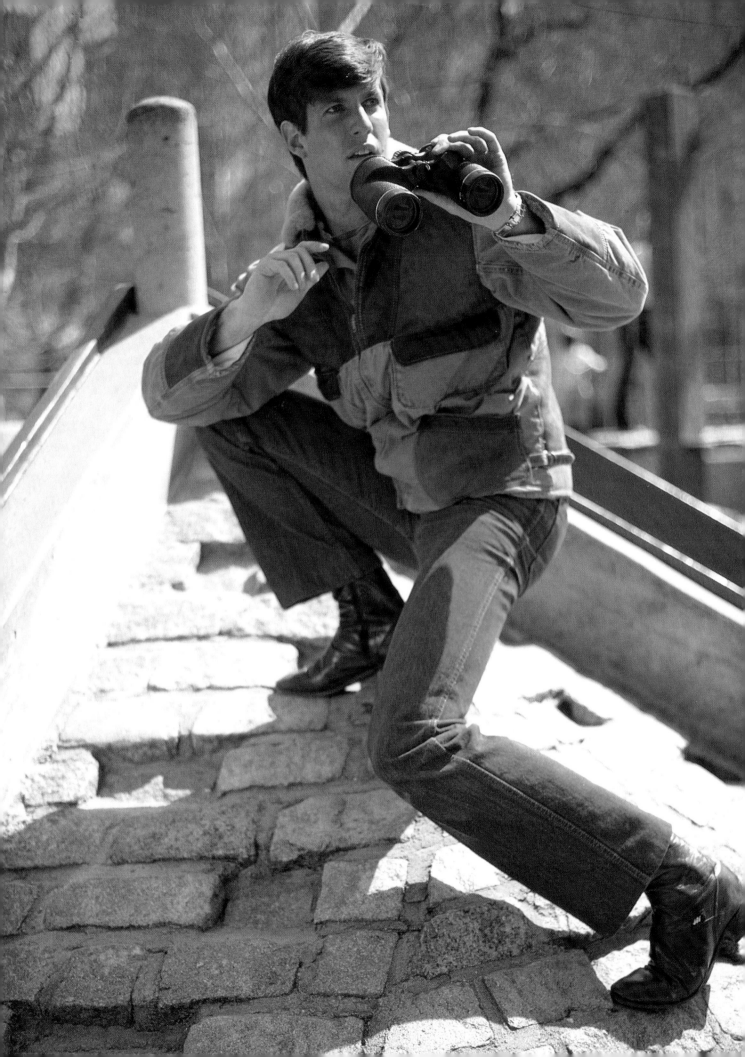

Hair Product

Since this technique is used to sell hair products in commercial advertising, the hair should be very well groomed and in a beautiful style. The model's face should have a very becoming expression and her makeup must be perfect. All the hair doesn't have to be inside the frame—most probably, cropping off part of the hair will add to the design of the photo which isn't often the case.

The model for this technique must have excellent skin with no scars or moles. Her face should be oval and her features must be very well balanced. She should have healthy-looking and thick eyebrows, and the whites of her eyes must be bright. Her lips should be full; her nose classical or delicate looking. She should be pretty in a commercial, rather than in a classical or exotic way. Needless to say, her hair must be in super condition— well trimmed, well conditioned, and well set.

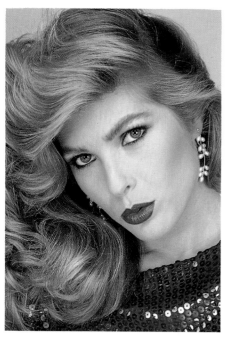

Do maintain good posture and keep your shoulders straight. Your head should be tilted to the side that shows the most volume of hair. This model's eyes look directly at the camera and her mouth is pouty, which is a very good expression for this type of advertising.

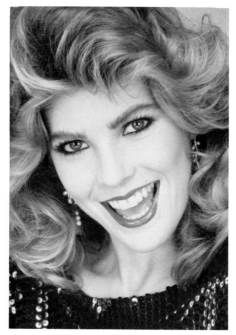

Don't bring the top of your forehead to the camera, thus bringing your chin down. Too much excitement makes your smile too broad, shows your bottom teeth and your tongue, and causes the neck to look strained.

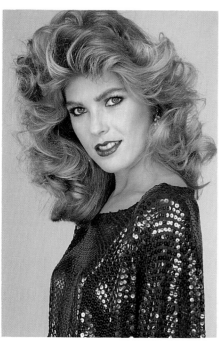

Do profile to the camera with your shoulders. This model brought her head back and tilted her chin down just a little bit, which helped her project an attitude.

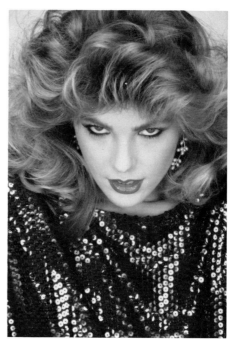

Don't bring your chin down so low that your neck is hidden completely—your eyes won't show to their best advantage either. This type of posing will make your nose look longer, your bottom lip larger, and your chin smaller.

Advice to the Model

For this technique, your hair should definitely be loose. The audience likes to see a luxurious amount of hair in this type of advertisement. You should move very slowly in front of the camera so that your curls don't loosen or get messy in any way. You should instinctively be aware of how your hair is falling, and if you feel it's falling incorrectly, you should draw this to the attention of the stylist, hairdresser, or photographer. If there's no one in the studio assisting except the photographer, you could ask his or her opinion and then get permission to gently move the hair around. The photographer will guide you where to place the hair. It's your responsibility to come to the shooting with clean, well-conditioned hair, unset and wrapped in a scarf. Your expressions should be varied: coquettish, sensuous, and happy. I would advise you to move extremely slowly, to position your shoulders slightly away from the camera, and to elongate your neck.

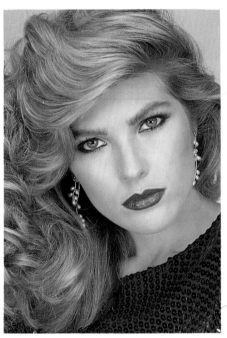

Do make sure your expression is calm, but that there's excitement in your eyes. The cropping of the hair in this photograph is just subtle enough to make it interesting. The model is tilting her head to the side where her hair has the most volume.

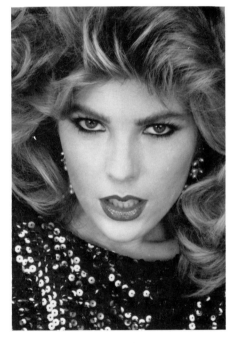

Don't bring your face too close to the camera using your neck to do so. As you see, this throws the proportions off and you lose not only the height of your forehead and the proportions of your whole face, but your entire neck as well. Keep your chin up and your neck long and elegant.

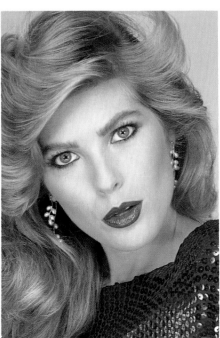

Do lift your shoulder to balance the falling hair. Here the hair is on the left, so the model lifted her right shoulder. The outline of her face is on a three-quarter angle and her eyes look up a bit.

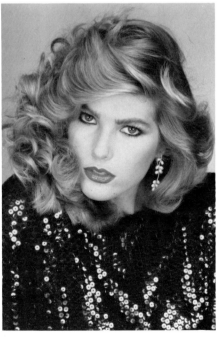

Don't allow your hair to fall so far forward that it dominates and covers your face and entire neck. You can feel when this is happening.

Advice to the Photographer

Color is most appropriate for this particular shooting because it's more realistic to show hair coloring when you're advertising a hair product. Subject-to-camera angle should be low to high. The camera should be much higher than the model so that her eyes will always appear large and the camera is not looking up the model's nostrils. This obviously should be shot in the studio, so you can manipulate the light. Lighting should be clear with no shadows, and the photo should be in sharp focus. It's not important for the model to be absolutely in the center of the frame. There may be times when you come close up and photograph her face very tightly, which will crop off part of her hair; that's perfectly acceptable in this particular technique. But it's also acceptable to pull back and give a little more room on the frame if you'd like, because you can always crop later. Ask the model to be seated and to use the table to lean her arms and shoulders on to assist her in making different shapes with her shoulders. Explain to her that she must keep her chin up at all times and not to do anything that doesn't feel natural. Tell her to keep changing her eye and mouth expressions. The most serious error that I made during this shooting was when I asked the model to project happier expressions. She then laughed, and her expressions become too exaggerated and her smile too wide. This is not good because it distracts from the hair and the pretty face in the photograph, and it makes the photograph look less controlled and beautiful than it should be.

Do arch your shoulder to way up under your chin. Both the expression on this model's face and her hair look very, very pretty. When you are selling hair products, it's important that the hair look especially beautiful.

Don't strain your neck to reach for a pose; instead, turn your shoulders first. Don't use your hand either, because it only distracts from your face, particularly if the palm of the hand is open and around the chin area.

Summary

The major problems in these sessions were getting the model to keep a long, elegant neck so the hair wouldn't fall in around her chin and completely cover up her neck, and getting her started and on the right track for the types of expressions required, which were moody and sensuous.

The best photograph (opposite page) was chosen because it has a very classical effect. The hair is neat and wavy and is clear of the forehead. There are no shadows on the face. The expression is relaxed and wonderful, and the eyes are beguiling.

Modeling for Commercial Products

Commercial Advertising

Consumer Products

In shooting commercial product photography, the product should be highly visible since that's what you're selling. The model is secondary, but her expression in relation to the product and the style she uses to present it will contribute much to the success of the photo. Her clothes should never be more outstanding than the product; they should be believable and appropriate. The product should always be held still and angled to the camera to show its best feature.

Models can be in any age range—children sell products and so do great-grandparents—but for products shown here, the model should be from 30 to 37 years old. She must have excellent skin, a pretty smile, and even teeth. Her weight should not exceed 125 pounds and she should be in the range of 5'6" to 5'10" tall. The model should be attractive in a pretty sense, not in an exotic, sexy, or high fashion one for the type of products shown here. If you have experimented with commercial product shots before, it would be helpful for you to share your contacts or color slides with the model before the shooting, pointing out the pros and cons.

Do make sure that your posture is erect and that the product is well balanced in the center of your body. The model here looks relaxed and friendly and her head is tilted a bit, which adds to the warmth of the photograph.

Don't hold the pie up too high; this forces you to hold your elbows out too far to the side. This model's expression isn't controlled enough and her chin is too low.

Do take a firm stance on the floor, with about two feet between your feet, and push your hips forward. Take a deep breath and relax. The pie in this photograph is tilted to the camera and you can see it well. The model's head is also slightly tilted, her smile is warm and she looks interested in what she's doing.

Don't drop your chin down too low so that it appears you have no neck. This model's expression is also too obvious.

Advice to the Model

Commercial product modeling is used to show off the client's product to its best advantage, making it look attractive and highly visible, so you should use your ingenuity and experiment with the product to see how many different ways there would be to show it and which would be the best. Start with the best pose and if that's successful, there may not be any need to change. But you may suggest other ideas and if the photographer agrees, try them.

Take a firm, open-legged stance. Keep the product close to you but don't drop it so low in front that it's not realistic or raise it so high that it covers your face. Keep your hands and thumbs relaxed and unobtrusive. They should be to the side or a little in back of and centered on the product. Keep it even and if it's flat, tilt it to the camera so it's easily recognized. Move very slowly and when you feel the product is in the most natural place, stop, and at that moment a friendly expression should emerge. These are considered still poses, so keep your neck long and your chin up, but don't lead with your chin forward to the camera. Keep your shoulders down and your arms close to your body. Your attitude and expressions should be friendly, warm, and proud.

Your hair should have a simple cut and style. Don't use any large or distinctive hair ornaments or jewelry. Your makeup should be light and simple but complete, and your nails natural pink or just natural.

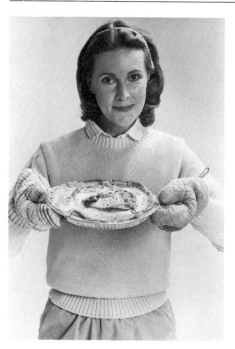

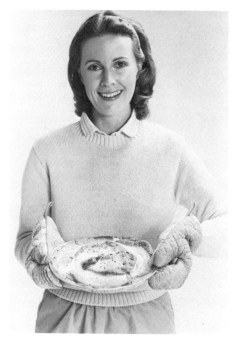

Do make sure that you have a look of interest on your face. The model's warm sweet smile and interested expression is what sells this product.

Don't hold the pie too low. It should be held balanced more at the middle of the sweater than by your waist. One arm is out too far from this model's body, which makes it look awkward. Her expression is friendly, but a little too exaggerated.

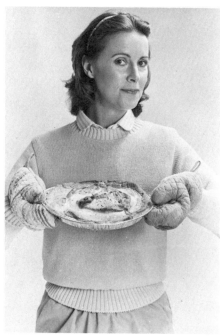

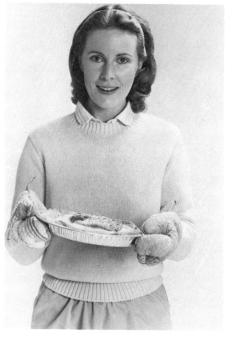

Do vary your expressions and the angle of your head. Here, the model turned her head away from camera front a little so you see more of the outline of her jaw, and her warm smile adds to the interest in her face.

Don't tilt the pie inappropriately because it will look sloppy. There isn't enough interest in this model's face.

Advice to the Photographer

A model feels more confident if you instruct her on the basic procedure and let her see the storyboard. Always be sure the clothes you will be using are ironed neatly, and fit the model (you can use clamps to pull them in tighter from the back). The clothes should be simple or complementary to the product. Solid colors are good because you don't want the clothes to distract from the product. The nails, makeup, and hair should follow the same principle. No special lighting effect is needed. You can use strobe or studio lighting combined with strobe, but flat lighting is often the best in this situation because it doesn't leave shadows or glare on the model or product. See that the lighting on the model's face is flattering, that there are no harsh shadows, and that the product is well lit and clearly identifiable. If your client asks for black-and-white film, don't choose one with lots of grain because the client will want the product to be seen very clearly, so work with a slow-speed film. A moderately low camera-to-model angle is excellent for true proportions because you don't want any distortions.

When you are ready to pose the model, ask her to experiment with the product. How would she hold it naturally? She'll give you some ideas and you'll add your own, so when you see something good, start there. Shoot frames with small variations, angling the product toward the camera and keeping it balanced, but don't pay too much attention to the hands. Ask the model to change head positions and facial expressions every other frame.

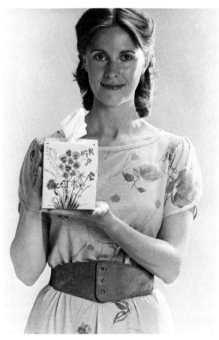

Do elongate your neck and direct your face to the camera for a charming and lively look. In this photograph, the product is perfectly balanced in proportion to the model's body. Her hands are unobtrusive, and her fingers are together.

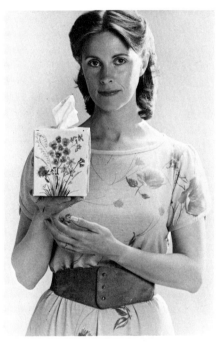

Don't cross one arm over your front, because, even if the product is held in a feminine position, this pose distracts from the purpose of the shot—showing the product. It's better if both hands come in direct with the product.

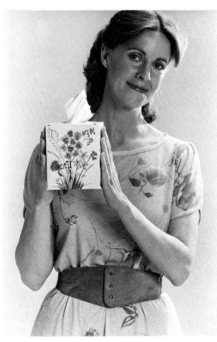

Do tilt your head to the side to add warmth to the photograph. This model's expression is wonderful, and she's holding the box in an unusual way. Her hands are flat and her fingers are together at the sides of the box, which doesn't distract in any way from the product.

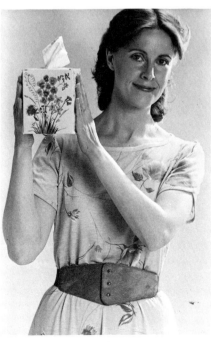

Don't angle your chin too far to the side—in this case, to the left. The model is holding the product in an interesting, feminine way, but up too high.

Summary

It's interesting to work with props because your attitude about each one is different, so your approach to each will be different. Most attention was given to correcting the balance and centering the product or showing it in a manner that didn't distract from the product. That was solved by checking the position of the product in each frame and directing it to exactly where it was desired. Remember, if your product has a label, it must be straight and clearly seen.

There were many excellent photos from each session and the one shown on the opposite page was chosen as an example representing all the other products because, as in so many of the other perfect poses, the model is centered, relaxed, and charming. The attention is on the product. It is balanced and not conflicting with the model's body, face, or hands.

Do hold the product in a very delicate and feminine way. This photograph has charm because of the model's sweet, direct smile. She used her neck to enhance her loveliness and to add strength to the pose.

Don't use your hands blatantly— this distracts from the product. It's better to hold the product in a very graphic manner in relationship to your body or in a more feminine way. Also, the back of the hand shouldn't be prominent.

Do hold the product in the center of your body, toward the middle of and close to the chest. If you hold the product further away from your body, it will appear larger because it's closer to the camera, so always try to keep everything on a two-dimensional plane, unless you're asked to do otherwise.

Don't hold the product down too low. It should be brought up a couple of inches above the belt. You can work in the center or off either side.

Product Hand Modeling

Selling products for magazine, newspaper, or brochure advertising involves keeping the product in the forefront so that it is easily seen. It must be kept flat to the camera because you're working on a two-dimensional plane and you don't want to foreshorten or distort the product.

The type of model most appropriate for this technique is one with good hands, either classical or rugged, whichever is appropriate. Sometimes it's not important that the hands or nails be groomed and sometimes it's explicitly requested that the nails of a male model be very well manicured. He should have no scars and a minimum of hair on his hands.

Do balance your hand and the product in the photograph. Here, the model's hand comes in from the side of the photograph, directing the scissors to the top corner and the film. The film was actually woven through the scissors and the hand and scissors are well displayed.

Don't leave the palm of your hand so open that it is prominent in the photograph. It is not interesting visually and throws the balance of the photograph off. Closing your palm half-way and arranging your scissors differently will automatically bring the scissors down more toward the middle of the photograph.

Do grip the scissors in a natural manner. The scissor points should be open enough to identify the object. It's perfectly all right to crop off the tips of the scissors because most of the product is seen.

Don't show too much of your thumb or the top of your hand—this takes away from the product.

Advice to the Model

For this particular technique, you should be very aware of the space that you have to work in and think in terms of using your hands, the product, and your wrist in a true proportion to that space. It's acceptable to show just the tip of the cuff. Balance your arm, either by holding it or by placing it on a table. Once your arm is projected into the space, hold it very, very still. Take the product in your hand in an appropriate way and gently rotate it around to camera front. As each photograph is snapped, move it just a trifle, maybe a quarter of an inch at a time. Show the most exciting side of the product. Experiment with opening and closing the blades of the scissors at various angles, holding the blades up slightly then point-

ing them downward. You will usually be asked to bring an appropriate shirt and jacket with a very good finish and sleeve trimming since only the wrist will show. Some studios actually have a whole wardrobe of nothing but cuffs of different categories—sports or formal evening or sweater cuffs, French cuffs, button cuffs, etc. You are expected to have very well-manicured nails with the cuticles pushed back and very smooth nails if that's the type of model that's called for. If the client requires the type of model who has little nicks in the nails, so that he can demonstrate a carpenter's tool, for instance, then you should have your nails groomed for that particular shot and that particular mood.

Do hold the scissors in a graceful way, as the model here is doing. These scissors are also open enough for clear identification and the hand is coming down from the top of the photograph—another well-balanced approach.

Don't hold your hand and the scissors straight across. Here, too much of the thumb is showing and there isn't enough height. Be aware of the space you have to fill with the product.

Do open the blades of the scissors wide enough to make an interesting visual effect. Here, the position of the model's fingers is correct and the scissors are held in good relationship to the hand.

Don't display too much of your palm. The fingers should close on the palm, which would bring the scissors more to the center of the photograph and balance it better.

Advice to the Photographer

Don't use lighting that distracts from the product but one that enhances it instead. A very contrasty background is often good because it makes the product jump out; in these examples I used a black velvet background. Shoot a Polaroid test to see that the lighting is falling correctly on the product. Camera-to-subject angles on product shots are usually camera high to product low, but there should be no extreme angles. The product should be in extreme sharp focus so that it is easily seen. No motion is required, but mood rather than flat lighting is often appealing.

Make your model comfortable sitting on a chair or stool; generally, it's better to keep the model lower than the table. Balance his arm on some phone books or on a table so that he will be able to keep the product very steady. Tell him to project his arm into the space and to be aware of the dimension he has to move in. You can tell him exactly what space is available. You might demonstrate to him beforehand all the different ways he could hold the product. Once he picks the product up, ask him to demonstrate quickly the different ways that *he* thinks would be appropriate and then start with the one that you both feel would be the best. Always ask the model to keep the palm of the hand away from the camera—it's not attractive and is distracting. The general rule is to keep the fingers together or the fingers in tight. Be sure to direct the model not to cover the product with his hand and, as he moves it, to rotate it very slightly displaying all of its best angles.

Do vary the position of your hand and of the scissors. Here, the hand is coming straight in, so you do see the inside of the palm of the hand. The prongs of the scissors are barely open but ready to snip the film—it's an interesting aspect.

Don't bring your hand in too low and don't point the scissors upward. Here, the fingers in the ring are crossed off because the hand is coming in too low and the scissors are not open enough. This photograph is not well balanced.

Summary

The major problem encountered in this session was getting the model to keep his hand absolutely, incredibly still. Be sure you have something comfortable for the model to set his elbow on to steady his hand; or if he's working from the top of the frame, pay attention to when he needs a break because you don't want fuzzy or out-of-focus pictures. Another major problem was getting the model to hold the product in a very delicate, but still masculine way. This was solved by keeping the top or three-quarters of the side of the hand to the camera because that's what makes a good picture in a shooting like this one. Well-balanced, the product is easily identifiable and the hand becomes secondary.

This photograph below was chosen as the best one because the product is very well balanced in the center of the frame, and the model's hand is secondary in balance with the product. The lighting contrast is excellent with emphasis on the scissors, and the clarity of the product in this contrasting environment makes this a beautiful, graphic picture.

Modeling Agencies

New York City

Action Models
136 W. 32nd St. 10001
212-279-3720

The Adair Agency
320 E. 42nd St. 10017
212-986-1906

The Barbizon
3 E. 54th St. 10022
212-371-4300

Big Beauties
159 Madison Ave. 10016
212-685-1270

Bonnie Kid
250 W. 57th St. 10019
212-246-0223

Click Model Agency
881 Seventh Ave. 10019
212-245-4306

Sue Charney Models
641 Lexington Ave. 10022
212-751-3005

DMI Talent Assoc.
250 W. 57th St. 10019
212-264-4650

Grace Del Marco
213 W. 53rd St. 10019
212-586-2654

Elite Model Management
110 E. 58th St. 10022
212-935-4500

Ferrari Models
1650 Broadway 10019
212-307-5107

Filor Talent
145 E. 49th St. 10017
212-832-1636

Ford Model Agency
344 E. 59th St. 10022
212-868-8538

Foster Fell Agency
26 W. 38th St. 10018
212-944-8520

Funny Face Brigade
527 Madison Ave. 10022
212-752-4450

Ellen Harth
515 Madison Ave. 10022
212-593-2332

Kay Models
111 E. 61st St. 10021
212-308-9560

Intl. Model Agency
232 Madison Ave. 10016
212-689-5236

L'Image
667 Madison Ave. 10021
212-758-6411

Legends Model Agency
40 E. 34th St. 10016
212-684-4600

Mannequins Models
730 5th Ave. 10019
212-585-7716

Maquette Int'l Models
62 W. 37th St. 10018
212-564-7734

Marge McDermott Agency
216 E. 39th St. 10016 (children)
212-898-1583

Models Service Agency
1457 Broadway 10036
212-944-8896

Other Dimensions
393 7th Ave. 10001
212-736-4260

Our Agency
120 W. 41st St. 10036
212-869-8591

Perkins Models
156 E. 52nd St. 10022
212-752-4488

Plus Model Mgt.
49 W. 37th St. 10018
212-997-1785

Pyramid Uno
Models Service
119 5th Ave., Suite 404 10003
212-674-1489

Wally Rogers
160 E. 56th St. 10022
212-755-1464

Gilla Roos
527 Madison Ave. 10022
212-758-5480

Charles V. Ryan
200 W. 57th St. 10019
212-245-2225

Wm. Schuller
667 Madison Ave. 10021
212-758-1919

Stewart Models
140 E. 63rd St. 10021
212-753-4610

Summa Models
250 W. 57th St.
212-582-6954

Van Der Veer Models
225 E. 59th St. 10022
212-688-2880

Wilhelmina Model Agency
9 E. 37th St. 10016
212-532-6800

World Wide Modeling
40 W. 39th St. 10018
212-354-7575

Zoli
146 E. 56th St. 10021
212-758-5959

Arizona

Hamco, Inc.
1802 N. Central Ave.,
Phoenix 85004
602-257-1626

Tor/Ann Talent & Booking
6711 N. 21st Way, Phoenix 85016
602-263-8708

Bobby Ball Talent Center
6061 E. Broadway, Tucson 85711
602-790-5550

Grissom Agency
2909 E. Grant Rd.,
Tucson 85716
602-327-5692

California

Adolfo's Agency
406 N. Golden Mall,
Burbank 91502
213-842-4260

Ryden Frazer Agency
1901 S. Bascom Ave.,
Cambell 95008
408-371-1973

Summer Models of California
2930 4th St., Ceres 95307
209-538-1360

Barbizon School
3450 Wilshire Blvd., LA 90010
213-487-1500

Nina Blanchard Agency
1717 N. Highland Ave.,
LA 90011
213-462-7274

CHN International Agency
7428 Santa Monica Blvd.,
LA 90046
213-874-8252

Cooper/Britton Agency
469 S. San Vincente Blvd.,
LA 90048
213-852-1321

Elite Model Management
9255 Sunset Blvd., LA 90069
213-274-9395

Playboy Model Agency
8560 Sunset Blvd., LA 90069
213-659-4080

Wilhemina West, Inc.
6430 Sunset Blvd., LA 90028
213-464-4600

Contempo Models and Talent
27767 Winding Way,
Malibu 90265
213-457-4594

Barbizon Agency of Pasadena
350 South Lake Ave.,
Pasadena 91101
213-795-8400

Empire West Agency
4255 Main St., Riverside 92501
714-781-0194

Starr Modeling
733 S. Main St., Salinas 93901
408-422-0127

Loyce Modeling Agency
1161 Cherry St.,
San Carlos 94070
415-591-5864

Chateau D'Or Fashion Models
1552 5th Ave., San Diego 92101
714-232-2200

Commercial Artist Mgmt Agency
2232 5th Ave., San Diego 92101
714-233-6655

Mary Crosby Talent Agency
2130 Fourth Ave.,
San Diego 92101
714-234-7911

Tina Real
505 Maple St., San Diego 92103
714-234-3337

Brebner Agency, Inc.
China Basin Bldg.,
161 Berry St., SF 94107
415-495-6700

Demeter & Reed, Ltd.
445 Bryant St., SF 94107
415-777-1337

Grimme Agency
214 Grant Ave., SF 94108
415-392-9175

McGraw Agency
591 Mansion St., SF 94105
415-495-3382

Sabina Models
278 Post St., SF 94108
415-495-3382

La Vonne Valentine Agency
2113 Van Ness Ave., SF 94109
415-673-7965

L'Agence Models
100 N. Winchester Blvd.,
San Jose 95128
408-985-7449

Colorado

Jack Blue Agency
1554 Fairfax, Denver 80220
303-333-9324

Illinois Talent, Inc.
2664 S. Krameria, Denver 80222
303-757-8675

Mary Mitchell Agency
1515 Cleveland Pl., Denver 80202
303-825-2069

Connecticut

Johnston Agency for Models
4 Bramble Lane,
Riverside 06878
203-637-5949

CTC
136 Main St., Westport 06880
203-838-7449

The Joanna-Lawrence Agency
82 Patrick Rd., Westport 06880
203-226-7239

Washington, D.C.

Black Model Agency
3220 Georgia Ave. NW 20010
202-726-5106

Central Casting
1000 Connecticut Ave.
NW 20036
202-659-8272

Florida

All Star Productions
133 Whooping Lane, Altamonte
Springs 32751
305-339-3612

Coconut Grove Talent
3525 Vista Ct.,
Coca Beach 33133
305-446-0047

Sharon de Russy
PO Box 322, Cocoa Beach 32931
305-773-2339

City Models
3212 N Federal Hwy,
Ft. Lauderdale 33316
305-522-3262

Florida Talent Agency
2631 E. Oakland Park,
Ft. Lauderdale 33301
305-565-3552

Marian Polan Talent
411 NE 11th Ave.,
Ft. Lauderdale 33301
305-379-7526

Palm Beach Casting
1342 South Killian Dr.,
Lake Park 33403
305-844-5570

Agency for Performing Arts
7630 Biscayne Blvd.,
Miami 33138
305-758-8731

The Agency South
1501 Sunset Dr.,
Coral Gables 33146
305-667-6746

Florida Casting Agency
1200 NW 78th Ave.,
Miami 33126
305-593-2115

Gold Coast Models
1720 79th St. Causeway,
Miami Beach 33141
305-861-6900

Glynne Kennedy Talent
1828 NE 4th Ave., Miami 33132
305-358-5998

Marbea Agency
104 Crandon Blvd.,
Key Biscayne 33149
305-361-1144

The Talent Agents
1528 NE 147th St., Miami 33161
305-940-7076

Talent Enterprises, Inc.
12555 Biscayne Blvd.,
Miami 33181
305-891-1832

International Casting
2607 N. Orange Ave.,
Orlando 32804
305-696-9700

Janice Haney Models
9 Seneca Rd.,
Palm Beach 33308
305-626-1811

Turnabout Modeling
585 SE Monterey Rd.,
Stuart 33494
305-283-1449

Dott Burns Model
and Talent Agency
478 Severn Ave., Tampa 33606
813-251-5882

Professional Touch
8411 Civic Rd., Tampa 33615
813-885-6480

Georgia

Arnold Agency
1252 W. Peachtree St.,
Atlanta 30309
404-873-2001

Atlanta Models & Talent
3030 Peachtree Rd. NE,
Ste. 308, Atlanta
404-261-9627

B B & A Talent
3098 Piedmont Rd. NE,
Atlanta 30305
404-231-9396

Chez Agency
225 Peachtree Rd.,
Atlanta 30303
404-588-1215

House of Talent of Coin
966 Lindridge Dr. NE,
Atlanta 30324
404-261-5543

Jacquelyn Jones Talent
1000 Clemenstone Dr. NE,
Atlanta 30305
404-252-2470

Models Touch
2945 Stone Hogan Rd. Cont,
Atlanta 30311
404-346-1210

Prof. Models and Actors
2975 Headland Dr. SW,
Atlanta 30311
404-346-1210

The Seitz Modeling Agency
4651 Roswell Rd., Atlanta 30342
404-257-9270

Serindipity Model and Talent
3130 Maple Dr. NE,
Atlanta 30305
404-237-4040

T A M C A
4540 F Memorial Dr. Decatur,
Atlanta 30032
404-292-4207

Take One Talent
1360 Brooklawn Rd. NE,
Atlanta 30326
404-231-2315

The Talent Shop
3379 Peachtree Rd.,
Atlanta 30326
404-261-0770

The Mathews Agency
702 Mall Blvd., Savannah 31406
912-355-6070

Hawaii

Barbizon
1600 Kapiolani Blvd.,
Honolulu 96814
808-946-9081

Illinois

Mary Boncher Model Agency
814 Four Seasons Blvd.,
Bloomington
309-662-5631

Exclusively Yours
535 N. Michigan Ave.,
Chicago 60611
312-329-9051

A-Plus Talent Agency
666 N. Lakeshore Dr.,
Chicago 60611
312-642-8151

Al Dvorin Agency
2701 West Howard St.,
Chicago 60601
312-743-8500

Ann Geddes Models
875 N. Michigan Ave.,
Chicago 60611
312-664-9890

Shirley Hamilton
620 N. Michigan Ave.,
Chicago 60611
312-644-0300

Helpmate Models
14021 S. Tracy, Chicago 60627
312-263-6660

Interlinque
333 N. Michigan, Chicago 60601
312-782-8123

David Lee Models
64 East Walton Ave.,
Chicago 60611
312-649-0500

Emilla Lorence
619 Wabash Ave., Chicago 60611
312-787-2023

National Talent Associates
3525 W. Peterson Ave.,
Chicago 60645
312-539-8575

National Talent Network
101 E. Ontario, Chicago 60611
312-280-2225

Jo Penny, Inc.
2 E. Oak St., Chicago 60611
312-943-5011

Playboy Models, Inc.
919 N. Michigan Ave.,
Chicago 60611
312-664-9024

Norman Schucart
1417 Greenbay Rd.,
Highland Park 60035
312-433-1113

Auditions Division
10400 Higgins Rd.,
Rosemont 60018
312-298-1730

Sharon Di Antonio
1550 S. Mount Prospect Rd.,
Rosemont 60018
312-297-6075

Indiana

Reflection Modeling Studio
645 Lafayette Ave.,
Columbus 47201
812-376-8331

Leo Crowder Productions
5310 Radnor Rd.,
Indianpolis 46205
317-547-4886

Kentucky

Barbizon, Oxmoor Center
7900 Shelbyville Rd.,
Louisville 40222
502-425-4900

Vogue Modeling
901 Dupont Rd.,
Louisville 40207
502-896-4479

Louisiana

Neel Shakir Modeling Agency
805 Lamar St., Lafayette 70501
318-232-9757

Barbizon
921 Canal St.,
New Orleans 70112
504-581-3737

Peter Dassinger Agency
1018 Royal, New Orleans 70116
504-525-8382

Maryland

Barbizon
1 Investment Pl.,
Baltimore 21204
301-321-0500

Central Casting
330 N. Charles St.,
Baltimore 21201
301-962-8272

Unlimited Talent
2431 E. Furnace Branch Rd.,
Glen Burnie 21061
301-760-1100

Talent Network
10305 King Richard Pl.,
Upper Marlboro 20772
301-372-8217

Massachusetts

Agency for Models
105 A Appelton, Boston
617-267-4211

Barbizon
480 Boylston St., Boston 02116
617-266-6980

The Boston Agency
163 Marlboro, Boston
617-247-0200

Copley Models
29 Newbury St., Boston 02116
616-267-4444

Cameo Models
392 Boylston St., Boston
617-536-6004

Hart Model Agency
137 Newbury St., Boston 02116
617-262-1740

The Model Shoppe
176 Newbury St., Boston 02116
617-266-6939

Models Group
129 Newbury St., Boston 02116
617-536-1900

Betty Goodman's Model Agency
375 N. Montello St.,
Brockton 02401
617-584-3553

Michigan

Advertisers Casting Service
15 Kercheval, Grosse Pointe
Farms
313-881-1135

Affiliated Models
28860 Southfield Rd.,
Southfield 48076
313-559-3110

Gail & Rice Talent
11845 Mayfield St.,
Livonia 48150
313-427-9315

Marce Haney Associates
1150 Griswold, Detroit 48226
313-961-6222

Mademoiselle Agency
21590 Greenfield,
Oak Park 48237
313-968-3232

New Jersey

Atlantic City Models Guild
8 S. Hanover Ave.,
Atlantic City 08402
609-822-2222

Magnum Talent Associates
186 Fairfield Rd., Fairfield 07006
201-941-1304

National Talent Associates
186 Fairfield Rd., Fairfield 07006
201-575-7300

Pat Evans Model Management
194 Passaic St.,
Hackensack 07601
201-581-4220

The Look You Want
10 Station Place,
Metuchen 08840
201-494-3011

Meredith Agency
91 Overlook Ave., Wayne 07470
201-694-7802

New York

June II Model Agency
1431/2 Allen St., Buffalo 14202
716-883-0700

Nefertiti Modeling Services
21 Central Park Plaza, Buffalo
716-833-0700

The Volkert Agency
310 Delaware Ave.,
Buffalo 14202
716-856-1500

Class Act Model Agency
175-20 Wexford Terrace,
LI 11432
212-657-4477

Ohio

Continental Modeling Agency
13229 Superior Ave.,
Cleveland 44112
216-761-6266

David Lee Modeling Agency
325 Cleveland Pl.,
Cleveland 44115
216-522-1300

Dorian Leigh Modeling
Suite 400, 1001 Euclid,
Cleveland 44115
216-579-1188

Nationwide Modeling Agency
Cleveland Plaza Towers,
Cleveland
216-566-8060

Skilstan, Inc.
Terminal Tower, Cleveland 44113
216-241-3870

Oregon

Imagery Talent Agency
2833 Willamette St.,
Eugene 97403
503-345-2186

Pennsylvania

Fashion Models Guild
24 W. Chelten Ave.,
Philadelphia 19144
215-844-8872

Kingsley Six Agency
1315 Walnut St.,
Philadelphia 19406
215-546-5919

Midiri Models
1920 Chestnut St.,
Philadelphia 19103
215-561-5028

Models Guild of Philadelphia
1512 Spruce St., Philadelphia
215-735-5606

Texas

Austin's 'Actor's Clearing House
501 N. Interregional, Austin
512-476-3412

Tanya Blair Agency
2320 N. Griffin, Dallas 75202
214-748-8353

Century Casting
1949 Stemmons, Dallas 75207
214-522-1435

The Creative Workshop
4115 N. Central Expy.,
Dallas 75214
214-522-1060

Dalls Intl. Artist Inc.
8383 Stemmons, Dallas 75247
214-630-8888

Kim Dawson Agency
1143 Apparel Mart, Dallas 75207
214-638-2414

Joan Frank Productions
9550 Forest Lane, Dallas 75243
214-343-8737

The Geraldon Agency
1949 Stemmons, Dallas 75207
214-522-1430

The Norton Agency
3023 Routh St., Dallas 75201
214-749-0900

Stars Over Texas Mgmt.
4515 Maple Ave., Dallas 75219
214-522-2030

Peggy Taylor Talent
3616 Howell, Dallas 75204
214-526-4800

Joy Wyse Talent Agency
6318 Gaston Ave., Dallas 75214
214-826-0330

Vargas Group of Texas
10400 N. Central Expwy.,
Dallas 75231
214-368-5500

TV Look Modeling Agency
PO Box 12138, El Paso 79112
915-581-6523

Aaron Che Modeling Agency
PO Box 56789, Houston 77027
713-784-5811

Actors and Models of Houston
1305 S. Voss, Houston 77057
713-789-4973

Nancy B and Co
2715 Bissonet, Houston 77005
713-524-4741

The Holland Group
2209 McArthur, Houston 77030
713-664-7700

Garri Halpin Agency
911 Kipling, Houston 77006
713-526-5749

The Mad Hatter Agency
7249 Aschcroft Bldg. B,
Houston 77081
713-995-9090

Intermedia Agency
2323 S. Voss, Suite 440,
Houston 77057
713-789-3993

On Stage Studios
3655 Fondren Ave.,
Houston 77036
713-785-0548

Valenna Models
11015 Ella Lee Lane,
Houston 77042
713-780-3650

Sherry Young Agency
6420 Hillcroft, Lubbock 77081
806-981-9236

Doe Hutson Agency
7549 McCullough,
San Antonio 78215
512-828-6052

Mannequin Modeling Agency
204 E. Oakview Place,
San Antonio
512-224-4231

T B K, 5255 McCullough,
San Antonio 78212
512-822-0508

Meadows Models
3223 S. Main, Stafford 77477
713-499-7638

Washington

Lola Hallowell Agency
158 Thomas St., Seattle 98109
206-623-7311

Barbizon
414 Olive Way, Seattle 98101
206-682-6611

Spokane's Newest Faces
South 2102 McDonald Rd.,
Spokane 99216
509-838-8503

Glossary

Art director: An ad agency employee whose job it is to create ideas for advertising.

Beauty: Refers to modeling assignments that are showing a cosmetic or hair product.

Booker: A model agency employee who sends models out on go sees and tests, decides with the clients the appropriate model for the assignment, and confirms the model's availability schedules.

Catalog House: Primarily a studio that deals in photographing catalogs for stores or companies, such as J.C. Penney's, Sears, Bloomingdale's, Simplicity Patterns, and special supplements that come out with Sunday papers, etc.

Client: The person or firm that hires the model.

Commercial: Refers to the selling or advertising of any product in print.

Composite: A series of photographs of the model that's left with the client to keep on file for referral for future work.

Frame: The area within the viewfinder of the camera, and seen in the resulting photograph.

Full-face Shot: Face straight on to camera.

Go See: An appointment made for you by a booker to visit a client.

Head Sheet: A sheet put together by the modeling agency that displays photos of all the models in the agency.

Loop: A magnifying glass to study contact sheets or proofs with.

Packaging: Any extended assignment where the model is booked for a long-term advertising compaign.

Portfolio: A book that contains photographs of the model or the photographer's work for the purpose of selling his or her look or work to potential clients.

Profile: Showing the face and/or body in complete side view to the camera.

Proof Sheet or Contact Sheet: A roll of exposed film displayed in miniature on sensitized film paper.

Release Form: A surrender of a right to claim further money and an agreement for a model's likeness to be used in a photograph intended for commercial use.

Rounds: General interviews for the model to meet the client and show his or her portfolio in the hope of future work.

Storyboard: A cardboard sheet on which a picture story is drawn of the ideas for the final photographs.

Tearsheets: Photographs promoting fashion or products that have appeared in newspapers or magazines.

Test: A photography session to explore a new look with fashion, hair, or makeup for the model, or new creative or technical ideas for the firm or photographer.

Three-quarter Shot: A shot that shows the model between profile and full face to the camera.

Voucher: A paper that states an agreement between model and client.

Strobe: A light source used in high-speed photography, capable of producing a series of short pulses of light.

Index

Credits

Front and back of jacket
Model: Paige Tiffany Hall/Ford Models Inc.
Hair and Makeup: Leonardo De Vega
Blouse: Summa
Earrings: Marsha Breslow
Flowers: Herely Popock
Bracelet: Andrew Hatfield
Background Artist: Sandro La Ferla
Stylist: Cheyenne

pp. 28–31
Model: Daniela Barbacini/Kay Modeling Agency
Hair and Makeup: Trevor Hunter
Stylist: Cheyenne

pp. 32–35
Model: Brenda Aaronson/Ford Models Inc.
Hair and Makeup: Leonardo De Vega
Earrings: Marsha Breslow
Blouse: Criscione
Background Artist: Sandro La Ferla
Stylist: Cheyenne

pp. 36–39
Model: Daniela Barbacini/Kay Modeling Agency
Hair and Makeup: Trevor Hunter
Dress: Reza Mohyeddin
Stylist: Cheyenne

pp. 40–43
Model: Tina Staley/Van Der Veer Models
Hair and Makeup: Cheyenne
Blouse: Herbert Runick
Set Designer: Don Manza
Stylist: Cheyenne

pp. 44–47
Model: Pamela Sue Medeiror/Van Der Veer Models
Hair and Makeup: Rennie Dawson
Lingerie: Lily of France
Stylist: Cheyenne
Location: Royal Mills Associates

pp. 48–51
Model: Daniela Barbacini/Kay Modeling Agency
Hair and Makeup: Trevor Hunter
Dress: Johnie Versace
Stylist: Cheyenne

pp. 52–55
Model: Daniela Barbacini/Kay Modeling Agency
Hair and Makeup: Trevor Hunter
Suit: Reza Mohyeddin
Hat: Jay Lord Hatters
Stylist: Cheyenne

pp. 56–59
Model: Christine Smith
Hair and Makeup: Tobi Birns and Donna Pitchon
Sweater: Quantum Sportswear Ltd.
Stylist: Cheyenne

pp. 60–63
Model: Keith Jones/Van Der Veer Models
Clothing: Capital
Stylist: Cheyenne

pp. 64–67
Model: Paige Tiffany Hall/Ford Models Inc.
Hair and Makeup: Leonardo De Vega
Earrings: Marsha Breslow
Bracelet: Andrew Hatfield
Background Artist: Sandro La Ferla
Flowers: Herely Papock
Stylist: Cheyenne

pp. 68–71
Model: Cristine Smith
Hair and Makeup: Tobi Birns
Clothing: Quantum Sportswear Ltd.
Set Designer: Don Manza
Stylist: Cheyenne

pp. 72–75
Model: Jennifer Burry/Ford Models Inc.
Hair and Makeup: Tobi Birns
Dress: Leigh-Alan Associates
Stylist: Cheyenne

pp. 76–79
Model: Shailah Elmonds
Hair and Makeup: Rennie Dawson
Lingerie: Lilly of France
Location: Royal Mills Associates
Stylist: Cheyenne

pp. 80–83
Models: Josyane Monaco/Ford Models Inc.
Allan Stokes/Wilhelmina Models Inc.
Gloves: Carrie Bishop
Location: Fashion Institute of Technology
Stylist: Cheyenne

pp. 84–87
Models: Shannon Engemann/Ford Models Inc.
Jennifer Burry/Ford Models Inc.
Dresses: Leigh-Alan Associates
Hair and Makeup: Tobi Birns and Donna Pitchon
Stylist: Cheyenne

pp. 88–91
Models: Keith Jones/Van Der Veer Models
Charles Tally/Van Der Veer Models
Sweaters: Calvin Klein
Stylist: Cheyenne

pp. 92–95
Models: David Tannenbaum/Van Der Veer Models
Bob Evangelista/Wilhelmina Models Inc.
Clothing: Phillippe Monet
Hair: Rennie Dawson
Stylist: Cheyenne

pp. 96–99
Model: Pat Harper/Ford Models Inc.
Dress: Calvin Klein
Hair and Makeup: Pat Harper
Set Designer: Don Manza
Stylist: Cheyenne

pp. 100–103
Model: Jonna Leigh Stack
Hair and Makeup: Cheyenne
Set Designer: Richard Biles and Cheyenne
Stylist: Cheyenne

pp. 104–107
Model: Lee Frost/Wallace Rogers Inc.
Hair and Makeup: Lee Frost
Stylist: Lee Frost

pp. 108–111
Model: Peter Lester/Wallace Rogers Inc.
Hair and Makeup: Peter Lester
Stylist: Cheyenne

pp. 112–115
Model: Brenda Aaronson/Ford Models Inc.
Hat: Jay Lord Hatters
Earrings: Marsha Breslow
Background Artist: Sandro La Ferla
Hair and Makeup: Leonardo De Vega
Stylist: Cheyenne

pp. 116–119
Model: Pamela Greene/
Hair and Makeup: Donna Pitchon
Clothing: Quantum Sportswear Ltd.
Stylist: Cheyenne

pp. 120–123
Model: David Tannenbaum/Van Der Veer Models
Hair: Rennie Dawson
Jacket: Jean Bernard
Stylist: Cheyenne

pp. 124–127
Model: Brenda Aaronson/Ford Models Inc.
Hair and Makeup: Leonardo De Vega
Earrings: Marsha Breslow
Blouse: Criscione
Stylist: Cheyenne

pp. 128–133
Model: Amanda York/Wallace Rogers Inc.
Hair and Makeup: Amanda York
Stylist: Cheyenne

pp. 134–137
Model: Peter Lester/Wallace Rogers Inc.
Stylist: Cheyenne